Facing
Change

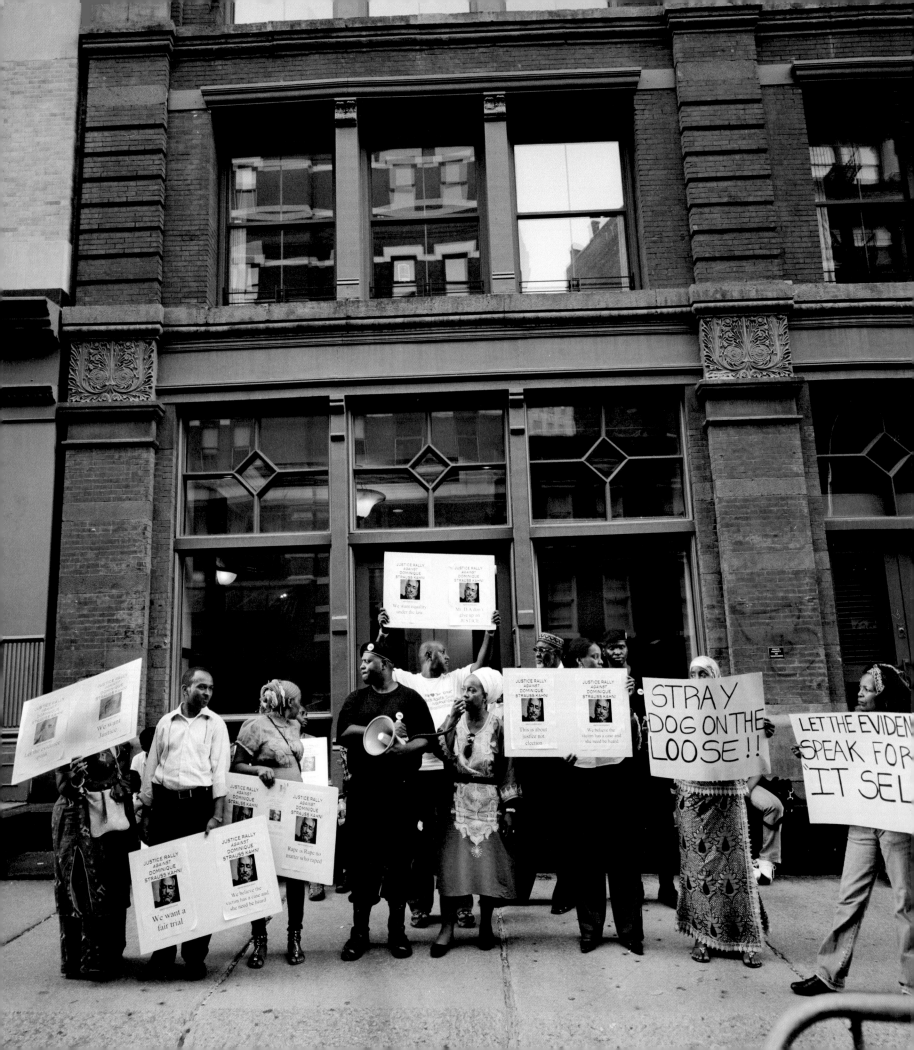

Facing Change

Documenting America

LEAH BENDAVID-VAL

in association with The Library of Congress

CONTENTS

Frontispiece:
Tribeca, Donna Ferrato, 2011

Opposite:
Miami, Maggie Steber, 2009

Fig. 1
Lisa and Garth, New Jersey, Donna Ferrato,1982.

PROLOGUE

Donna Ferrato took the picture, opposite, for a 1982 magazine assignment that was meant to showcase families epitomizing the American success story. She later captioned the photograph, "Lisa and Garth, the couple I thought had achieved the American dream." After taking the picture, she says, "I saw something I was not meant to see. . . . Garth attacked Lisa and beat her mercilessly as she cowered in the bathroom." Ferrato followed and photographed. The alarming scene, right, triggered a resolve to explore the largely hidden crime of domestic abuse. More than three decades after that first encounter with Lisa and Garth, Ferrato still trains her camera on domestic violence, its aftermath, and on injustice wherever she sees it. She pours her compassion and moral outrage, and her talent for inspiring trust, into helping victims.

Ferrato recently joined a unique collective calling itself Facing Change. The idea for the collective originated during President Barack Obama's first inauguration in January 2009. The inauguration was emotionally charged, and several photographers who were covering it began to talk about ways to live up to its implications. Their important and complicated idea was to embark on a long-term project to document America. This book tells the story of Facing Change as it has unfolded so far.

A photography collective like Facing Change would have been unique in any era. Photography has almost always been a solitary endeavor, and in photography's early days, cameras were too cumbersome to be used for active social documentation. Nineteenth-century poet Elizabeth Barrett Browning's response

Fig. 2
In the bathroom, New Jersey, Donna Ferrato, 1982.

Fig. 3
Section 60, Arlington National Cemetery, Andrew Lichtenstein, February 2007.

to the invention of the photograph was typical: Upon seeing her first daguerreotype, she wrote a letter to a friend that conveyed her astonishment at the photographic portrait's likeness to the sitter and "the sense of nearness involved in the thing." She expressed her "longing to have such a memorial of every Being dear to me in the world."

In a remarkably short time Browning's longing became a fact of life. Louis Daguerre had announced his daguerreotype invention to the world in January 1839. Technical variations and improvements—far too many to mention here—followed quickly. Photographs were made on glass and on tin, on wet plates and on dry plates. Experiments with color began as early as the 1860s. The roll film camera was invented in 1881. In 1900 Eastman Kodak introduced the Brownie, which led to the snapshot and made photography accessible to everyone. By the end of the twentieth century, digital technology was transforming photography again.

Technology matters. It shapes content and influences what we care about. Technical advances enable photographers to control photographic outcomes in situations previously out of camera range. New technologies put cameras into more hands, leading to explosions of photographs of newly available subjects.

Today, most cameras capture digital information that can be transmitted, stored, manipulated, and presented without ever being printed. Photography has become, among other things, an international language of conversations between image-makers, their subjects, and their viewers. New communication channels open constantly, images appear and evaporate, distribution is often the chief objective.

The new photographic developments and possibilities are intoxicating, but many wonder where photography is headed. A *New York Times* article in January 2014 reflected on the future of photography "in an era when cameras and lenses are optional." Art museums mount huge prints on their walls and ask about photography in an era when photographic fact and fiction are intertwined. Meanwhile, scientists looking at

cells inside the human body and landscapes on Mars give us images of the unimaginable. Photographers have been documenting wars and politics for over a century, yet few these days believe photographer neutrality is possible or even desirable. Through it all, societies preserve depictions of yesterday, and all of us, like Browning, preserve photographic memories of people we care about, of birthday parties, and past loves.

Our online culture, open to everyone with the proper software, does away with institutional gatekeepers who select pictures worthy of public viewing. Now we can all post our photographs to a global audience. Many applaud the democracy and power shift inherent in this. Sites like Instagram, Flickr, Tumblr, and Snapchat allow billions of photographs to be seen that otherwise wouldn't be. These days amateur and professional photographers can upload images that have global impact alongside pictures of trivial passing moments. Critics complain about the impossibility of intelligently managing these billions of images. Meanwhile, many professional photojournalists find it harder to make a living. Money to photograph breaking news and financial support for deeply done documentary projects is ever scarcer.

In an interview with *Mother Jones* in July 2013, author, editor, and philosopher Fred Ritchin said, "We need curators to filter this overabundance more than we need new legions of photographers." But Ritchin, in that same interview, also called for strong photographers "who know how to tell stories with narrative punch and nuance, who can work proactively and not just reactively." The book you hold in your hands, filled with images by Facing Change photographers, can be seen as a response to that call.

A well-crafted photograph moves us intellectually and emotionally as no other medium can. Effective documentation enlarges our world and is crucial to understanding it. Working proactively, the ten gifted and accomplished photographers of Facing Change practice one of documentary photography's earliest self-appointed tasks—to furnish evidence, to provide facts, to authenticate that which is claimed. The importance of their work cannot be overstated.

The grave opposite is in Section 60 of Arlington National Cemetery. Section 60 is where soldiers who died in Iraq are buried. The photograph records these facts and also tells us this man was loved. It doesn't tell us how he died, whether the war was just, or whether Andrew Lichtenstein, the photographer, or the family who suffered the loss saw the sacrifice as patriotic, the outcome of a violated public trust, or both. The photographer bears witness, sometimes with great restraint. We the viewers, completing the process, have a responsibility to understand and find meaning.

Facing Change photographers photograph independently and function as a community. They persist, as they must, in celebrating our best selves and forcing us to face our failings in our efforts to effect change. With their many diverse interests and points of view, they have embraced this mission to show us what we look like now. And they are writing our history for tomorrow.

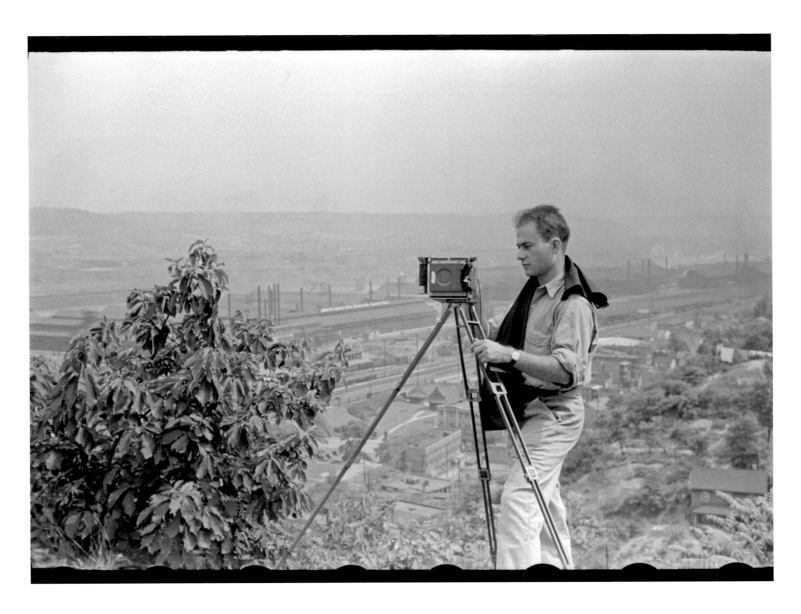

Fig. 1
Arthur Rothstein in Aliquippa, Pennsylvania, unknown photographer, July 1938.

INTRODUCTION

LOOKING BACK AND FACING CHANGE

The central campus of the Library of Congress, on Capitol Hill in Washington, comprises three stately buildings. Each fills a square block and has a presidential name—the Thomas Jefferson Building (1897), the John Adams Building (1939), and the James Madison Memorial Building (1981). The Farm Security Administration (FSA) photographs of the 1930s are in the Prints & Photographs Division, on the third floor of the James Madison Building. You can find your way to them through a maze of color-coded hallways.

Upon arrival, you enter a quiet, pleasant reading room and see, off to the right, rows of dark-red file cabinets that house the legendary photos. You can open a drawer and pull out pictures by Dorothea Lange, Walker Evans, Ben Shahn, and all the other FSA photographers. You can hold the prints in your hands.

The FSA photographs were created to advance Franklin Delano Roosevelt's New Deal recovery programs during the Great Depression. But the photographs rose above politics and found their way first into our national consciousness, and then into our collective memory. This was no small feat.

The key to the success of the FSA's Information Division was its director, Roy Stryker. Stryker had been at Columbia University illustrating textbooks before being invited to Washington to be the "photo person" in the FSA's fledgling department. Beverly Brannan, curator of photography at the Library of Congress, speculates that Lewis Hine "probably taught Stryker a lot about looking and seeing and understanding photography."

When Roy Stryker got to Washington he was assigned to work at the Resettlement Administration (RA) in the Department of Agriculture, and he seems not to have had a clear concept of what he was supposed to do. He sought out people with a visual orientation, among them artist Ben Shahn and his wife, Bernada, both working in the Poster Division of the RA. They had recently received notebooks from California showing Dorothea Lange's up close photographs of Dust Bowl arrivals, desperate people facing joblessness and exploitation by California agribusiness. Lange's photographs were utterly unlike the stand-at-a-distance pictures US Department of Agriculture photographers were coming up with at the time. The Shahns told Stryker that if he wanted work like Dorothea Lange's, they'd like to leave the Poster Division and work for him.

Walker Evans was another photographer in on early conversations with Stryker. At issue was how to convince the public of the need for Roosevelt's New Deal programs when America, as a country, didn't like the idea of government intervention. How could they make the New Deal palatable to as many people as possible and win support in Congress?

"At the beginning Stryker was apparently the student," says Brannan. "It seems that Shahn and Evans and Lange told him how things should go. But as he became more comfortable in his role and began to see more clearly what he could do to advance the cause for supporting poor farmers, he became the teacher."

Russell Lee
Arthur Rothstein

Roy E. Stryker

Shooting Script. NEVADA AND OTHER ROCKY MOUNTAIN STATES

Mining

 Ghost Towns

 Long shots of the towns – some are located in the valleys;
 others are built on the hills. Be sure to take your pic-
 tures in a way to emphasize this.

 Streets
 Deserted streets.
 Old buildings – the signs on them.
 Boarded-up windows.
 Old mining offices – watch for the signs on windows or
 on buildings.

 Cemeteries
 Look in these for interesting head stones. Check local
 history.

 Mines
 Deserted mines and mills
 entrance to tunnel or shaft. Look for signs of disuse.
 old, rusty and broken machinery.
 note detail of timber construction of mills and mine
 buildings.
 Waste piles (town shots against waste piles).

 Prospectors (Important)

 Portraits

 Cabins – interiors and exteriors.

 Tools – pick and shovel – hammer and drills.

 Burro – pack animal.

 Workings
 Shaft or tunnel.
 Prospector at work.

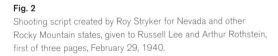

Fig. 2
Shooting script created by Roy Stryker for Nevada and other
Rocky Mountain states, given to Russell Lee and Arthur Rothstein,
first of three pages, February 29, 1940.

Fig. 3
Update from the field, Arthur Rothstein to Roy Stryker,
February 3, 1937.

Fig. 4
Homesteader family in Tygart Valley, West Virginia,
John Vachon, June 1939.

Fig. 5
A hole punched in a negative deemed the photograph
unworthy to print, John Vachon, June 1939.

When ready to enlarge his team, Stryker gave prospective photographers small assignments around Washington, DC, to observe how they would do. Most went out a few times and were let go. According to Brannan, nearly a hundred photographers worked for Stryker's projects at one time or another. More and more photographers wanted to work for him when they saw what was coming out of his office.

Stryker gave assignments to photographers by whatever means seemed effective and convenient in the moment. His detailed shooting scripts are fairly well known, but he also gave photographers instructions in person, and he sent personal letters and notes to them once they were in the field. They wrote back to him, reporting their accomplishments and problems.

Photographers on assignment had to send their undeveloped film back to editors in the home office in those days. Unable to see their pictures as they worked, "they overshot," says Brannan. "A lot of FSA photographs that came in were near duplicates or double exposures, and it was really expensive to print everything."

Brannan isn't quite sure who came up with the money-saving solution to punch holes in negatives not considered useful, but "Stryker probably did the hole punching," she speculates. "He probably didn't do it entirely independently. He may have had the lab people or whoever was nearby come in to help decide what to get rid of." She believes it's likely Stryker worked by committee to arrive at the cuts, but he made final decisions himself. "I wouldn't be at all surprised if he didn't just call in the next photographer who came in and say, 'Look, Carl is out shooting.... What do you think of this strip?' They would select what they wanted and punch the others." Brannan points to an analysis by historian Nicholas Natanson, who found that in addition to poor-quality shots there were a small number of other subjects that weren't printed—"a few communists... some drunken scenes... some prostitutes," Brannan says. "But those kinds of things just don't sit well in a government archive. Then and now that's the case."

In *Killed: Rejected Images of the Farm Security Administration,* author William Jones suggests that perhaps broader censorship of subject matter, or high-handed or arbitrary aesthetic judgment, were also at work. Whatever the case, opinions on the

documentary content and aesthetic value of a photograph can change from generation to generation, a fact that makes the destruction of any photograph a very serious matter.

Stryker gained strength and certainty as time went by. At his prime he exerted tight control over his department and its product. Friction erupted between him and photographers who considered themselves artists and saw their work as their own. The tension between Dorothea Lange and Stryker was widely known. Other photographers also felt the strain. Still, photographers who had a personal viewpoint and style managed to stay true to it.

Stryker was the one who kept the program going. "He was the consummate bureaucrat," says Brannan. "He knew how to work the system; he knew how to get resources and then more resources for continuing his project." And he got his pictures seen. FSA photographs were exhibited and distributed to popular magazines and daily newspapers to show how New Deal strategies benefited American farmers. Stryker also had a larger agenda for his program: his photographs showed urban life and America's great social diversity in addition to documenting agricultural economies and life in rural farming towns.

In June 1942, President Roosevelt created the Office of War Information (OWI). Stryker continued to oversee his photography program under the new agency. FSA photographs had been used before World War II to explain New Deal programs to the public. Now, as America entered the war, a team headed by photographer Edwin Rosskam printed and assembled twenty-two FSA photographs for a gargantuan photomural promoting sales of war bonds. The imposing photomural was installed in the concourse of New York's Grand Central Station (opposite). While some have since labeled this use of FSA photographs as propaganda, others have seen it as appropriate support for a legitimate cause. Roy Stryker himself certainly had a high-minded agenda for the FSA program. Stryker and his photographers were earnest in their pure documentary and aesthetic intentions.

One of Stryker's major accomplishments was getting the FSA and OWI collections into the Library of Congress. We take for granted the fact that these now-famous photographs reside in the Library, but this was never a given. Every government department, both before and after the 1930s, has made a photographic record of its work and has kept it on file.

Yet Stryker was highly conscious of the fact that he had created a unique and important archive, and he didn't want it to get lost in the shifting tides of bureaucracy. He made backup copies of photographs, some to be distributed for publicity, others placed with contacts in the New York Public Library. He also turned to people he knew in Washington, contacts that led to Archibald MacLeish, the Librarian of Congress. Many meetings and letters later, the FSA photographs, together and intact, were acquired by the Prints & Photographs Division at the Library.

Curator Beverly Brannan's association with the FSA is deep and long and personal. It began in 1980 when, as a student, she studied FSA pictures made in her home state of Kentucky. Though she was born after the FSA ceased to exist, she says, "I always feel like these pictures were taken in my childhood."

In her job as curator, Brannan was instrumental in acquiring the personal papers of FSA photographers John Vachon, Jack Delano, and Arthur Rothstein. Through the years she has stayed in touch, when possible, with the photographers and their wives and children.

Helena Zinkham now heads the Library's Prints & Photographs Division, of which the FSA's more than 175,000 photographs constitute only a small part. Zinkham oversees more than fifteen million pictures altogether with the goal of making them as available and useful to the public as possible. It's a big job. "The mission of the national library of the United States is to place these resources at the fingertips of the American people and their elected representatives," she says.

Zinkham, humble and prescient, understood the importance of computers for libraries earlier than most people did. In the

1970s and 1980s, computers began to make a serious appearance in academic libraries, but only a few foresaw the day when they would play a key role managing collections in all libraries. Zinkham says, "I'm not claiming I understood anything more than it wasn't going to work if pictures continued to be one card typed for one picture. We weren't going to be able to share the collections with very many people."

Getting to where we are today was a step-by-step process. It included a whole team of people making images available on videodiscs in the 1980s and launching the Prints & Photographs Online Catalog (PPOC) in 1998. PPOC currently provides access to some 95 percent of the division's holdings—including all the FSA images. More recently, Zinkham was part of a core team of innovators who developed a site within Flickr called Flickr Commons. The Library of Congress and other archives, libraries, and museums can upload any pictures to this site that have no known copyright restrictions.

Millions of people have seen the FSA photographs in the seven-plus years since the creation of Flickr Commons. "Visitors to the site comment on the pictures, add keywords, identify people and places, have conversations with each other," Zinkham says. "People debate what year an event took place or exchange thoughts about what kind of plane this was or wonder if that person is really 'A,' or maybe it's his brother or son. . . ."

The world Zinkham and her colleagues have opened up gives new life to the FSA collection. The photographs draw attention like magnets, and they can now be enjoyed whether you're standing in the Library of Congress browsing through physical images or viewing them on a computer anywhere in the world. The Prints & Photographs Division also digitized all the hole-punched and previously unprinted and uncaptioned negatives, so it is possible to see pictures that were once virtually inaccessible to many. We are learning new things about photographs made two and three generations ago as they are seen around the world through twenty-first-century eyes.

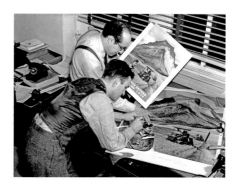

Fig. 6
Edwin Rosskam and Milton Tinsley print images for the Defense Bond Sales photomural in Washington, DC, John Collier, 1941.

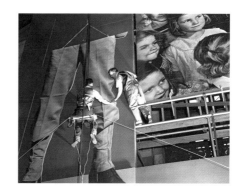

Fig. 7
Workers install the photomural in New York's Grand Central Station, Edwin Rosskam, 1941.

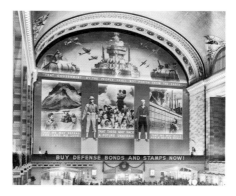

Fig. 8
Defense Bond Sales photomural, Grand Central Station concourse, Arthur Rothstein, 1942.

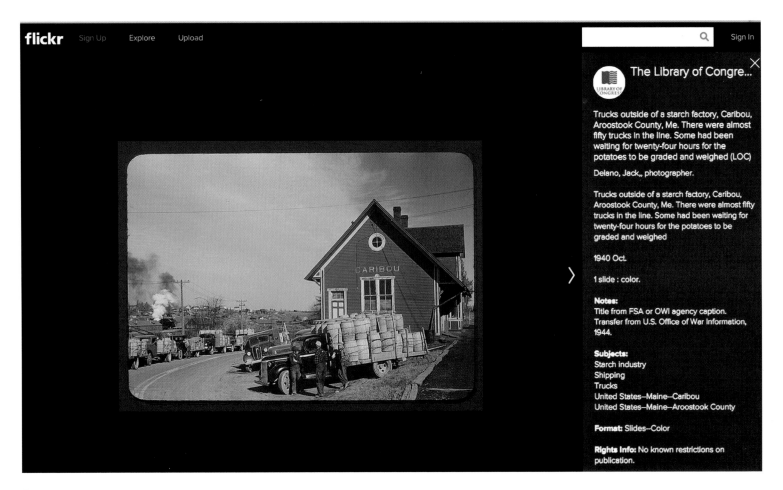

Fig. 9

FSA on Flickr: Image of Caribou, Maine, by Jack Delano, 1940.

Facing Change photographers, like many of their colleagues, are deeply inspired by the accomplishments of the New Deal FSA photography. They are aware of the fact that they have little in common with the Farm Security Administration, either organizationally or technically. They live at a different time in a different world. But there is a deeply held belief in the power of photography that brings the photographers from the two eras together. The aspirations of Facing Change and innovations in the Library of Congress make the relationship between the FSA and Facing Change both natural and possible.

"The inauguration of President Obama in 2009 was a highly exhilarating and moving event, and everybody was coming to Washington," says photographer Lucian Perkins. "That whole time period was very, very exciting. There was hope. There was a lot of discussion about the country, where we have been, and where we are going. That's when the idea for Facing Change first came up."

Anthony Suau, in town from New York to photograph the inauguration, was staying at Perkins's house. Curator Alison Nordström was there, too. Lofty conversation around the dinner table focused on how photography can advance social justice. "We talked about the FSA," says Perkins. "We started thinking, why can't we do this again? And by the end of the inauguration, when Alison and Anthony were leaving, our thought was—wow, maybe we could do something like this again."

"Something like this" meant creating a new, collective portrait of America. The time felt right. Thousands of photographers had descended on Washington for the inauguration of the first African American president and the start of a new era promised by his youth and idealism. When the festivities were finally over, Suau rode back to New York with photographer Andrew Lichtenstein, who says, "We felt it couldn't be sponsored by the government. It couldn't be associated with any political party or interest group."

One challenge early on was that none of the photographers had created a nonprofit collective before. "A nonprofit, as I learned along this journey, is not owned by anybody," says photographer Alan Chin. "It is created by its founders, but its founders don't own it. That was something that was hard for some people to understand. You put all this work into it. You get funding for it. You volunteer your time. But that doesn't mean you own it. You *don't* own it."

Several months were spent defining goals and figuring out how the collective would work. Stanley Greene, an early joiner, says, "One of the first meetings was in my studio at 475 Kent Avenue in Williamsburg, New York. I was sick with hepatitis at the time. I was sitting in my chair all wrapped up in blankets. At that meeting I actually came up with the name *Facing Change*." On April 26, 2009, Suau sent an email to everyone proposing Greene's name. Chin saved Suau's email and remembers "everybody agreed."

"Anthony had a lot to do with drawing the group together," Perkins says. "It was a very organic thing. There was no call for applicants. When a photographer was proposed, we would run it past the few people we had already brought into the group." Chin adds that balance was important. "Every person involved in this project cares very much that it be representative of people living in different parts of the country, men and women, young and old, different races." Over time the process was formalized. Today the ten current members vote privately before a proposed photographer is admitted. There is no limitation on numbers, no magic in the number ten. Facing Change continues to evolve.

Early on, in addition to organizational questions, there were technical questions. Some photographers thought everyone should shoot only film because film is physical, and it would be here to stay. Others pointed out you can scan and print physical photographs from digital files, and every new generation can upgrade existing scans. The digital group felt digital was safer. In the end, they decided photographers should do whatever they wanted.

They discussed who would own rights to the photographs. The question of rights is a complex one, and it gets even more complicated when tied to issues of how to cover expenses and how to support the myriad of causes dear to the hearts of the

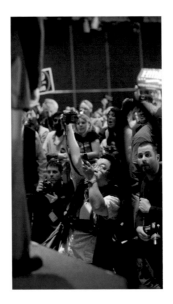

Fig. 10
Alan Chin in the field in Toledo,
Ohio, David Burnett, 2008.

Fig. 11
Carlos Javier Ortiz shows work at the Facing Change
annual meeting in New York, Lucian Perkins, 2013.

how to support the myriad of causes dear to the hearts of the diverse membership.

Each Facing Change member has come to the group already deeply involved in a photographic venture, sometimes more than one. "We have to be socially activist—that's who we are," Perkins says. "But we have to show all sides of a story and not just preach to the choir. I think Stryker was doing that in his own way." Perkins is particularly struck by a quote he encountered referring to the aspiration of the FSA to "Introduce America to Americans."

The world has changed, not once but multiple times, since the 1930s. Publishing is almost unrecognizable even compared to the 1960s, when there were a handful of newspapers and magazines everybody read. The burst of new media and the demise of the old is one aspect of the technological upheaval that has transformed photography.

This fact influences discussions that continue to go to the very core mission of Facing Change. Perkins reports an active interest in the possibility of bringing unseen projects produced by non-Facing Change photographers to the Facing Change website. "There's such good work being done today that's just not getting out," he says. "The idea is that if people want to see what photographers are doing to document America today, they would go to the Facing Change website."

Chin also envisions something broader. "I don't like the idea that this is elitist or a private club or anything like that. It's not. But by the same token I do have to say that, imperfect as any of these mechanisms might be, you have to start somewhere. This is a place to begin."

Facing Change is a bold and unique enterprise, a non-profit collective with a board of directors, a website, and high aspirations. Members meet regularly to critique one another's photographs and share stories. They publish and exhibit their work and seek grants for projects deemed important. They encourage one another, support one another, and look for more ways to get their work out. The community has had its share of turmoil—what creative group hasn't—but fresh ideas continue

to emerge and fresh work continues to be produced.

Facing Change does not replicate the FSA. There isn't one strong decision-maker. And there isn't any government funding. This didn't diminish Andrew Lichtenstein's elation when he visited the Library's Prints & Photographs Division recently. After his visit he emailed, "Looking into the original FSA filing cabinets . . . I am reminded in such a direct way why still photography retains all of its emotional power, even during these stormy times of branding and smart phones."

Stanley Greene shares this view, reflecting, "You have to know what your roots are. If you don't acknowledge the sacrifices that were made by so many who put their work in your hands, you're not doing them justice."

Illustrating Greene's point, photographer Carlos Javier Ortiz says, "My project on migrant workers was directly influenced by Dorothea Lange's migrant workers." Ortiz also pays tribute to Russell Lee, who photographed migrants, Ortiz says, "living like gypsies, working in places reminiscent of plantations. The faces have changed from European in the thirties and forties to Mexicans and Central Americans today."

Chin, recalling a photograph he made in New Orleans, says, "When I processed the film and was looking at the contact sheet, I thought, okay, we are definitely in debt to our predecessors. . . . The FSA is in our blood whether we want it to be or not. I'm not saying in the moment, when you are working and thinking 2.8, 1/125, and focused on the composition, on framing, on light, on your own human approach. But somehow you know you want the picture. It's back there affecting your work."

Our memory influences how we see.

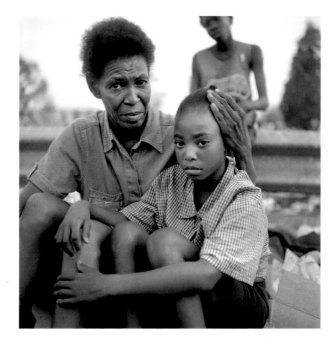

Fig. 12
Displaced mother and child in New Orleans in the aftermath of Hurricane Katrina, Alan Chin, September 5, 2005.

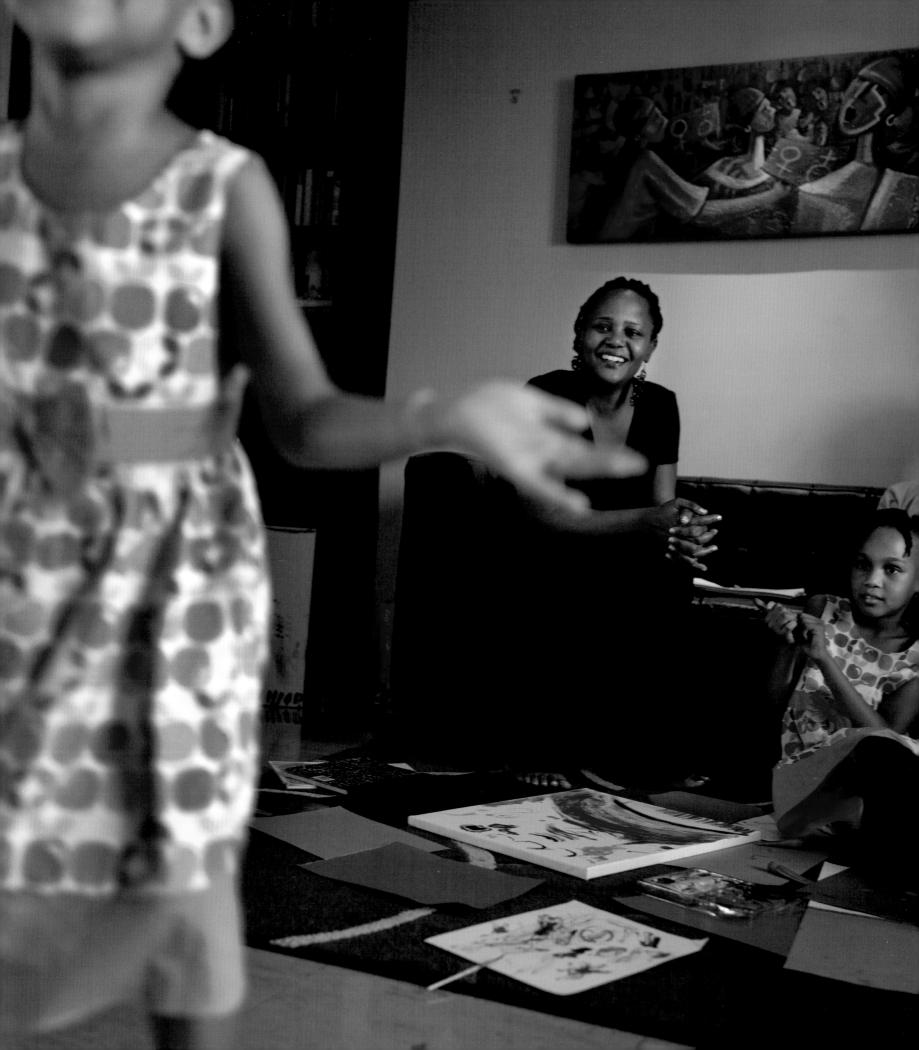

MIAMI'S LITTLE HAITI

Photographed by Maggie Steber

Maggie Steber's photographs of Miami's Little Haiti tell a timeless story of immigrants, courageous or desperate or both, who leave their homeland for an unknown future. Embarking on the search for a better life in the United States, Haitian immigrants try to keep their native language and culture—their very identity—alive.

Steber has photographed in Haiti hundreds of times over more than three decades. She says she feels like she will never finish her work there "because of what a layered, complicated, fascinating, and mysteriously beautiful country it is." When she misses Haiti, she goes to Little Haiti in Miami "to be around Haitians and speak Creole and just have a sense of Haiti."

Steber sees the Haitian diaspora with unique clarity, yet she finds it harder to photograph Haitians in Florida than in Haiti itself. "Haitians coming to live in the US seem more guarded," she says. "Maybe it's a matter of how hard it is to make a new life in the US, sometimes harder than staying in Haiti, because of the racism they face here. And many only speak Creole or French, and that further separates them from the larger English- and Spanish-speaking populations."

To understand Haitians it is necessary to know at least a little of their tumultuous history. Steber believes Haitian talents have emerged and thrived at least in part as a result of past events: "The only successful slave revolt in the history of the world took place in Haiti. That fact is a source of great pride for Haitians and has a lot to do with how Haitians view themselves. Haitians beat back Napoleon's armies. Haiti is so much more than a small impoverished nation. It's a place of great intellectual accomplishments, producing great writers, painters, and musicians. It's a place filled with magic and ghosts and powerful humanity; a portal between heaven and hell where everything falls into one of those categories. It is a place of remarkable and sometimes vicious despots, kings, dictators, and presidents—all characters playing roles in some great Shakespearean epic."

Steber finds beauty in the midst of Haiti's hardships, violence, and grief, not by shunning reality but by facing it. She recalls times in the aftermath of the 2010 earthquake when people came together to help one another despite the odds. "There was beauty even in pain," she says, "and the experience of seeing that reminds you how much you love somebody." The love goes both ways. "If Haiti loves you, it wrings your heart out every day, but you always come back for more because you simply have no choice."

When Haitians come to the United States, they bring their past. Steber describes Miami's Little Haiti as "a place about memory as much as anything. Every story is a story about survival, about life and death, about escaping violence and hiding from gangsters who followed you from your homeland."

Opposite:
Internationally renowned Haitian writer Edwidge Danticat lives in Little Haiti with her husband, Faidherbe (Fedo) Boyer, and their two daughters, Mira, eight, and Leila, four. Danticat has written and contributed essays to fourteen books and has won numerous awards. She is involved in Haitian cultural issues locally and abroad.

Once in Miami, the newcomers are confronted with complicated, often hostile immigration policies, racism, and potential expulsion.

Residents of Little Haiti are aware of how Haitians have been depicted for decades, and they assume that's what photographers want to show. "It takes time, and little by little you get past scratching the surface," Steber says. She has watched members of the Haitian diaspora help one another and met a few who opened doors for her. Steber's determination and patience go a long way toward getting what she's after, but she has something more—an idealism, an intuition, a love for her subject—qualities she takes into the community and which are ultimately expressed in her deeply felt and finely crafted photography. She says if you don't care about your subject, your photographs will end up empty.

Approximately thirty thousand residents make Little Haiti the largest Haitian community outside the Caribbean island home itself. Like communities everywhere, it is a place in motion. But though Haitians and others move in and out, Steber portrays a strong and diverse population with established roots in Miami. "There are many wealthy and middle-class Haitians who carve out quite a nice life for themselves," she says. "The people in this community are not going away, and I am so grateful for their being here." They add another layer of culture, art, music, and literature to Miami's exuberant social scene.

Politically and socially engaged locals have created organizations to help newcomers find jobs, register for Social Security or unemployment, prepare taxes, and teach those who never had the opportunity to learn to read and write. Notre Dame D'Haiti Catholic Church, at the center of community life, takes care of the most basic physical and spiritual needs, offering health care services, literacy classes, exercise classes, and a rich religious program. Masses are held in Creole and English. Religion, always the mainstay of Haitian life, flourishes here. Steber writes that "young and old gather for four masses on Sundays, to take communion, greet each other, visit, and cement the idea of a Haitian community."

Residents dissatisfied with their citizenship status have benefited from the church's function as a gathering place, assembling there to launch rallies and marches for immigration reform. But there are also other places to meet. Community activists, including organizations like Haitian Women of Miami (FANM, or Fanm Ayisyen nan Miyami), operate in a diversity of venues to serve health, educational, and social needs.

A rich and sophisticated cultural life, redolent of life back home, nurtures distinguished artists and writers. Paintings by Edouard Duval-Carrié, inspired by Haitian history and religion, hang in museums throughout Europe and the Americas. Acclaimed author Edwidge Danticat was born in Port-au-Prince, moved to Brooklyn at age twelve, then settled in Little Haiti, where she lives with her husband and two daughters today. Both she and Duval-Carrié are activists on behalf of Haitian culture in the community and abroad.

Little Haiti is known for its lively street culture, too. Musicians perform outdoors and murals by Serge Toussaint enliven the neighborhood. Toussaint himself has taken visitors on tours of the community.

Libreri Mapou, a pink bookshop with a green awning, was founded in 1990. It is a local landmark sitting in the midst of other colorfully painted establishments on NE 2nd Avenue, the main street going through the heart of Little Haiti. It offers thousands of books in Creole, French, and English. Jan Mapou, the founder, hosts readings, recitals, plays, and dances in his museum and cultural center upstairs. Mapou is a community leader and elder statesman who goes on Haitian radio from time to time to speak about the Creole language. He gives lessons with the aim of keeping Haitian culture vital and alive in his adopted land.

On a backstreet vendors sell fresh vegetables, herbs, soaps, and clothes. Adolphe's grocery store offers basic provisions to low-income Haitians who are able to sustain themselves and also ship goods to their families back in Haiti.

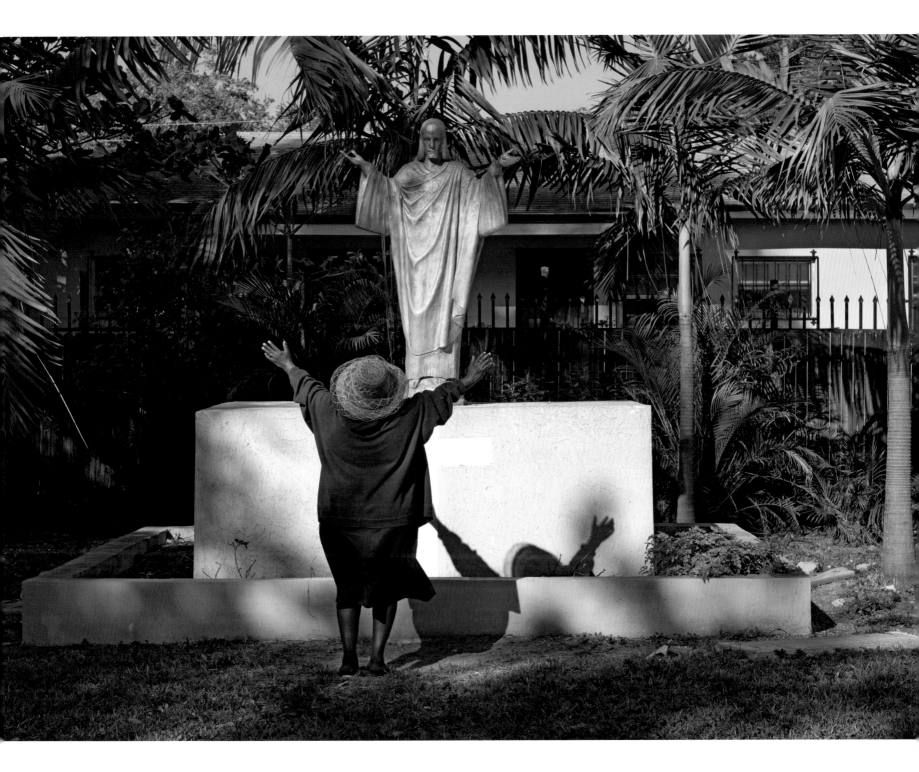

Notre Dame D'Haiti Catholic Church, Miami.

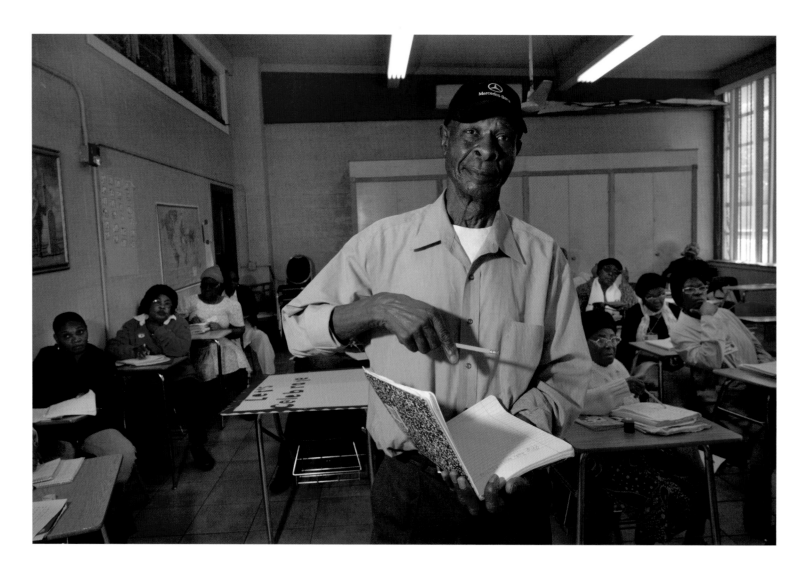

Haitians who never learned to write Creole in Haiti attend literacy writing classes weekday mornings at the
Pierre Toussaint Leadership and Learning Center, located in Notre Dame D'Haiti Catholic Church.

Literacy class, Pierre Toussaint Leadership and Learning Center.

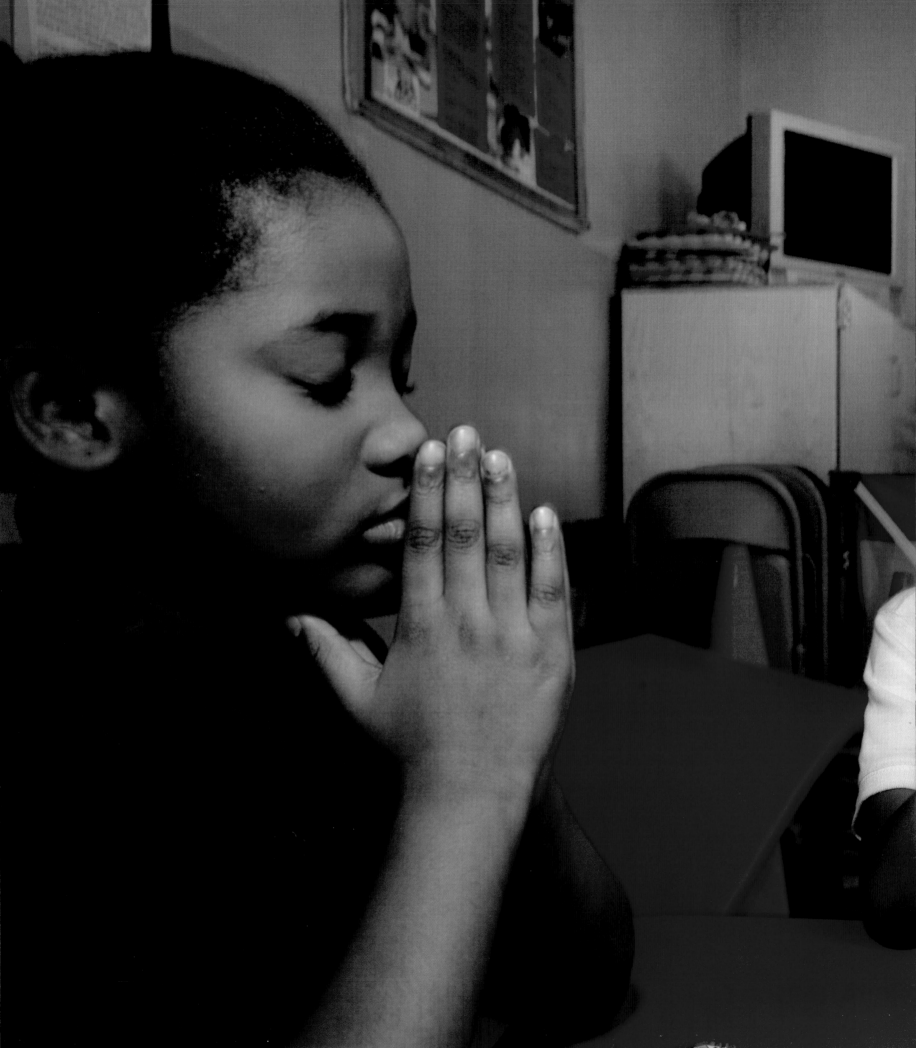

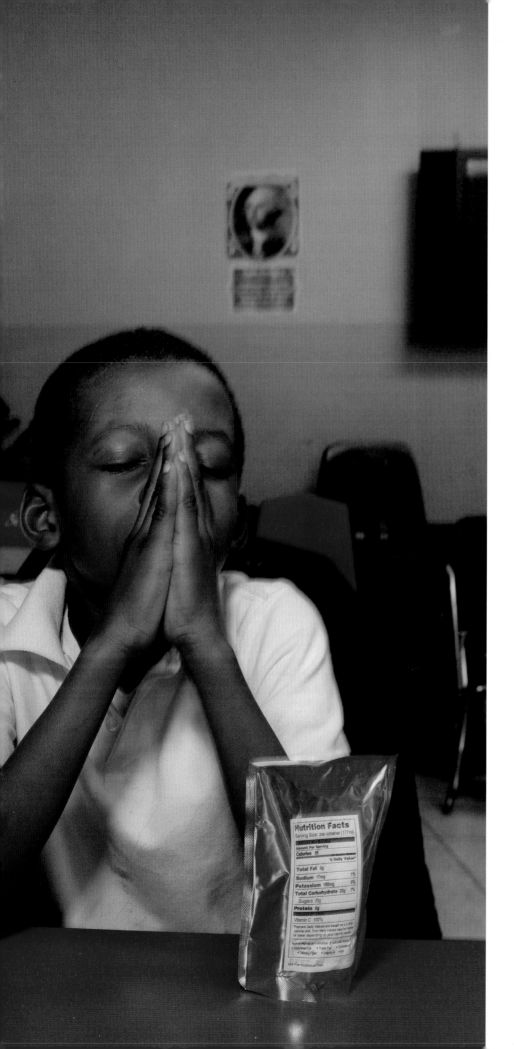

Two children attend an after-school program in February 2013. In this program, thirty-five children, from first grade to middle school, do their homework, practice word games, enjoy snacks, and learn social skills.

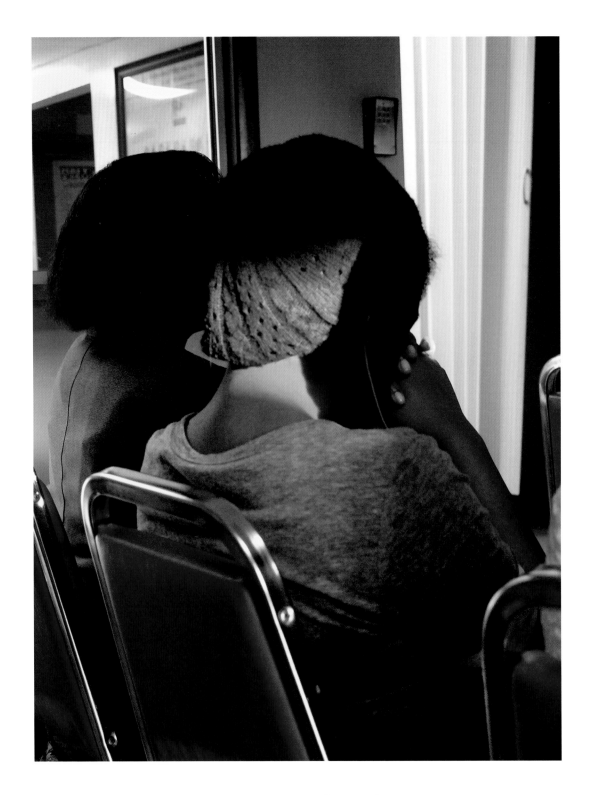

Women pray while waiting for doctors to arrive at a free women's health fair organized by
FANM (Haitian Women of Miami) at the Center for Haitian Studies on March 23, 2013.

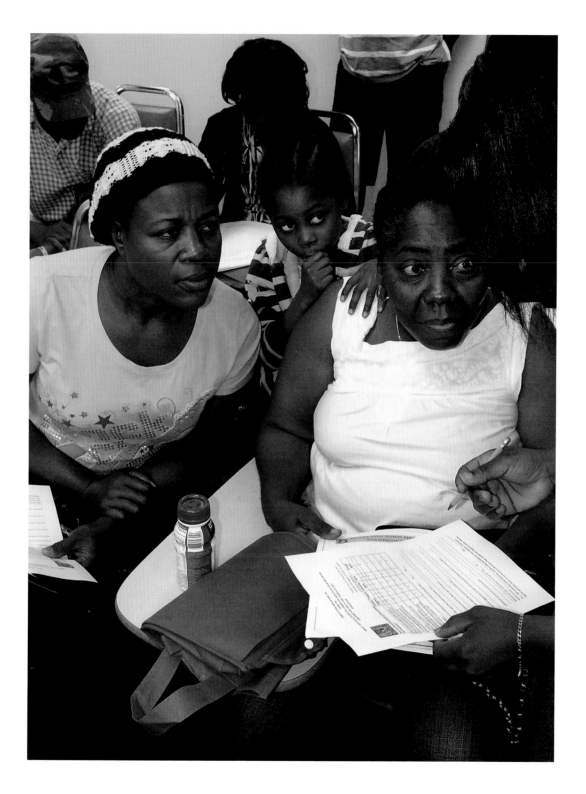

Fair participants are taught to recognize warning signs and to access appropriate medical care. They register to have their blood pressure checked and back problems and fatigue addressed. They are tested for AIDS and given free condoms to combat the spread of HIV.

Seven-day revival begins with Sunday mass at the Notre Dame D'Haiti Catholic Church, February 17, 2013.

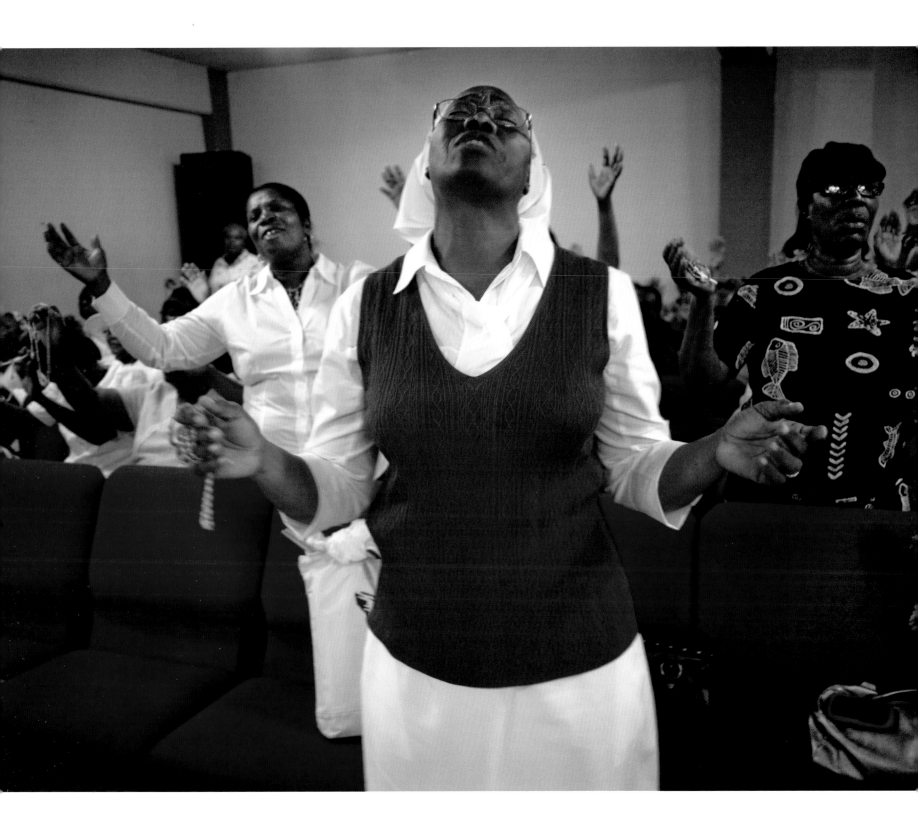

As a documentary photographer, Steber observes that the big issues never change. To see with fresh eyes, to tell a story differently, are all that's possible. She says, "We still have war, hunger, domestic violence, abuse of women and children, slaughter of animals, men devouring the earth in search of gold and oil and leaving gaping wounds behind. So the challenge is to bring new visual points of view, and perhaps we can change just a few minds."

Stories and photographs quickly become memories. Memory, understanding it and holding it dear, is a central subject in Steber's photography and in her life. To lose memory—national, cultural, or personal—is to lose a piece of oneself. An immigrant becomes acutely aware of this. Steber's work is a complex and ardent act of remembering.

Libreri Mapou is a cultural and commercial landmark offering thousands of books in Creole, French, and English in the heart of Little Haiti, December 2012.

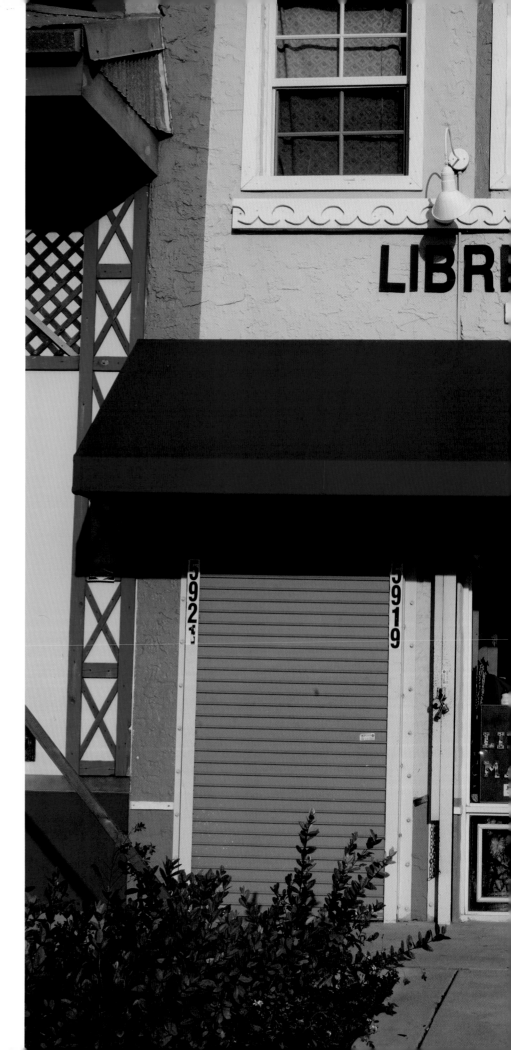

Upstairs at Libreri Mapou, Haitian women authors prepare a program of readings in January 2013. Bookstore owner Jan Mapou stands by the fireplace. Mapou also has a small museum of Haitian history and a radio program. He is respected for his role in keeping Haitian culture alive in Miami.

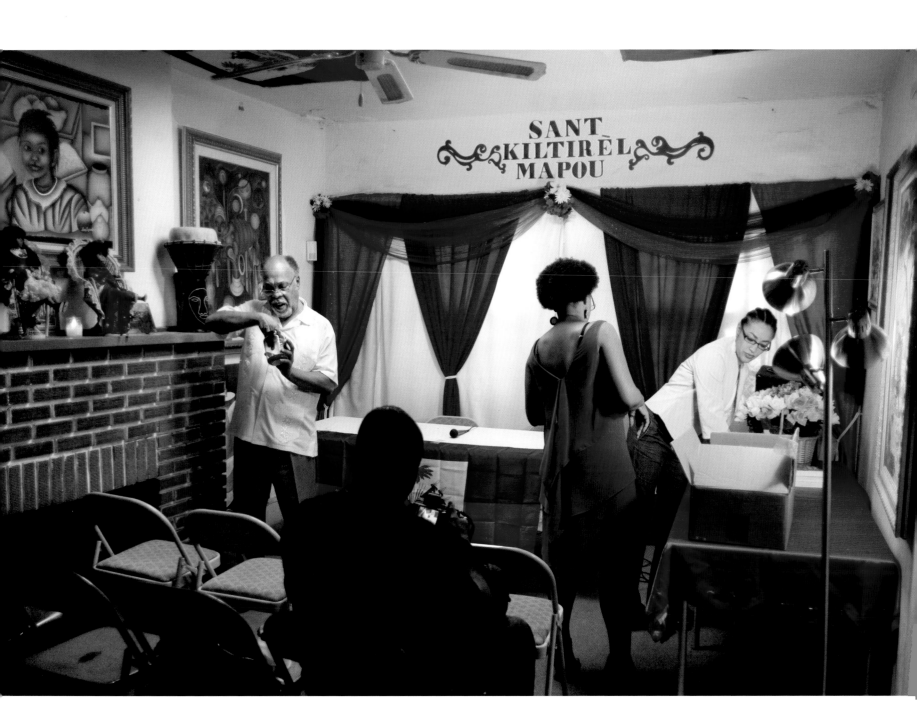

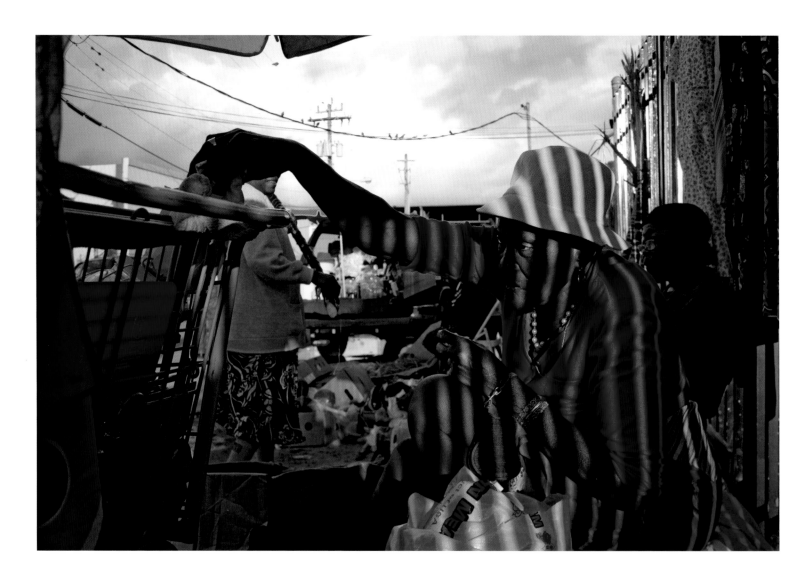

Women set up stands selling food, fresh vegetables, herbs for medicinal teas, clothes, and soaps, just as they do in markets in Haiti. On a backstreet, Adolphe's grocery store offers oil, bags of rice, beans, and other basic goods in large quantities. Haitians in Miami live off these provisions and buy bags of food to ship home to families in Haiti.

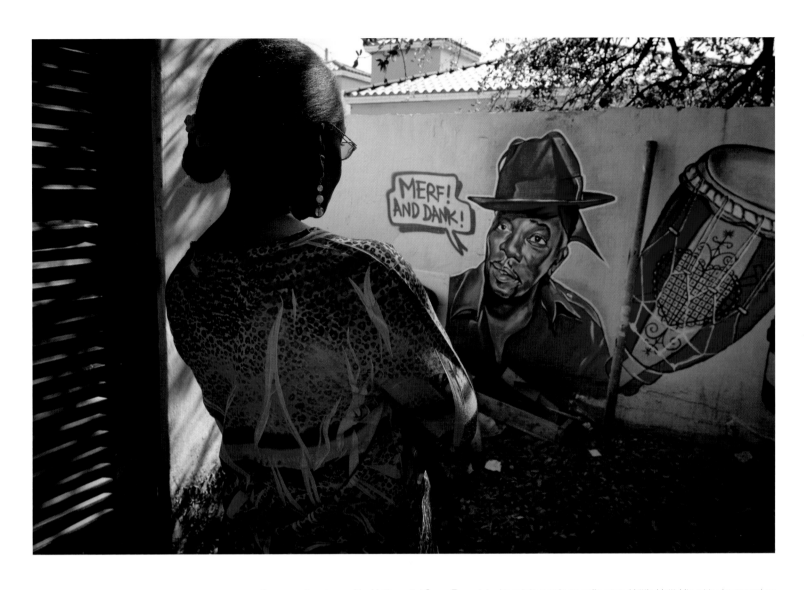

A woman views a mural by Haitian artist Serge Toussaint, who paints murals on walls around Little Haiti. His art is showcased on historical society tours, which bring people to Little Haiti who might not otherwise come to the area.

Every Friday night, beginning at about 9 p.m., musicians gather on a local street corner and play their traditional Africa-inspired instruments. They dance and sing their way through the streets of Little Haiti, gathering people as they go. Non-Haitians are welcomed without hesitation. This traditional Haitian street party, called Rara, is a joyful release from the challenges of making a new life in America, a celebration of life and a remembrance of home. Back in Haiti, Rara occurs spontaneously, frequently at carnival time.

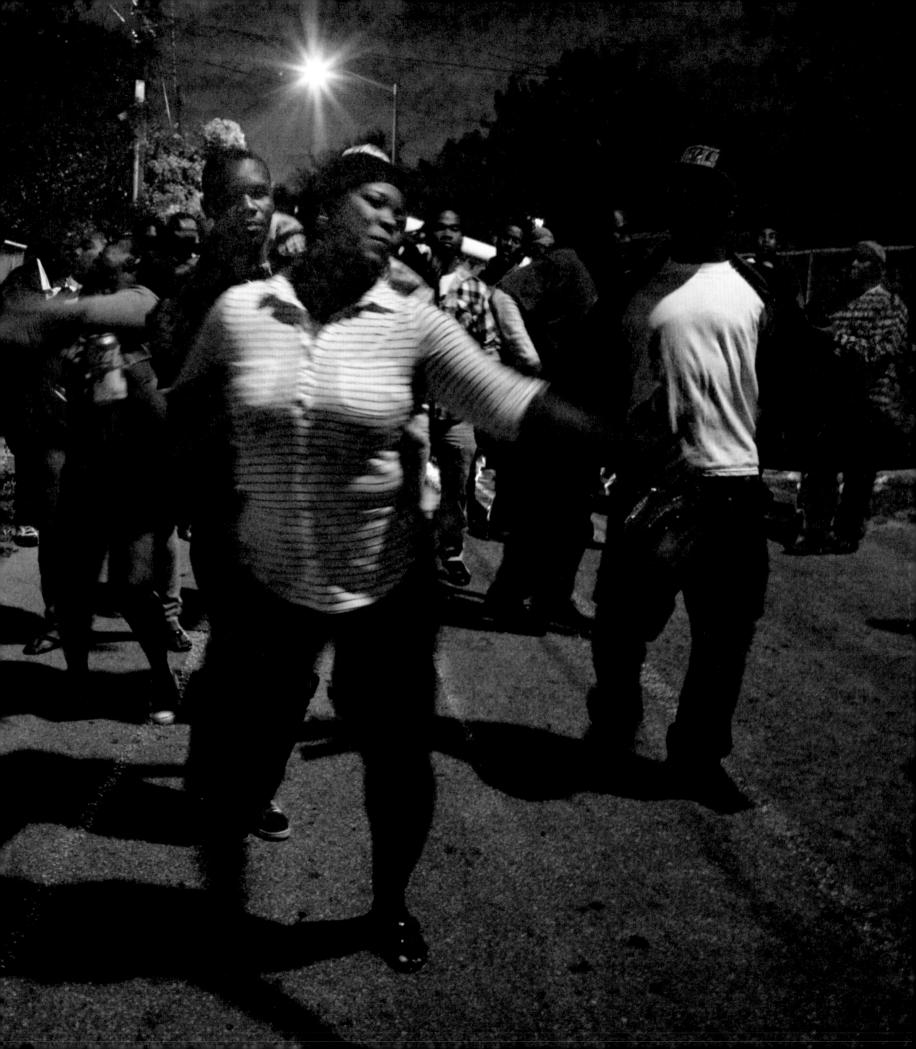

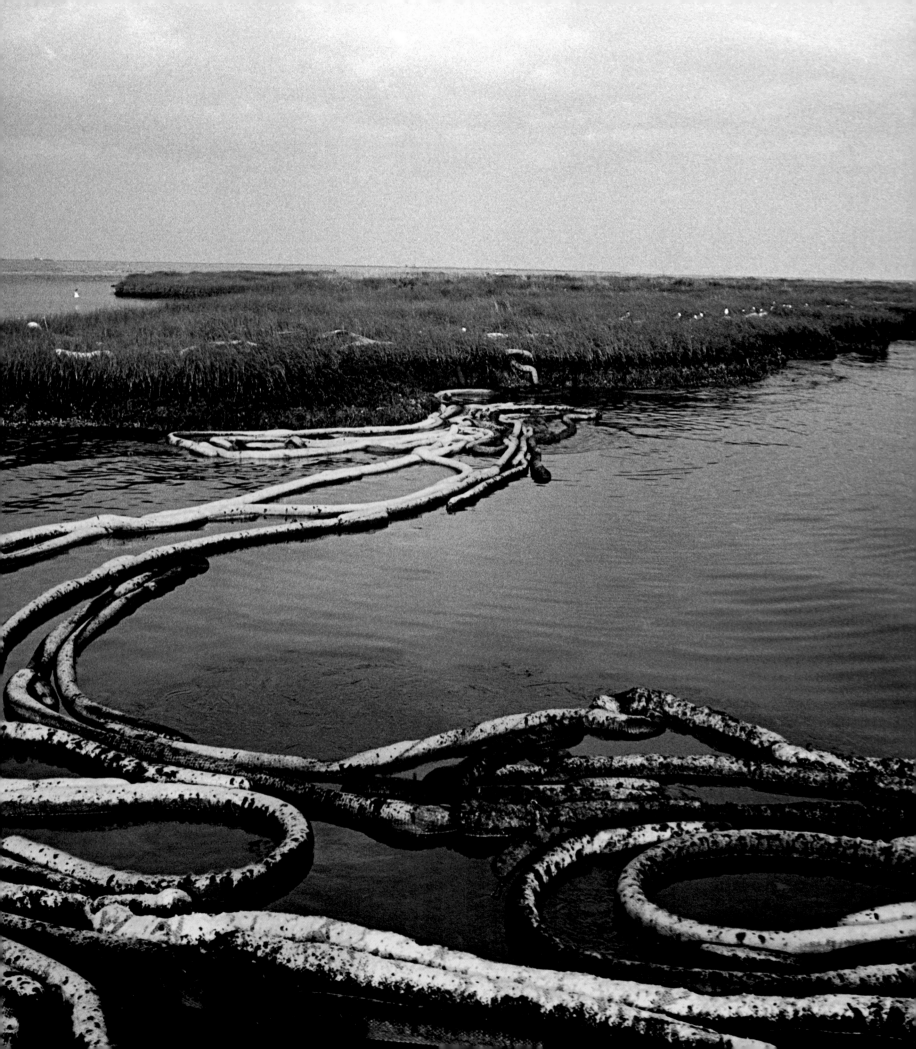

BEYOND SPOT NEWS

Photographed by Alan Chin

Alan Chin uses the phrase "spot news photographer" to describe how some might label him. The *New York Times* gave him his photographic break in 1996 with assignments to Sarajevo, Bosnia, and Afghanistan. His successful coverage of these conflicts led to more work in Central Asia and the Middle East. Chin has also photographed widely in the United States, including near his home in lower Manhattan the day the Twin Towers went down on 9/11.

At times Chin's assignments are physically perilous. Asked what it takes to photograph when your life is threatened, he says, "You just do what you have to do. I see something and think, okay, yes, maybe some people have died or been hurt, but then you have to move on." Fear of the unknowable is part of the equation for Chin, but his curiosity seems stronger. The main thing is to get the story told, he says. In many cases this means being on site after the violence subsides, when the immediate physical danger has passed, to cover the aftermath and its consequences.

Hurricane Katrina struck New Orleans on the morning of August 29, 2005. It was deadly and it was costly. "But actually," says Chin, "the difficult part of the recovery was not the natural part. It was the unnatural part, the human part, dealing with the government, the Bush administration's initially really poor response." He describes "all the simmering tensions in American society breaking apart at a moment where everyone imagined their worst fears."

He flew down to New Orleans several days after Katrina hit to photograph the aftermath of the storm. After that he returned again and again, over a period of several years, long after the hurricane was a front-page story, to document the expected recovery. He saw how badly the evacuation was handled; wealthy individuals could simply drive away, while poor people without cars suffered. He says he witnessed "the total crazy breakdown of law and order and rational thought."

On his first day out he photographed in color, but that night, looking at his pictures, he realized color was not the way to get what he was after. He was seeing too many instantly recognizable color icons in his photographs—Coca-Cola and Starbucks, McDonald's golden arches. "You don't get dressed up when your house is destroyed, right? You wear what you're wearing," he says. "So if you are wearing a Bart Simpson T-shirt, or SpongeBob, or whatever . . . if you're wearing a Pepsi-Cola T-shirt and you've just lost your home and your family has been displaced . . . that's an interesting irony, a comment on America, a comment on commercialism. But what matters is that you lost your home and your family. What's crucial here is that these people are having the worst day of their lives. I think black-and-white photography allows you to get at that."

Chin wants intimacy with his subjects. He wants photographs that reflect the complexity of things. In New Orleans he concentrated on the physical particulars of the destroyed city and on affected individuals. "I walk over and make eye contact," he says. "I'm just amazed at how many times people, even in that moment, how many people want you to take their picture, want you to know that what is happening to them matters."

Previous Spread:

Anti-oil booms are constantly monitored because tides, weather, and oil saturation throw them out of position, Barrier Islands off Grand Isle, Louisiana, June 16, 2010.

Right:

In the aftermath of Hurricane Katrina, Alan Chin photographed haunting details of destruction as he witnessed tragedy and resilience.

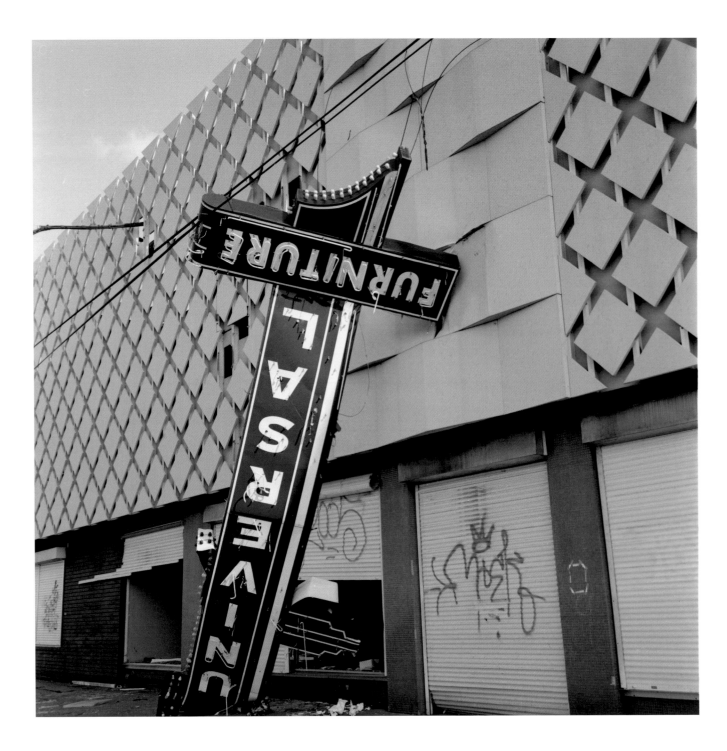

Hurricane Katrina, 2005.

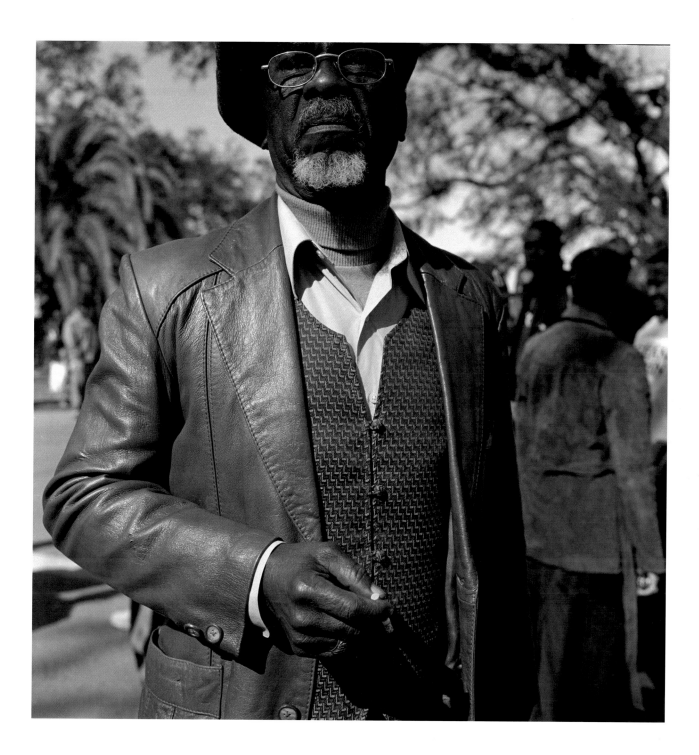

Participant in first "second line parade" after Katrina: Second line parades are a New Orleans tradition where people follow a main line brass band just to enjoy the music, January 20, 2006.

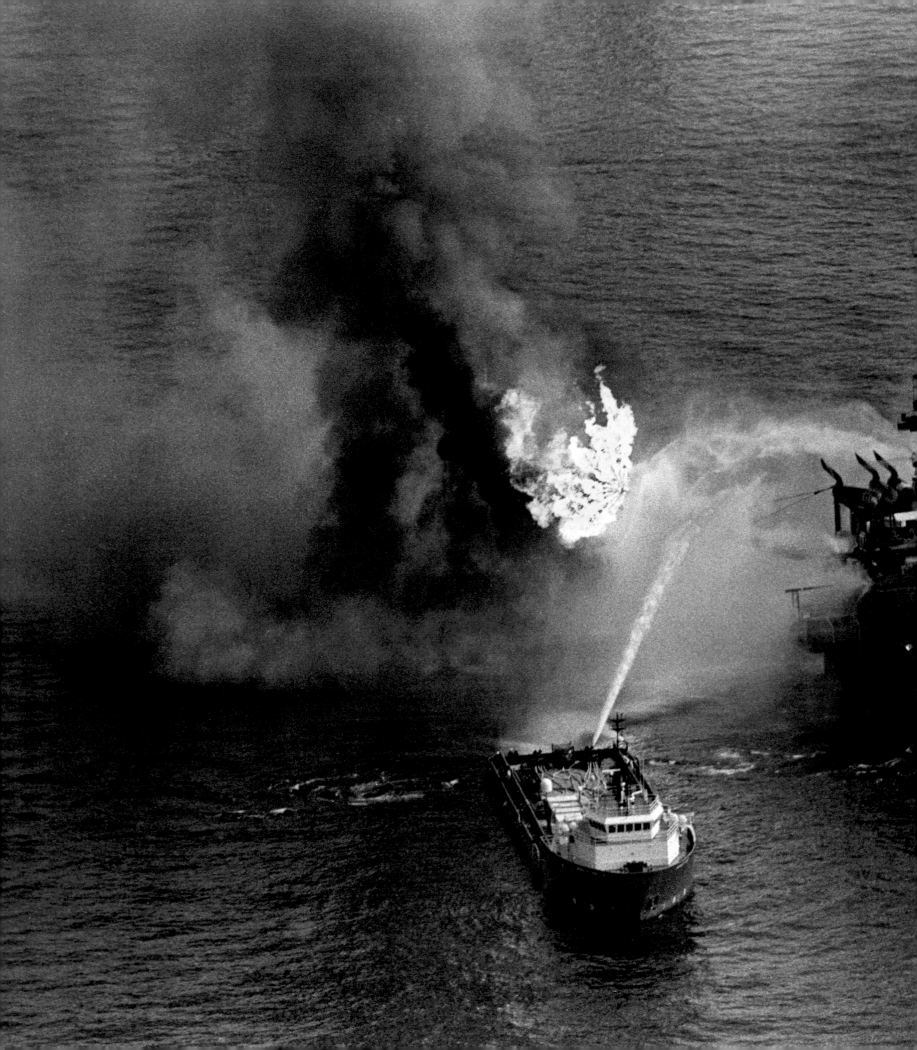

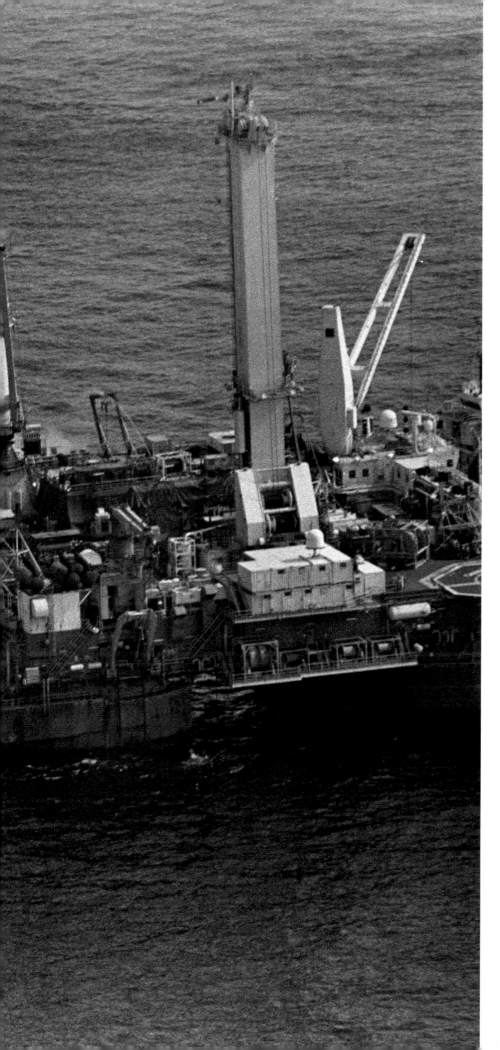

On April 20, 2010, BP's Deepwater Horizon oil rig exploded and killed eleven people. For months afterward, the country became gripped by BP's desperate inability to get the raging oil spill under control. Chin, sensing New Orleans had turned a corner, thought, "This is important. I should go." Facing Change, sponsoring projects whenever possible, had raised a little money to support the work.

Arriving at the site in June he found the situation hard to photograph. "The uncapped well was spewing I don't know how many gallons of oil every minute," he says. "It was going full bore." One solution was to burn off the oil as quickly as possible. "It wasn't very good for the atmosphere, but they figured it was the best they could do," he speculates. Chin believes the real story will unfold in the future microbiology of the Gulf of Mexico. "The time to photograph isn't now, it's ten years from now. It's a before/after picture of this piece of coastline. The after picture will be the subtle, unsexy result of pollution."

Chin flew over the site twice, once in a Coast Guard aircraft and the second time in a BP helicopter. "The only thing I can compare it to visually is the pictures we've seen from the Second World War, the Pacific War, of kamikazes crashing into American naval ships setting them on fire," he says. BP officials in charge of managing PR facilitated some kinds of coverage, but not others. "You could fly above it, but I tried to get on one of the ships that was actually down below and no, forget it. That wasn't going to happen. They give you certain kinds of access—I think that is always true—and you push it as far as you can."

National Guard staging area for helicopters that drop 3,000-pound sandbags to build up an artificial breakwater or berm against Deepwater Horizon oil spill, Venice, Louisiana, June 15, 2010.

Ecumenical interfaith prayer service, part of the community response to the
BP Deepwater Horizon oil spill. Grand Isle, Louisiana, June 13, 2010.

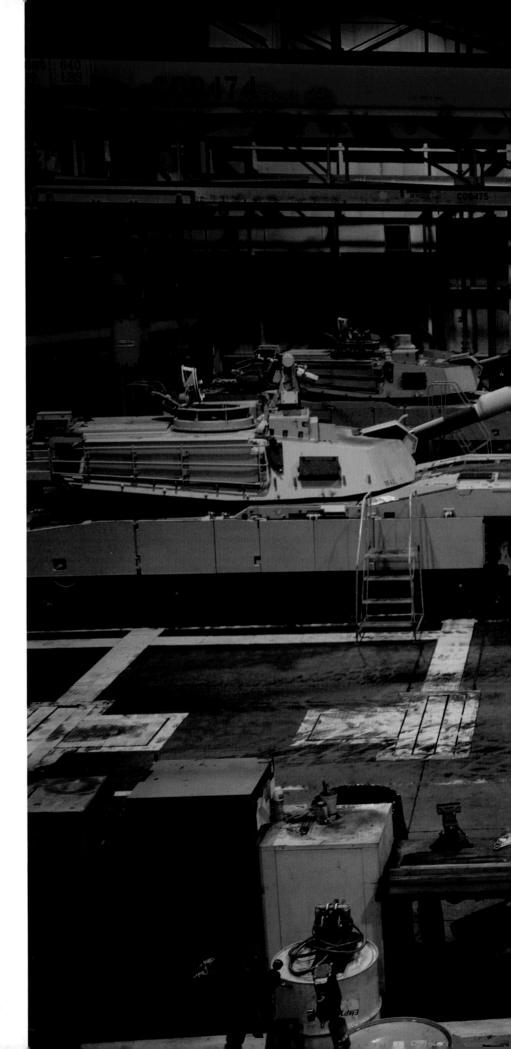

Chin went to Lima, Ohio, in March 2012, to photograph the only heavy-armored tank factory in the United States: the Joint Systems Manufacturing Center, which builds and refurbishes tanks, armored personnel carriers, and other weapons systems. Lima's community of forty thousand residents supports a large industrial base for its size. In addition to the tank factory there's an oil refinery, a Ford engine plant, a Procter & Gamble factory that manufactures laundry detergent, and a large regional hospital. Chin says Lima resembles many midwestern small towns with closed businesses and boarded-up storefronts along with a few new buildings and industries that continue to survive.

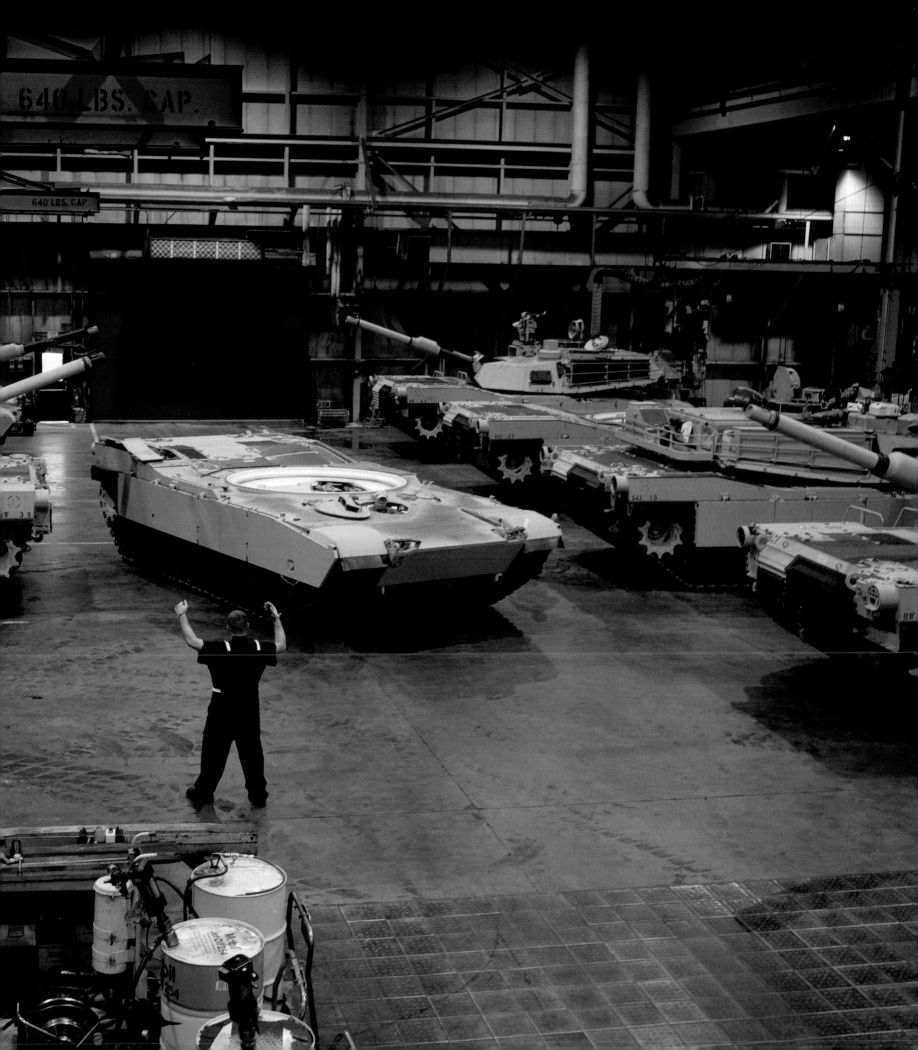

Chin grew up in New York's Chinatown. His father, Fow Sang Chin, immigrated to New York from Guangdong Province, China, in 1951 and worked in the garment industry. Those who came to the United States to work were not allowed to bring their families until the 1960s. "My family's story is classic," Chin says. "My father came here and was separated from my mother for nineteen years.

"It was hard for me, as I think it was for a lot of immigrants, to pull two worlds together. My parents didn't speak English. I remember being ten years old, and like a lot of immigrant children, I felt kind of ashamed." When a classmate asked for the second or third time why his mother didn't speak English, he came up with a snappy comeback: "There's a problem here and it isn't my mother. Why don't you speak Cantonese?" The tug between loyalty to family roots and a yearning to be part of mainstream America can be painful for immigrants and their children. Alan had more spunk than many. It could be that his experience growing up in an immigrant family heightened his natural empathy for people who are hurting.

On January 4, 2012, Chin photographed the Miss Angel beauty contest taking place at a school run by New York's Chinese Consolidated Benevolent Association (CCBA), "which is basically the Chamber of Commerce of Chinatown," he says. Chin went to Chinese-language school here from first to fifth grade. "All the Chinese American kids go to this school in the afternoon after regular school. I'll probably send my daughter there or to something like it."

He photographed the beauty contest for a long-term Chinese project that's close to his heart. Speaking about the contest, he says, "You see all the different strains, the kind of girls who really don't speak much English because they are recent immigrants, the girls who don't speak Chinese because they are second- or third-generation already. The different regions of China are represented—my people are Cantonese-speaking, but the more recent girls are from Fujian Province and are Mandarin-speaking. At other times there were waves of immigration from Taiwan and Hong Kong."

In June 1989, on Chin's first trip to China with his parents, he happened to be in Beijing when the Tiananmen Square protests erupted. He biked his way toward the turmoil, took pictures, and sold some of them to Reuters. He says, "Even though I'm the guy who is maybe the spot news guy, or one of the more spot newsy guys, I think the work we do now is going to be judged ten or twenty years from now. What matters is how it's going to age, how it's going to age over time. That's ultimately what I care most about."

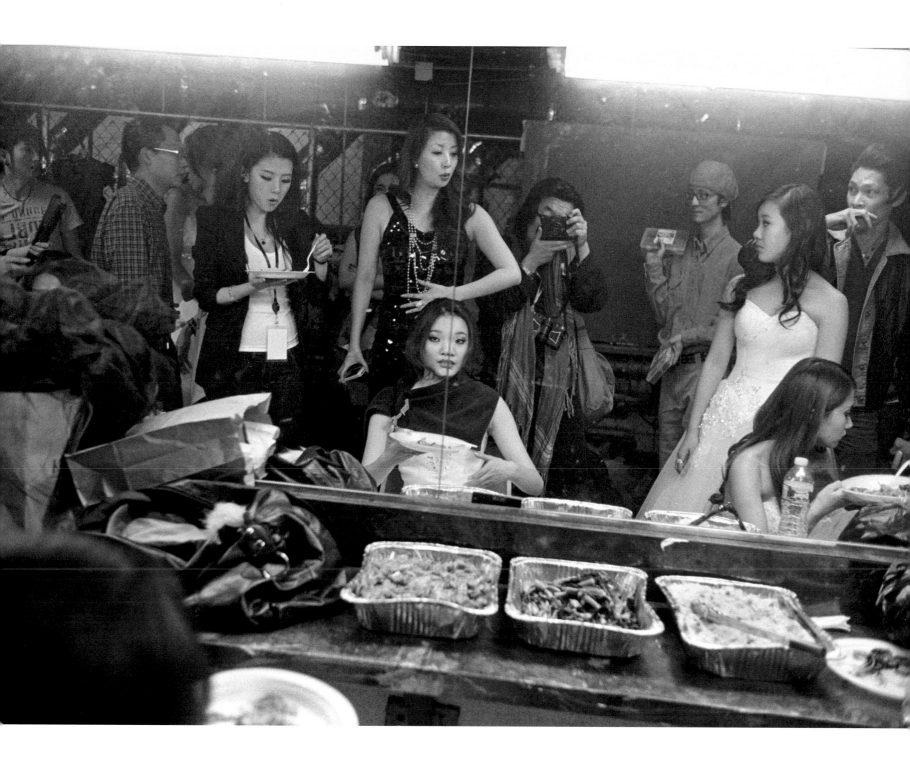

The Miss Angel beauty contest at the Chinese Consolidated Benevolent Association (CCBA), 62 Mott Street, in Chinatown.

Miss Angel beauty contest.

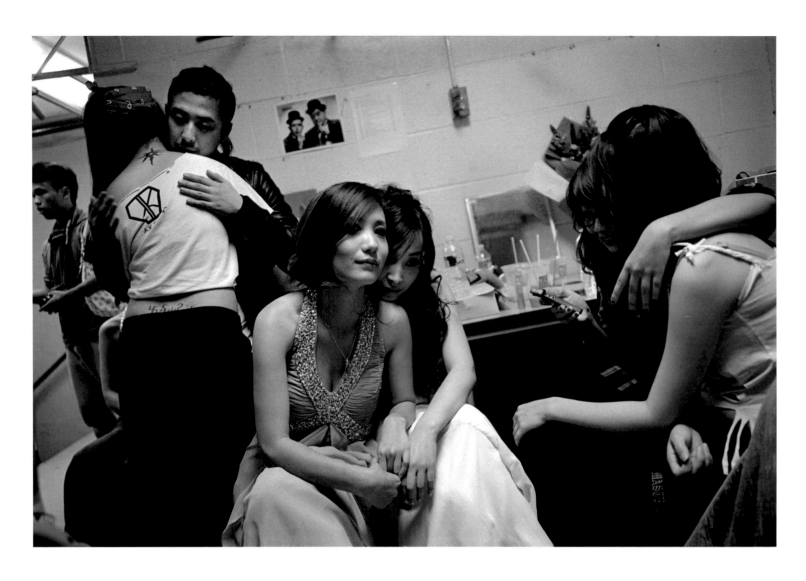

Miss Angel beauty contest.

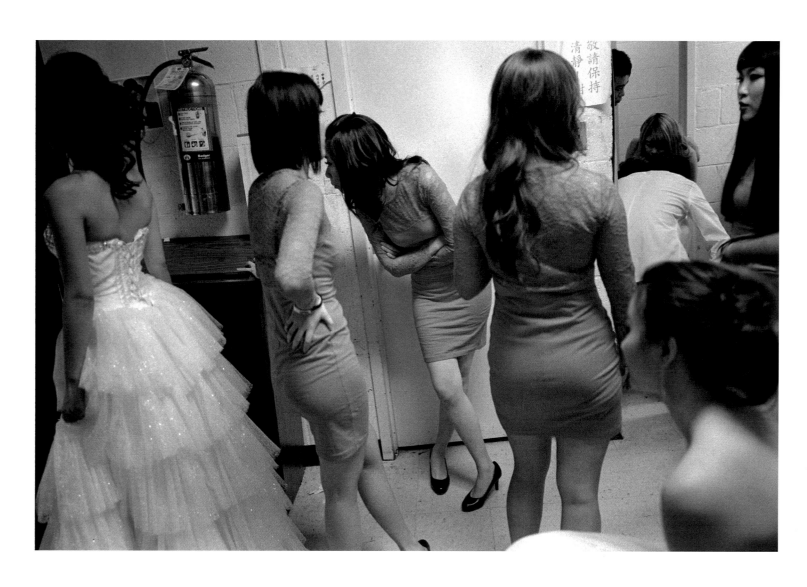

Miss Angel beauty contest.

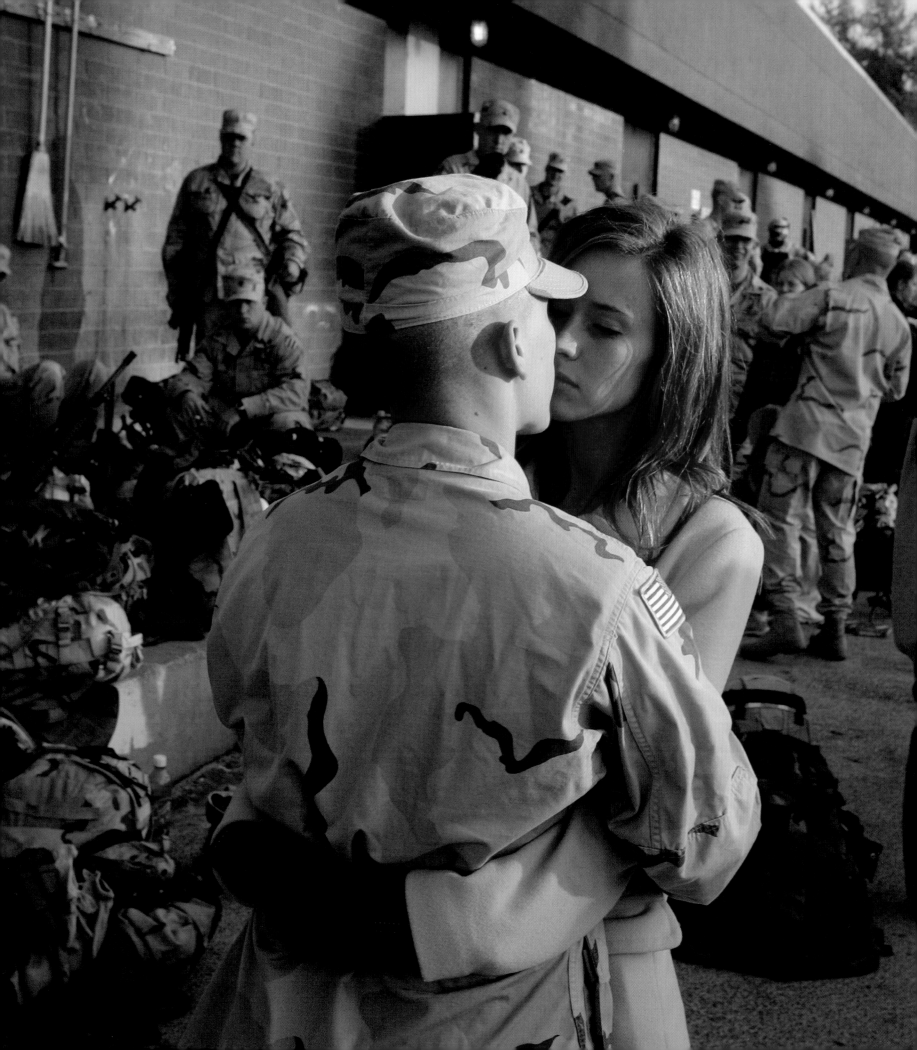

PATRIOTISM, JUSTICE, REALITY

Photographed by Andrew Lichtenstein

"You can walk by something hundreds of times without stopping and thinking about it," Andrew Lichtenstein says. And of course we all do that. It's easy and all too common to walk by a vestige of some significant historical event without noticing. Sometimes evidence has been eradicated and there's nothing to see. Events disappear from view and eventually, if we're not attentive, from history itself.

Lichtenstein maintains that if we don't address our wounds, the scars don't heal. Plenty of examples attest to the truth of this. His project *American Memory* looks at how we have and have not remembered a myriad of historical events. He photographs what remains.

There is no visible sign of the deadly fire that broke out on March 25, 1911, in the Triangle Shirtwaist Factory in New York's Greenwich Village. The owners had locked all the doors so workers couldn't take breaks from their assembly-line jobs. One hundred forty-six garment workers, mostly Jewish and Italian immigrants, the majority women in their late teens and early twenties, jumped to their deaths or died from fire and smoke inhalation. The factory is long gone. Volunteers quietly keep memory alive on the anniversary of the fire by chalking names of victims on sidewalks in front of their former homes throughout the Lower East Side. "They died brutal deaths because of greed," says Lichtenstein. Forgetting is not an option.

His search for memory has taken him around the country. In Natchez, Mississippi, he found a symbol of the Forks of the Road Slave Market, the second-largest slave market in America.

Opposite:
In January 2005, members of the Third Battalion, Seventh Infantry Regiment, Fourth Brigade, Third Infantry Division prepare to deploy to Iraq for the second time. Sergeant Dave Tafolla and his wife, Tiffany, say good-bye.

Road Slave Market, the second-largest slave market in America. The site is marked by a puddle of concrete anchoring a couple of chains. The marker sits in a busy traffic circle on the way to the city's downtown. "We all walk around as if this huge crime doesn't exist, as if it never happened," says Lichtenstein. This kind of amnesia amounts to a denial of the crime nearly equal to the crime itself.

Lichtenstein doesn't photograph reenactments and can feel let down by a modern museum, even when museums do their job well. "I go to a town where a former mill has been turned into a museum and there's a gift shop, and I'm not opposed to that. But as a photographer I want to be able to walk up to the top floor that's been abandoned, a place with some physical connection to history." Photographing what a historic site looks like now may mean documenting an empty landscape or simply a mood. Absence can have more power than a manufactured presence.

Then again, Lichtenstein can be baffled by some existing memorials and monuments: "There is definitely a cult in America for Stonewall Jackson," he says. "I as a Northerner am fascinated by that. Here is a general who may have been very great, very talented, but who fought for white supremacy and for slavery." Jackson, beloved by his men, was shot in the arm by friendly fire on an active battlefield. In an effort to save Jackson, his arm was amputated. He was moved thirty miles south to get him away from the front lines, but he still died. "When I heard there was a gravestone to his arm, I thought that expresses the cult of Stonewall Jackson—who else's arm is buried with a tombstone?"

In a paupers' cemetery owned by the Texas Department of Criminal Justice, Lichtenstein photographed an anonymous grave marker. The "X" on the cross is for somebody executed by the state of Texas. "There is something about a nameless cross in a cemetery," he says. "Things are different now. Texas runs a website, and even with your iPhone you can see who was executed and when. Not only will the person's name come up, what they ordered for their last meal is there, too."

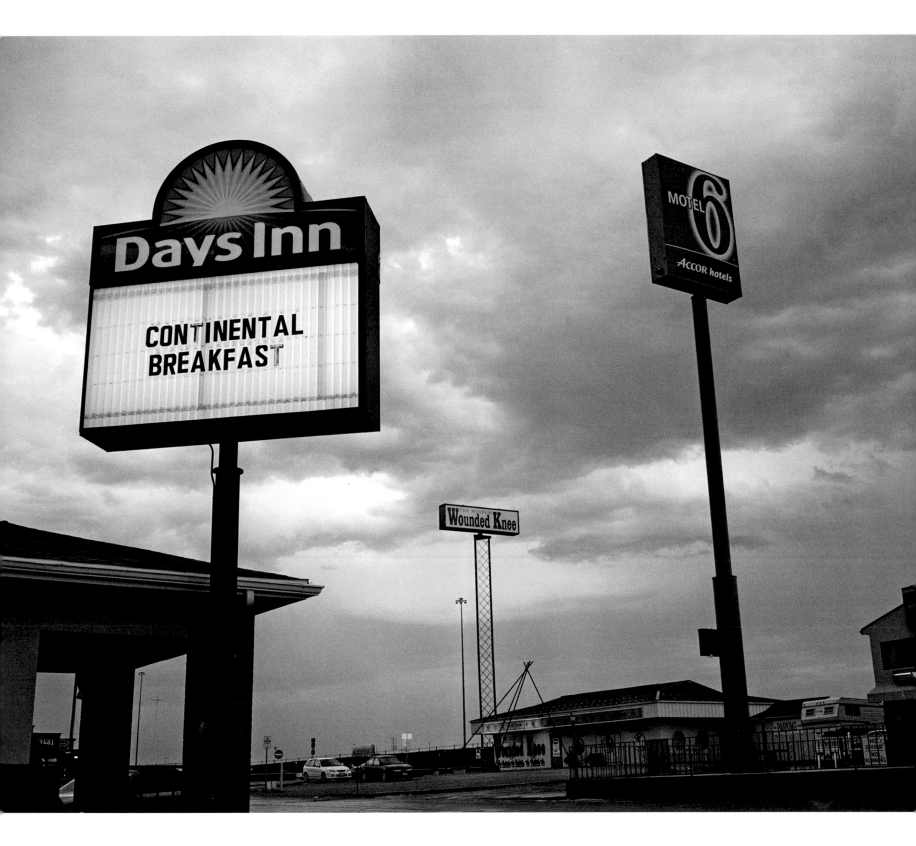

Wounded Knee, South Dakota, July 24, 2011.

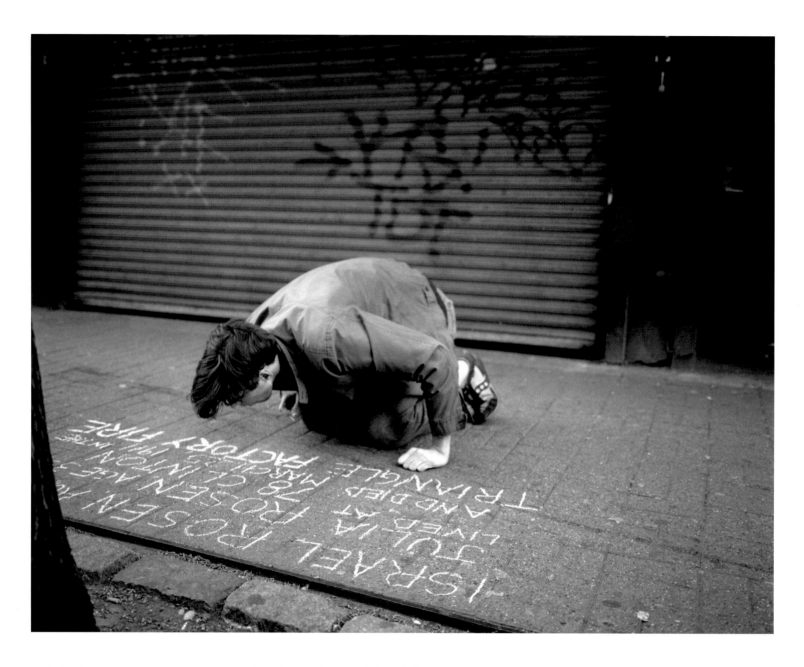

On the 2010 anniversary of the March 25, 1911, Triangle Shirtwaist Factory fire, volunteers chalk victims' names on sidewalks where their homes once were throughout the city's Lower East Side.

From the 1830s through the 1850s, the Forks of the Road slave market, on the eastern edge of Natchez, Mississippi, grew into the South's second-largest slave market. The traders Isaac Franklin and John Armfield organized shipments of slaves from Virginia to Louisiana, Mississippi, and beyond, ruthlessly separating families in the process.

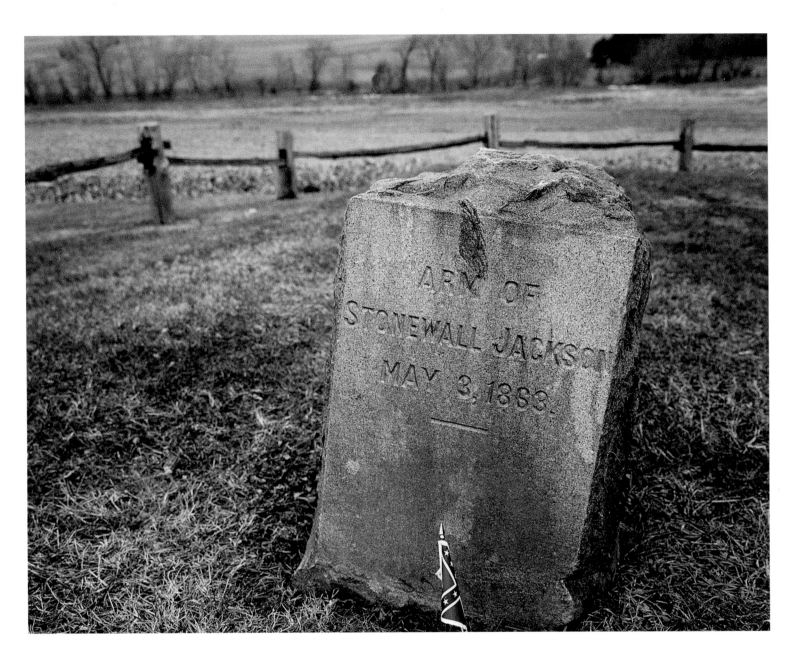

A grave marker for General Stonewall Jackson's arm lies behind the Lacy House on the Ellwood estate, part of the Chancellorsville Battlefield in Virginia. After the wounded general's arm was amputated, he was transported away from the front lines. He died six days later.

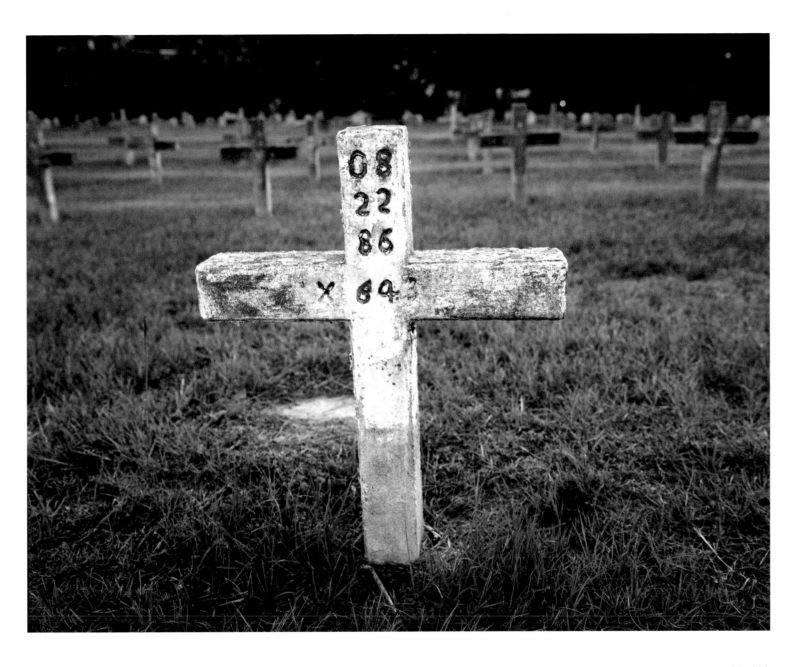

A grave marker in the Texas prison system's cemetery in Huntsville notes that on August 22, 1986, a prisoner identified as "X 693" was executed.

Andrew Lichtenstein grew up in the shadow of the 1960s. "It was a time when you expected your government to lie to you," he says. The country was in the grip of a civil rights struggle; the Vietnam War was on television every night. "I had the sensation of just not wanting to obey, of feeling the power structure is rigged. I still believe the system is dishonest and unjust and distorted. I have to protest. I have to have a voice." His documentation of how we remember the past is linked inextricably to his photography of events occurring right now.

Lichtenstein would rather work in America than overseas. "I feel I understand my own country better than I do other places," he says. He takes on issues he feels impelled to investigate, whether or not he has financial support. If his interest is peaked by an assignment, he continues to explore the subject on his own even after the assignment is done.

Some of Lichtenstein's projects are straightforward, in the sense that he sees a clear right and wrong. He never bought the Bush-Cheney-Rumsfeld rationale for the invasion of Iraq in 2003. He was enraged by the meaningless deaths of the ensuing Iraq War and decided he wanted to somehow honor lives lost and the pain of families at home. He wanted to force people who were perhaps unconsciously going about their daily lives to understand the war's costs. With this in mind, he went with his camera from one funeral to another. He rarely approached grieving relatives on the day of the burial, assuming they would not be interested in dealing with a photographer at such a time. There were occasions where, feeling uncomfortable, he left without taking out his camera at all. But there were families who welcomed him. He sent them photographs and visited them in their homes. He photographed the war around its edges.

Lichtenstein doesn't always embrace the viewpoints his photographs portray. While deeply concerned about economic inequality, the enormous divide between the wealthy and the impoverished in America, he was not an advocate of the Occupy movement. "I felt the so-called movement was way too focused on media attention, and the media were for the most part interested in confrontations with the police," he says. "It was very important to the Occupy organizers to stay structureless, but that means once the media attention fades, once you become yesterday's story, you're going to have nothing."

He made a photograph during a protest march against strip-mining in West Virginia that troubles him particularly. The image is of an affectionate lesbian couple who were participants in the march. "I really have misgivings about this," he says. "There's nothing wrong with being lesbian, but you're walking through one of the most conservative regions of America, and it's so easy for your enemies to make this into a culture war. I'm of two minds about it because I feel like you are handing your political opponents a diversion from the immediate issue, which in this case is the exploitation of natural resources for ruthless profit."

New York, July 24, 2011.

In June 2011, two marchers take a break from walking to Blair Mountain in West Virginia to protest plans for a strip mine.

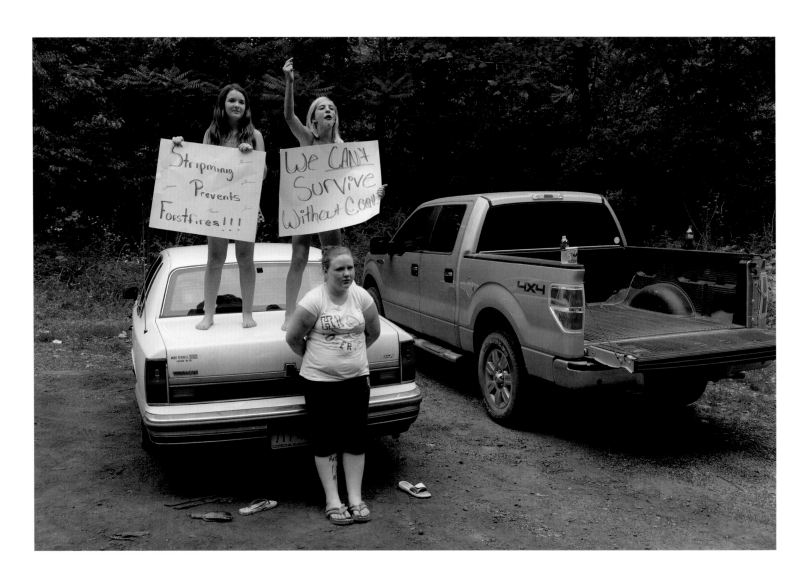

On June 9, 2011, in Racine, West Virginia, local teens who support the coal industry shout at protesters walking past them on a fifty-mile march to Blair Mountain. The march route follows the same one taken ninety years before, in 1921, when union coal miners marched through the mountains of southern West Virginia in an attempt to rescue fellow workers who were being terrorized by company gun men.

In Clothier, West Virginia, a local resident who has worked for the coal industry for forty years as an ambulance driver watches as marchers opposed to strip-mining nearby Blair Mountain walk past his home. The local community is generally supportive of some kind of memorial for the coal union struggles of the past, but they are wary of "outside" environmental groups who oppose strip-mining. They see environmental laws as a direct threat to their economic security and the few remaining industrial jobs in the impoverished area.

Near Three Points, Arizona, in April 2007, Arizona Minutemen, members of an independent militia, pass through a stretch of the Sonoran Desert littered with clothing discarded by migrants on their journey north. Most Minutemen carry guns, but they are under strict instructions not to chase or apprehend migrants. Instead, they are asked to report sightings to border patrol.

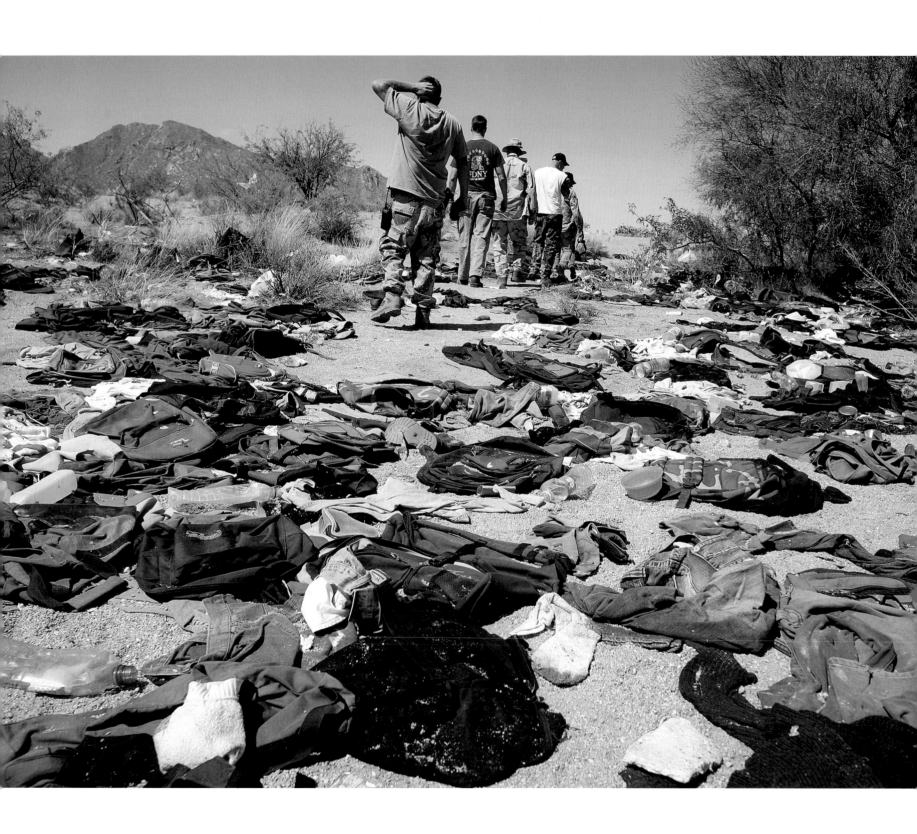

The Occupy movement protesters' numbers are small, but they manage to make their presence felt during the morning commute to work on September 21, 2011, along the narrow streets around New York's Wall Street.

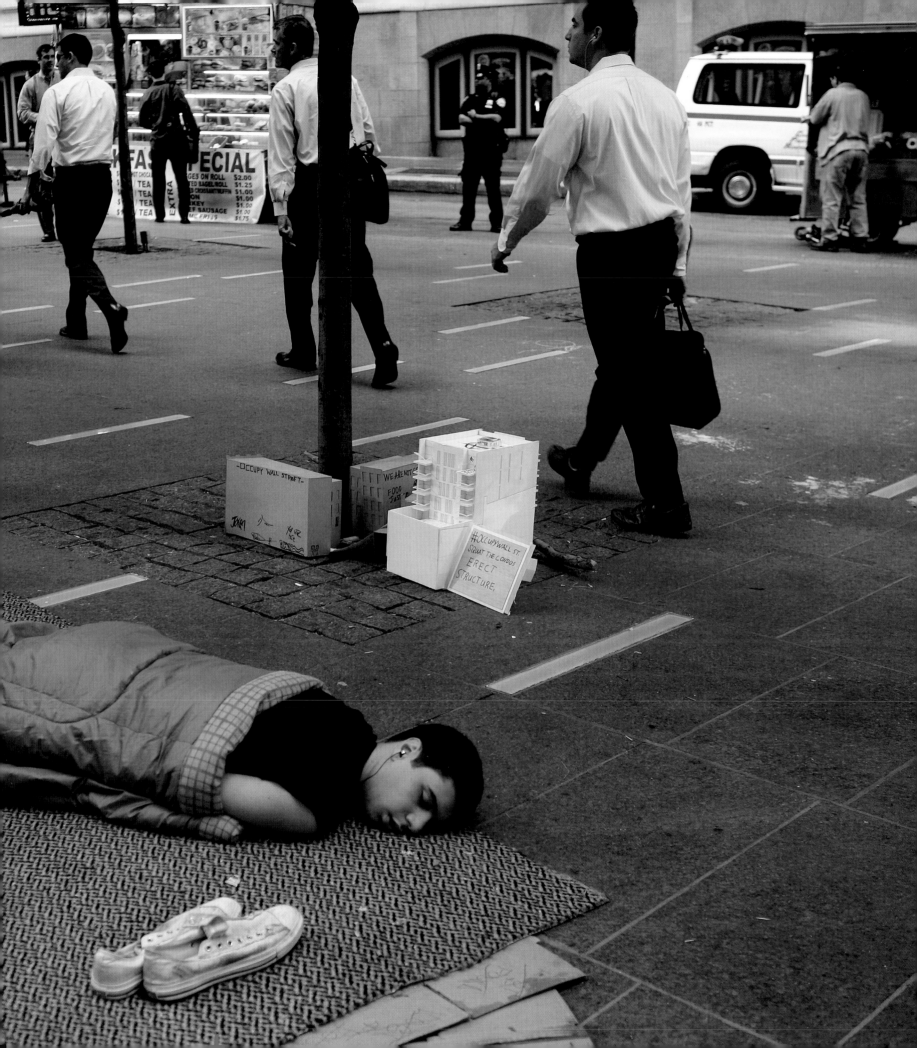

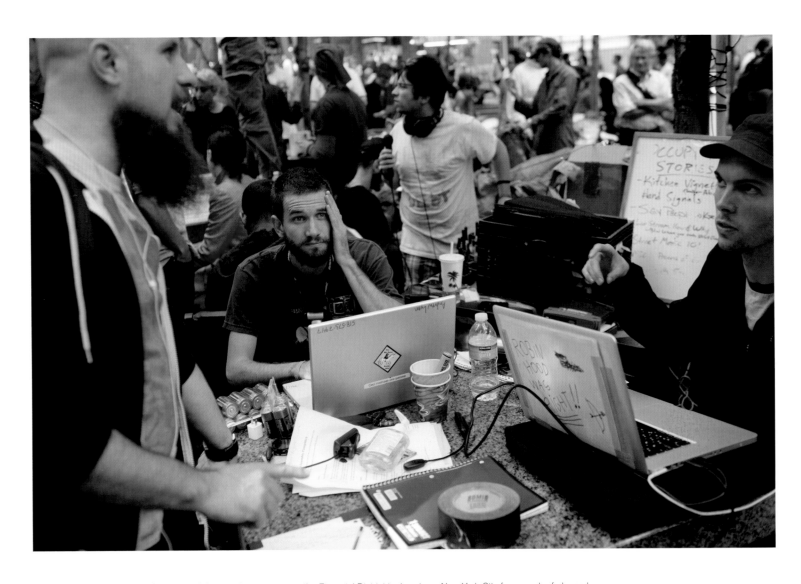

In September 2011, activists from around the country converge on the Financial District in downtown New York City for a week of planned demonstrations around Wall Street to protest corporate greed during the height of a deep recession.

Businessmen leaving Wall Street during rush hour on September 25, 2008, try to make their way through a crowded demonstration against President Bush's $700 billion plan to bail out troubled Wall Street firms.

Texas prison inmates accepted Lichtenstein's presence, and he got along all right with the wardens. Most were decent working people doing a difficult job. But the vast majority of prisoners he met were trapped in a system more interested in keeping them locked up than in helping them better their lives. In addition to incarcerating lawbreakers, the prison was serving as a stopgap for mental health cases. Lichtenstein saw people sleeping all the time, a sign of severe depression. While he was there, a lockdown was instituted because the prison was understaffed, and sandwiches from the cafeteria were brought to the cells.

Of all the photographs Lichtenstein made in that Texas prison, his favorite shows visiting day. "This is the day you see what prison is all about. It's not just about the prisoner—it's about the family left behind. But no visitor, not even a family member, can know what it's really like," he says. "Only those who can't leave the prison get the complete story."

Lichtenstein feels that as an American his viewpoint of the country is fundamental, but he sees value in how non-Americans photograph the country, too. "I live in New York and see people coming to the city and making amazing pictures because it's all new to them," he says. "The classic example that we're all still to this day inspired by is Robert Frank's *The Americans*. But while *The Americans* is incredible and ground-breaking, I personally sense in it a removed cynicism that only a European might possess. An American would be emotionally more connected."

—

Texas prison inmates at work in a Trinity River Bottom
cotton field, May 24, 2002.

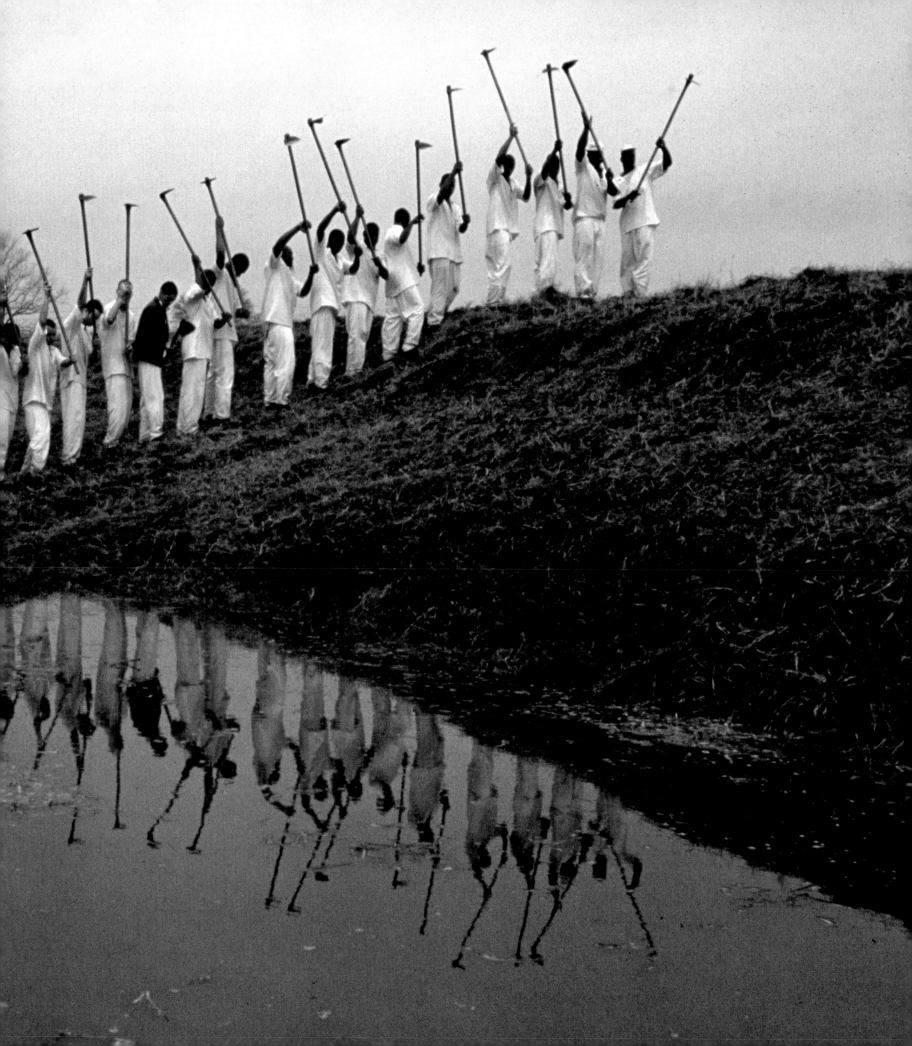

In the solitary wing of a Texas prison, inmates are separated by gang or alleged gang affiliation. They are not allowed to eat in the cafeteria, and food is brought to their cells. During lockdown, they get sandwiches. On April 26, 2002, a lockdown is instituted because the prison is understaffed.

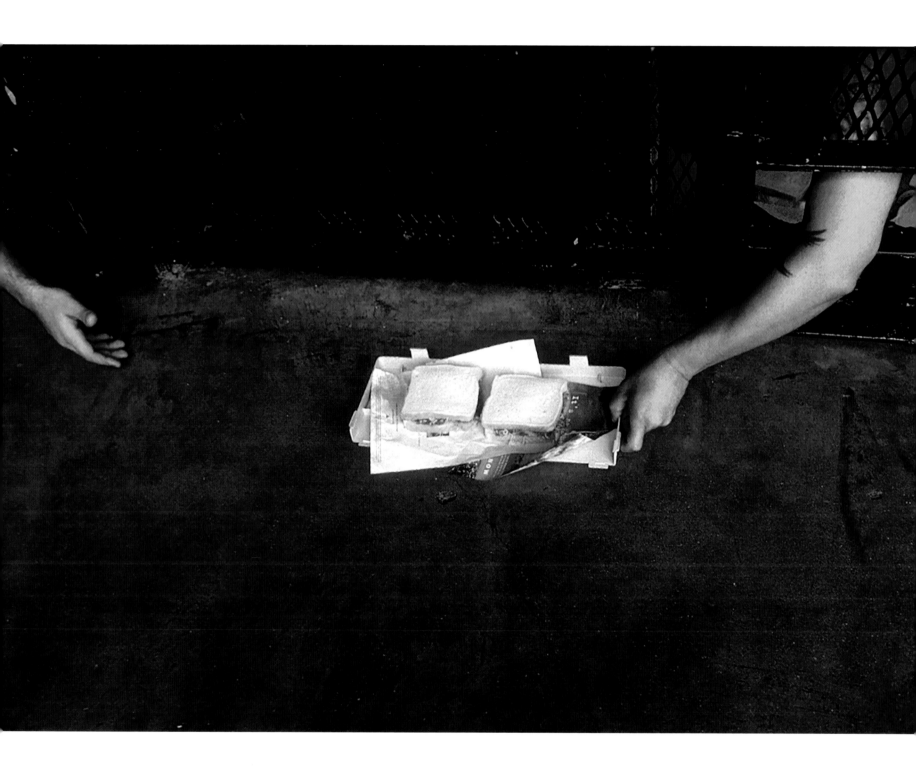

In prison people sleep all the time, which is a very common sign of severe depression.

It's an old story: prisons are being used as a stopgap to house mentally ill people.

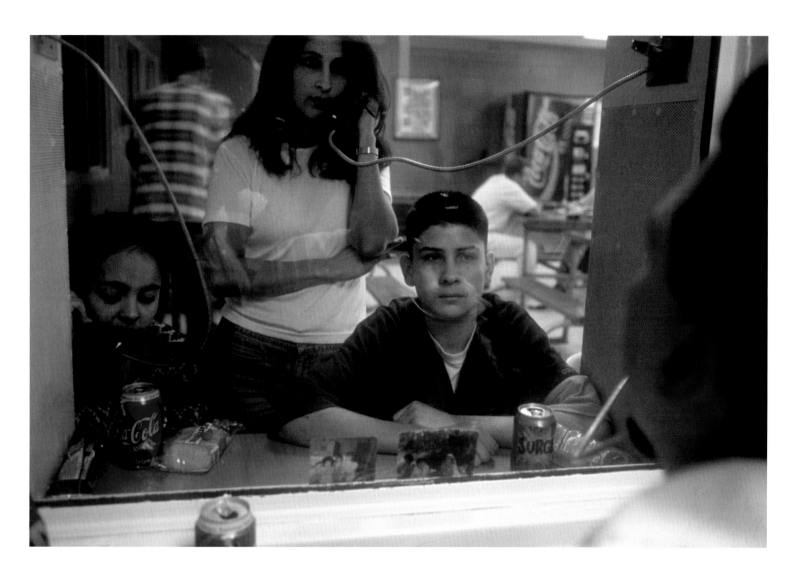

Visiting day, Gatesville, Texas, May 4, 2002.

In the small village of Sandy Hook, Connecticut, balloons and flowers mark the spot close to where a gunman opened fire in a local elementary school killing twenty-six people, December 15, 2012.

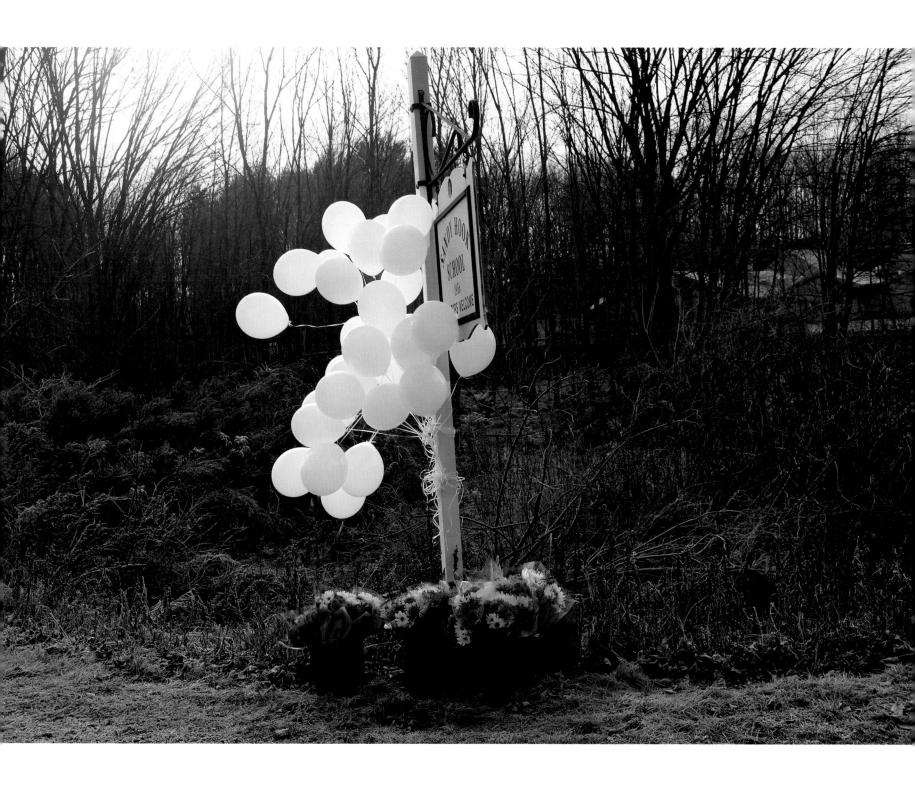

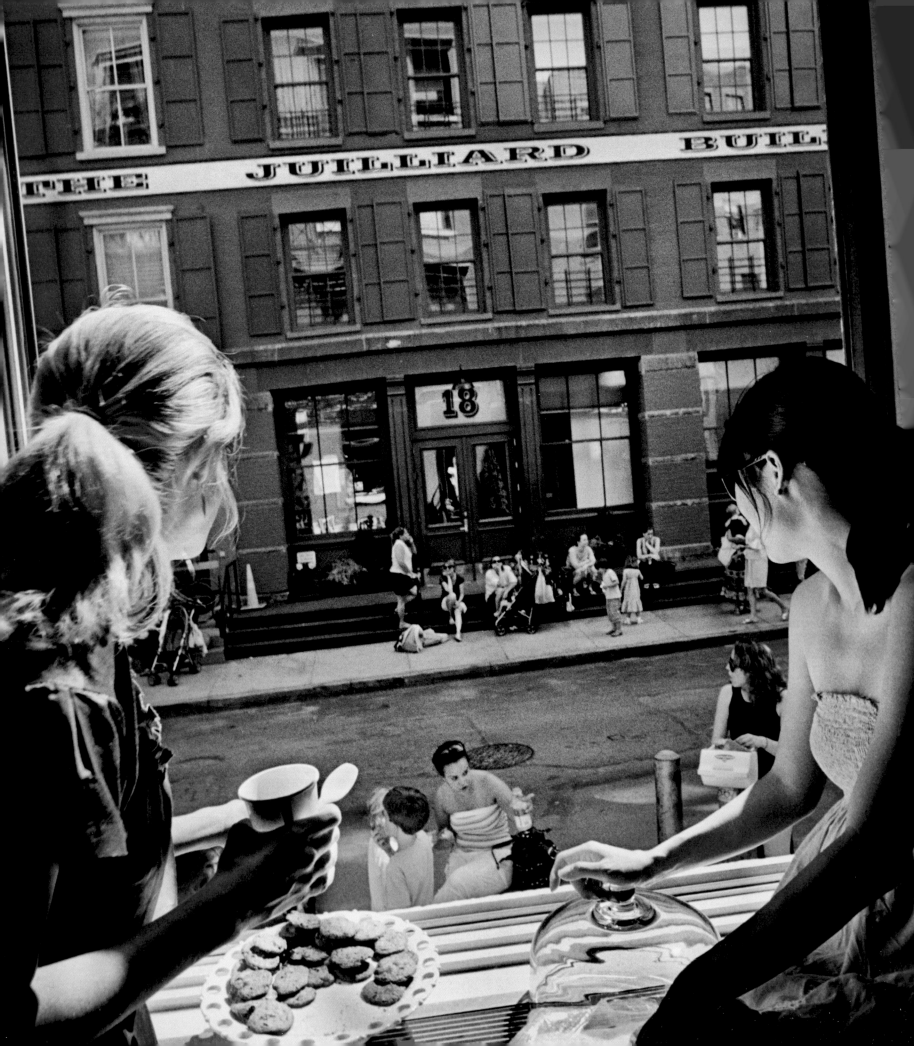

COMPLICATED FUTURES

Photographed by Donna Ferrato

In an effort to end domestic abuse, Donna Ferrato has spent years photographing atrocities hidden from public view. She means for the gut-wrenching stories she uncovers to "grab you by the throat," and they do. Photography is Ferrato's starting point. "I know it's possible to really motivate people, not just through my eyes and my pictures," she says. She assures victims she will stand with them, and she does.

In more than one interview, Ferrato has said, "My dream was to stop domestic violence, and I failed." In truth, such a dream simply wasn't fully realistic or attainable. The obstacles were—and still are—overwhelming. Ferrato's contributions to fighting domestic abuse have been remarkable. She has been instrumental in changing laws and changing individual lives.

Back in 1982, when Ferrato started out, nobody really understood the enormity of the problem. Sadly, victims who need help are often afraid to seek it. In Ferrato's landmark 1991 book, *Living with the Enemy*, writer-photographer Ann Jones describes in the introduction what can sometimes happen to women who have the guts to fight back and come forward: they can be ignored, further endangered by their abusers, and even prosecuted by legal authorities, who further hurt rather than help these women.

Despite much progress in the quarter century since Ferrato's book was published, domestic violence hasn't gone away. This was made shockingly clear in 2014, when a video surfaced showing Baltimore Ravens running back Ray Rice punching his then-fiancée Janay Palmer and knocking her

Opposite:

Referring to Lila Rose (left), Ferrato says, "I heard her calling from my fire escape, 'Ice cream for sale, ice cream for sale.' I ran down the street. I didn't know who she was, but I walked into her apartment and saw her hawking her cookies and homemade ice cream out the window. She raised money for poor children. I stood on a chair to get the picture. They just ignored me."

unconscious in an elevator. After the story made headlines, the NFL penalized Rice with a mere two-game suspension, but widespread public outrage, and the discovery of the video, finally spurred the Ravens to terminate Rice's contract and the NFL to suspend him indefinitely. Rice appealed the suspension in federal court, won, and as of December 1, 2014, had regained eligibility as a free agent to play in the NFL with any team willing to sign him.

In the meantime, Palmer and Rice married, and Janay defended her husband and blamed the media for his punishment. *Washington Post* columnist Ruth Marcus, on September 10, 2014, described Janay Rice as "the most tragic, and the most puzzling, figure in this sordid episode." Marcus wrote, "It is difficult for someone who has not been a victim of domestic violence to understand how she could stand by her abuser."

Ferrato has witnessed the brutality of domestic abuse and feels compelled to help victims. She created a project she calls *I Am Unbeatable* to support women who have the courage to leave an abuser. She photographed a woman named Sarah, who survived a long, painful history of abuse, and who has been given a lifeline through *I Am Unbeatable*. Ferrato says, "In the beginning it was really hard for her to even talk about what her ex had done. So much emotional turmoil. Huge depression." Ferrato stays with her subjects as they face their past and eventually connect with a community. She photographs *I Am Unbeatable* in color because she wants the pictures to resonate positively with younger people, to be accessible to a larger audience. "I felt like the dark, black-and-white photography is so grim. Especially the way I shoot it," she says.

On October 19, 2013, Sarah and her two sons attended an event at the Shelby Street pedestrian bridge in Nashville. It was an important occasion held annually to remember murdered victims of domestic violence and to honor those who are dedicated to preventing it. "The boys had never been a part of something like that," Ferrato says. "That was the first time they stepped out in public. It was a really triumphant moment."

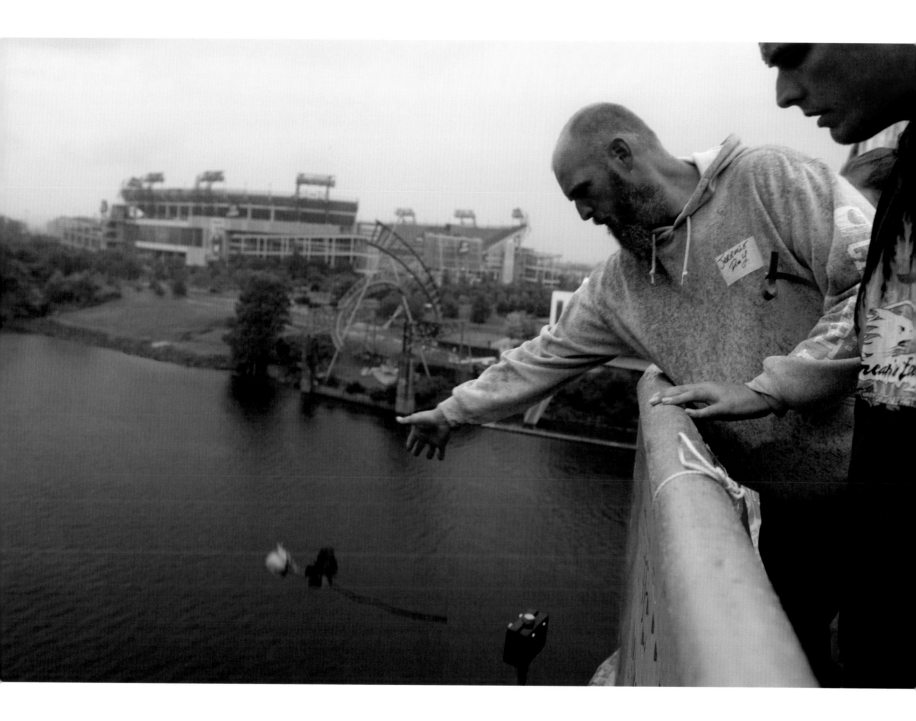

This annual October event at Nashville's Shelby Street pedestrian bridge memorializes murdered victims of domestic violence and honors those dedicated to preventing it.

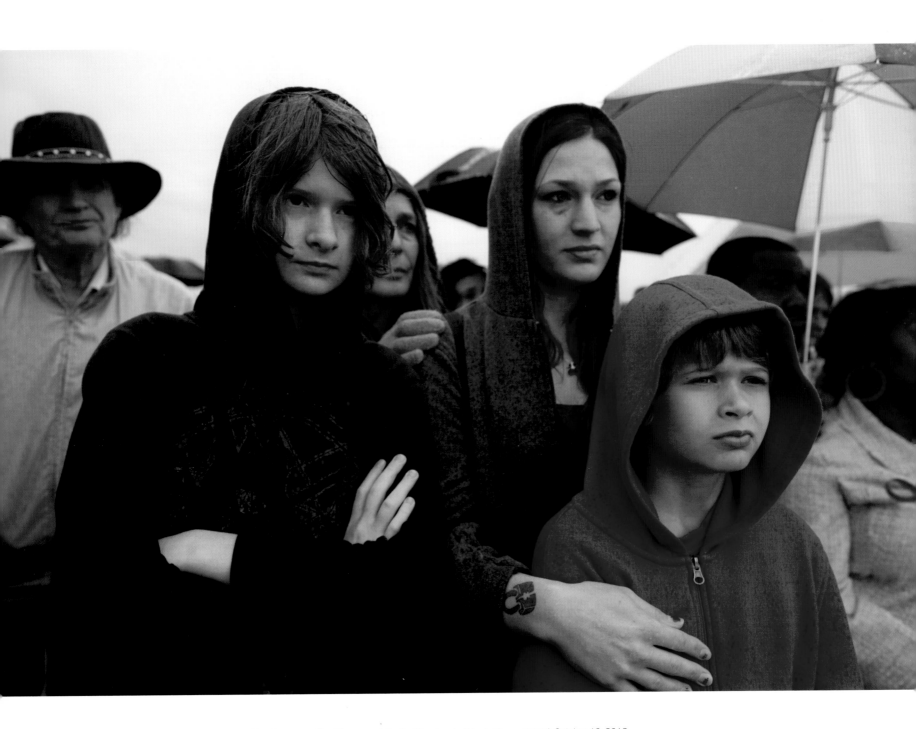

Sarah, a survivor of domestic abuse, and her two sons attend the annual Shelby Street pedestrian bridge memorial, October 19, 2013.

Ferrato was away, working in Germany on a book, when the World Trade Center went down on 9/11. The enormity of the tragedy and the immediacy of its impact shook her to the core. "The World Trade Center is ten blocks from where I live on Leonard Street in Tribeca," she explains. She agonized over what she would do going forward. She gradually began a new project, bringing a very different photographic perspective to her photography. She would photograph Tribeca.

The neighborhood was changing. "Developers were coming in, knocking down this and knocking down that," she recalls. El Teddy's—a gathering place and landmark with a 2,500-pound replica of the Statue of Liberty's crown on its roof—had been torn down. "My little block used to be the crummiest block in Manhattan. My neighborhood was going from this little mousy street to being the Dubai of the United States." She was angry about the physical damage caused by the construction itself. "It's cracking our walls. It's damaging our water system. We've got a lot of problems because of all this construction."

Ferrato decided to photograph "the older buildings, the intimacy, the artists, the eccentric people." She loves the work. "I feel like Supergirl here. I can run out my door and photograph whenever I see something. I can jump on top of garages—everybody knows me. If I say I need to get on top of that building, they let me go up." Sometimes she has to negotiate for access. "Right now I'm having a little trouble getting the right views of 56 Leonard Street. I really need to be right across from it. The law school wants my pictures, and I need their vantage point."

In Ferrato's new photographs, it's possible to discern influences from some of her favorite artists of the past. "I always loved Weegee a lot," she says, "and Diane Arbus is influencing me more these days than she used to. And I really like Tina Modotti and Imogen Cunningham."

Ferrato layers her photographs. Foreground and background speak to each other. Some of her images feel ominous, like something is going on just outside the frame. Her photographs are filled with symbols and historic references. She reads the history of the neighborhood, thinks about the people who have lived there, and when moved, she'll boldly stage a photograph.

"I can do things in Tribeca to try to re-create history—things I can't do with anything else as a documentary photographer," Ferrato explains. She staged a photograph portraying Helen Jewett, a mid-nineteenth-century prostitute who was bludgeoned to death. "Everybody was so stunned at her awesome, hideous beauty. People would line up just to come and see her body. The photograph is like an homage to Weegee."

There is a sense of vulnerability in some of Ferrato's new images that may come in part from how she works: "I always try to bring in someone who's not afraid because we have to do this in the early morning hours or in the night. We have to climb over fences to do this. We have to be quick." Photographically, she loves the machinery, the steel, the dirt, the big pipes—presences she hates in real life. She uses them to show truths that can't be easily expressed.

More often than not, Ferrato's photographs are of encountered, unstaged moments. "The light is so beautiful in Tribeca," she says. "Eccentric things are happening. There's still that intimacy in my neighborhood that I want to preserve. I want to say, 'Look, this is something that is so wonderful.'"

Taken up with her Tribeca project, Ferrato is sometimes afraid to leave. She asks, "What if something happens and I'm not there?"

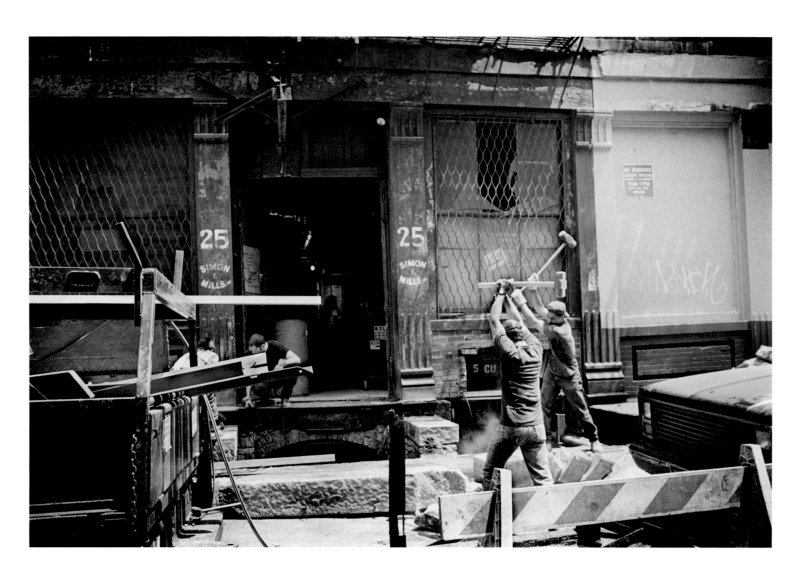

Ferrato's connection to New York's Tribeca neighborhood grows deeper as time goes by. "This is my house. This is how it was when I first fell in love with it," she says of 25 Leonard Street.

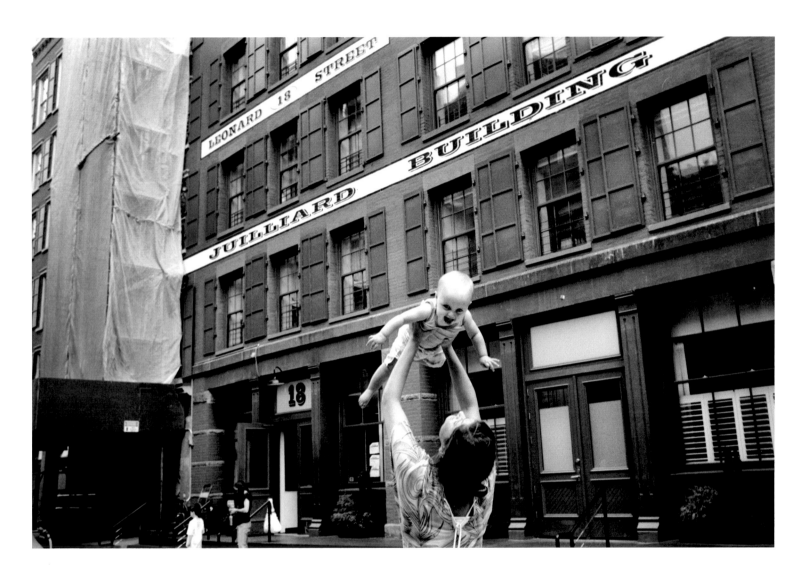

"When I saw her holding her baby up like that, it was boom—a really symbolic image," Ferrato says. "We try to make our world better so children can flourish and feel safe and know they are loved. That's sort of the whole point of why we are here, right? And the Juilliard School for Performing Arts has become my muse in a lot of ways."

"As I was taking a picture of these girls dressed for Halloween, Al, a guy who works in the garage across the street, comes running over and just scoots in there, and it's like a great moment. In a minute they'll be gone."

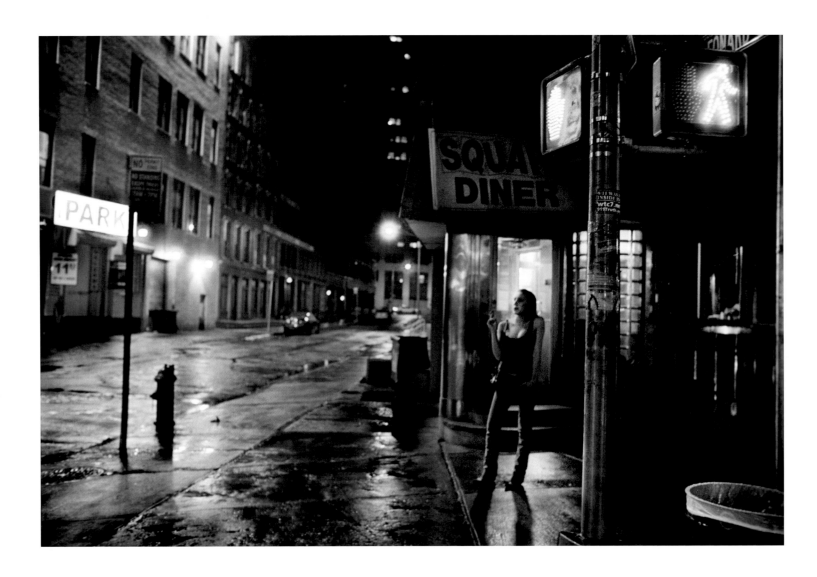

"I'm having a lot more freedom with Tribeca," Ferrato says. "I can do things in Tribeca to try to re-create the history that I can't do with anything else as a documentary photographer."

Church and Beach Streets, 2007.

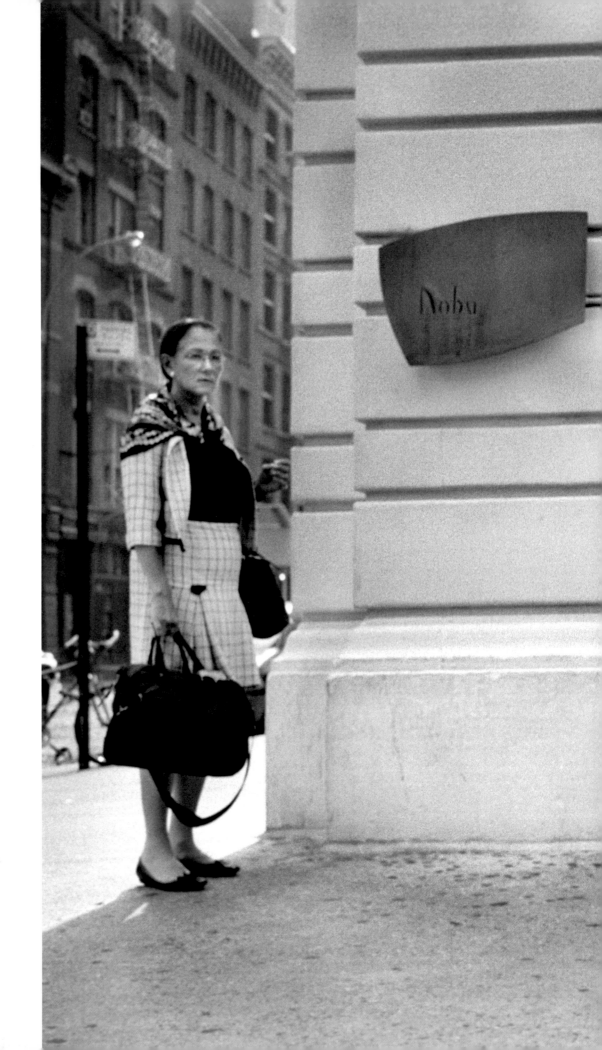

"This is a very famous chic restaurant, Nobu, Robert De Niro's restaurant," says Ferrato. "I like the elements in this scene: the older woman, staid and conservative, checking out this girl who is so hot. This is what Tribeca is all about—artists and more professional people with money mingling together."

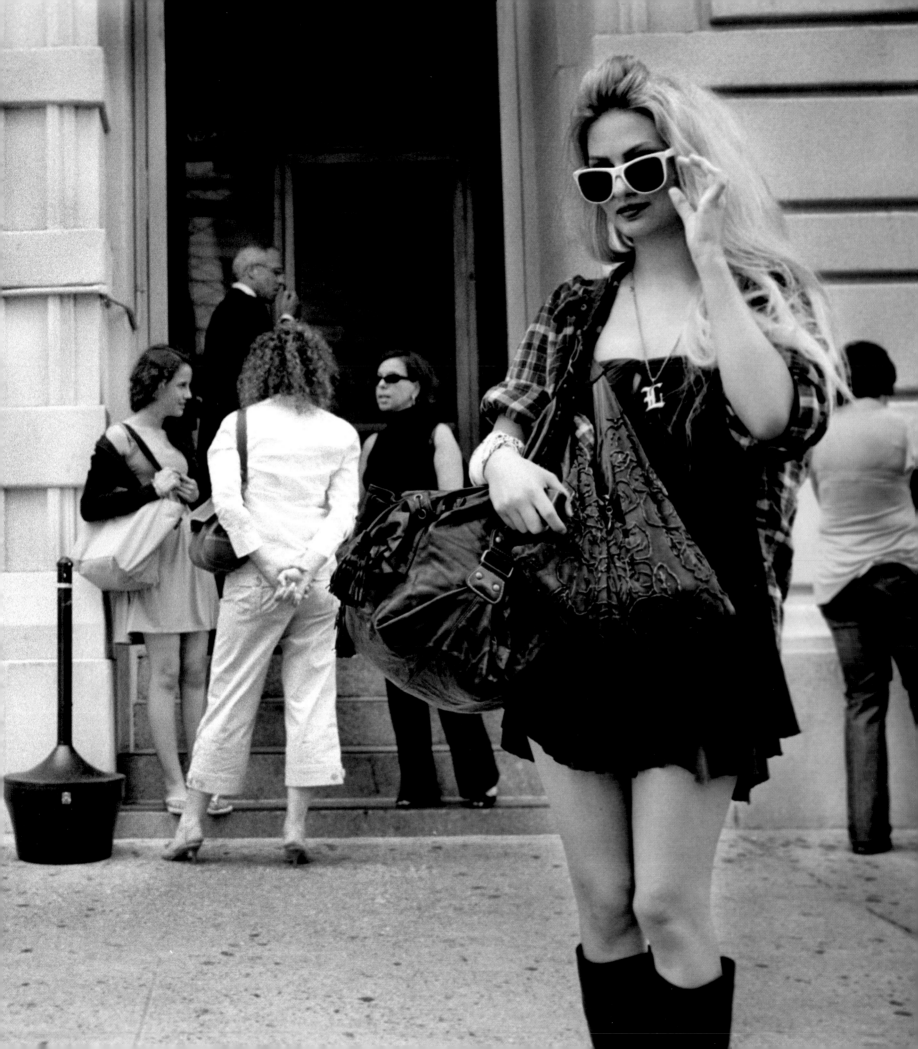

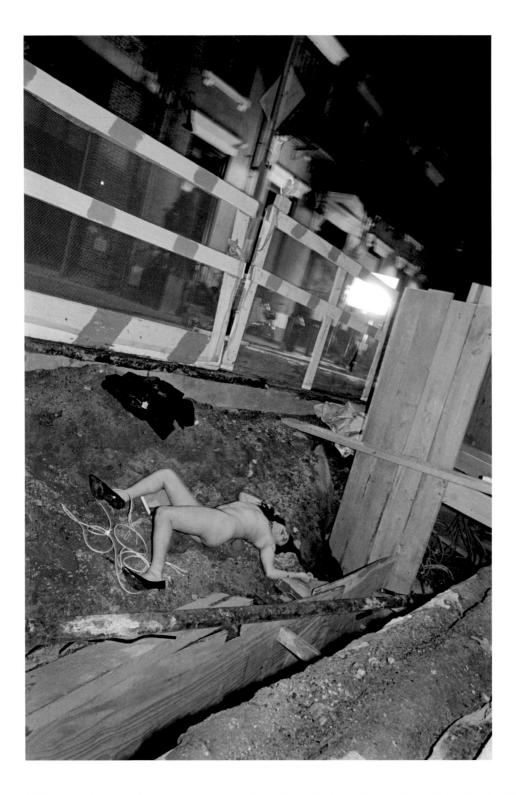

In Tribeca, Ferrato is inspired by histories of people who lived in the neighborhood: "An incredible prostitute, Helen Jewett, lived on my street, a block from a whorehouse on Thomas Street. She was brutally murdered by a guy who knew she planned to turn him in to the police because he had murdered another prostitute. When construction opened my street, I was able to sneak over the fence and bring my friends, and we created scenes based on the murder. This isn't a real dead woman. In fact, it's not even a woman; she's really a man. She's a transsexual. And she's posing."

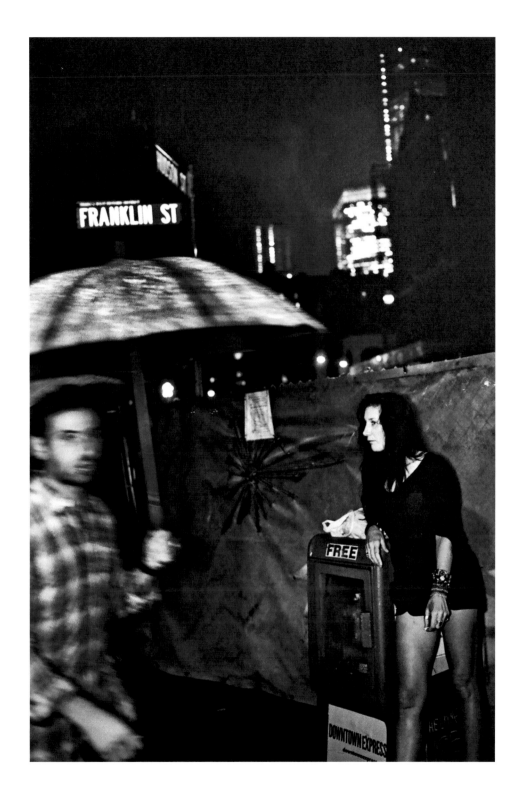

"Franklin Street used to be where all the prostitutes hung out," Ferrato explains. "There's no nightlife there anymore. Now it's mothers and babies, stockbrokers. Things are changing so fast, but where is our humanity? Not to say that we should have prostitutes on every corner. But nobody is really out anymore."

Ferrato says this photograph shows the future of Tribeca: "The rich couple inside have their car and driver waiting for them. So different from the photo [page 96] of that woman standing outside on a rainy night on a rough and seedy street all patched with tar. It's the place for the super rich. It's peaceful, definitely peaceful. You can stand out in the street. You don't have to worry about being run over. He's brushing his teeth. Everybody feels safe."

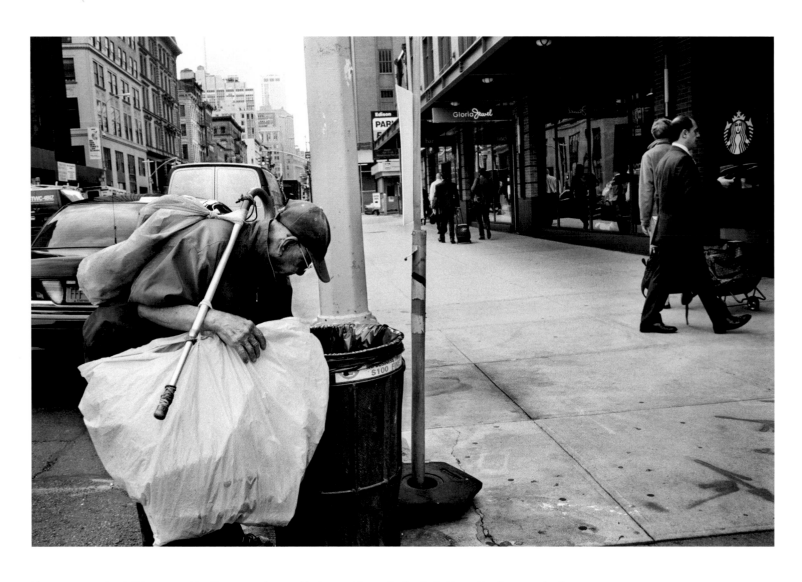

"Morning, noon, and night," Ferrato says, "the Chinese people on my block are out there collecting the bottles, putting them in sacks. They work so hard. They usually have two or three shopping carts. I admire them so much. They are the ones who are really working. What I need to do is show this alongside more of these guys in suits. This was my first stab at it."

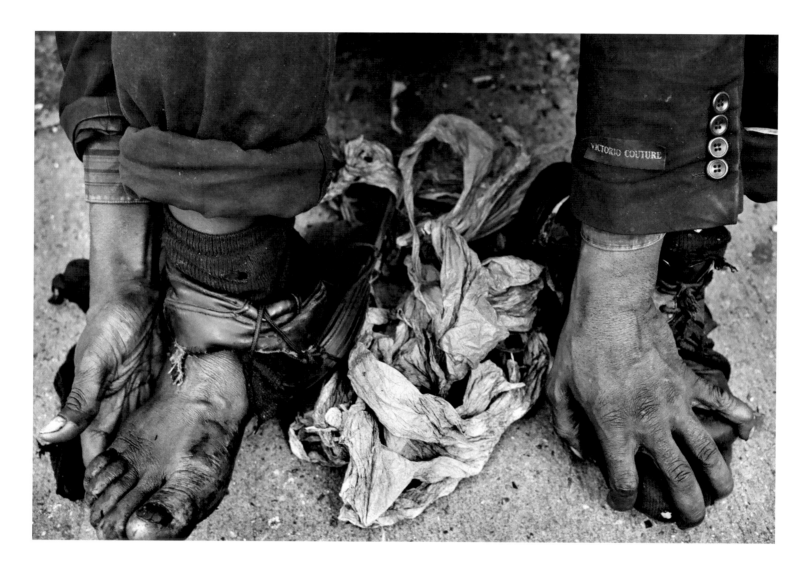

Ferrato says, "One day I just said to this man, Can I actually see what your feet look like? He said yeah. He took off his shoes and they were so infected. Gangrene. I took a couple of pictures. I said, I'm going to bring you some food, okay? I gave him like five bucks, and I said just stay here. He said, I have to be in another place soon. I said just give me fifteen minutes. I went home and made him a hot sandwich and juice, and I went running back. And he'd gone. I'm going to see him this spring, I'm sure of it. He's going to be out there this summer and spring. How do they get through with the pain, the discomfort? Sleeping out there. He had his feet wrapped up in these plastic bags. It's shocking to me."

Self-portrait, One World Trade Center, 5 a.m., September 11, 2011.

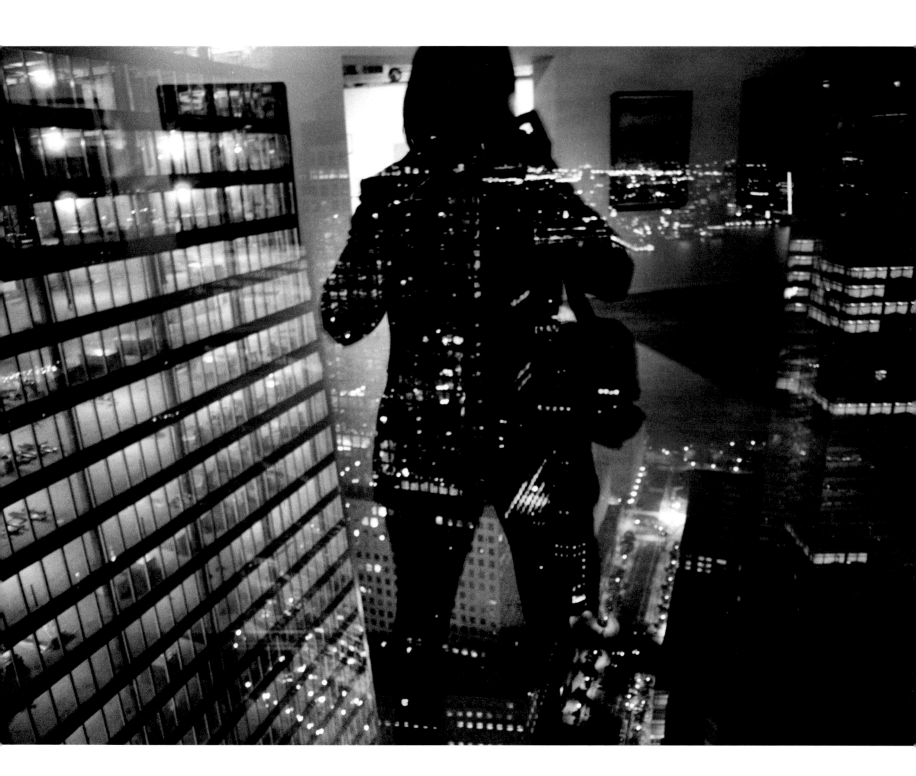

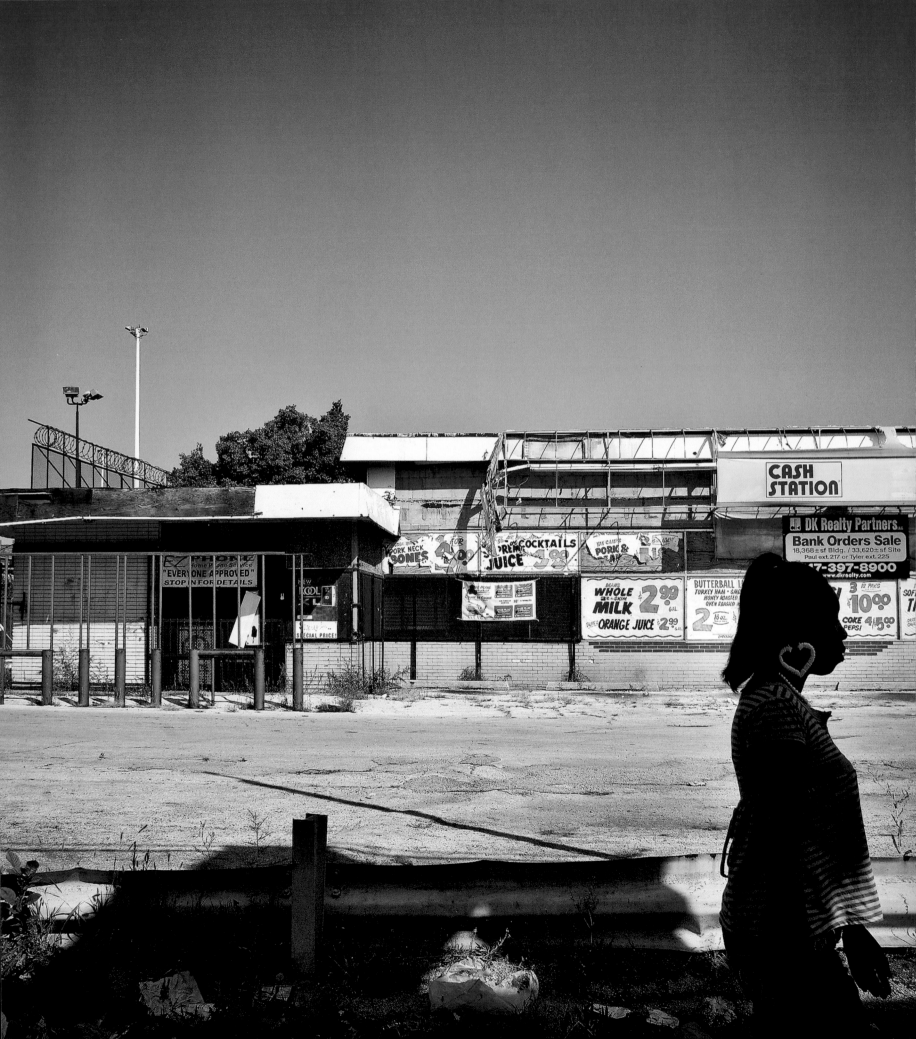

LEFT OUT AND LEFT BEHIND

Photographed by Carlos Javier Ortiz

Carlos Javier Ortiz was born in San Juan, Puerto Rico, and raised mostly in Chicago. "When you come from Puerto Rico, most people don't think you're American," he says. Being labeled an outsider permanently shaped his perspective. He sympathizes with every migrant and immigrant group coming to America— Mexicans, Irish, Italians, Jews from Europe. "My wife is African American and Jewish," he explains. "Her Jewish grandparents were immigrants from Belarus. People inherit the lives their parents and grandparents lived."

Ortiz's decision to photograph migrant workers was influenced by his background and also by Dorothea Lange's photographs of the 1930s. Though Lange's migrants came from circumstances quite different from those of Ortiz's subjects, the issues faced are similar—they are vulnerable people who are being exploited, underpaid, with no security or safety net.

In April 2010 the Arizona state legislature passed a bill aiming to rid the state of illegal immigrants. The Support Our Law Enforcement and Safe Neighborhoods Act, known as Arizona Senate Bill (SB) 1070, stipulated that anybody who didn't have a proper ID or passport could be deported. Before the law went into effect at the end of July, pro and con rallies were held on the grounds of the Arizona state capitol. Ortiz describes the demonstrators favoring the law as "very patriotic but also condescending." He says people came with handguns, as if expecting to be threatened or attacked. "There was a lot of animosity, a lot of Tea Party people. I had never seen anything like that."

Opposite:
Neighborhoods like this one on 63rd Street in Chicago, which have little or no access to the foods needed for a healthy diet, are called food deserts. Often, they are served by fast-food restaurants.

The day before SB 1070 went into effect, Judge Susan Bolton, concerned about racial profiling, challenged the bill's constitutionality and placed an injunction on the most controversial parts. Ortiz was there when the migrant community celebrated, and then prayed.

"They actually do deport people in Arizona," he says. On July 29, 2010, the day the law went into effect, he photographed two men being questioned by authorities. "It's unclear and strange that they were in the middle of nowhere on this mattress," says Ortiz, but the officials asking for papers were satisfied with the results of their query, and nothing happened. "We tend to think of the sheriff and police officers as bad guys, but they felt there was no wrongdoing in this case, and the men were allowed to continue with their day."

Ortiz went to North Carolina in September 2011 to photograph migrant sweet potato pickers. One Sunday, Ortiz documented pickers filling buckets with potatoes and running with the loaded buckets to dump the contents into waiting trucks.

Every time they emptied a bucket into the truck they got a voucher. The migrants, as young as eighteen and as old as seventy, worked seven days a week. "They took pride in how many vouchers they got, how hard they'd worked," says Ortiz. At the end of the workday a bus took the workers back to their camp.

Ortiz judged them well treated, but he has no illusions. Many migrants, both men and women, work twelve-hour days, breaking their backs for almost no pay. Some get visas for two or three months during the picking season and the harvest; some have been coming to the United States for a dozen years or more with no improvement in pay or conditions. "I wanted to show a glimpse of this other America, the America people don't pay much attention to," he says. "Their work makes our food cheap." He wants to put a human face on injustices seen largely from afar.

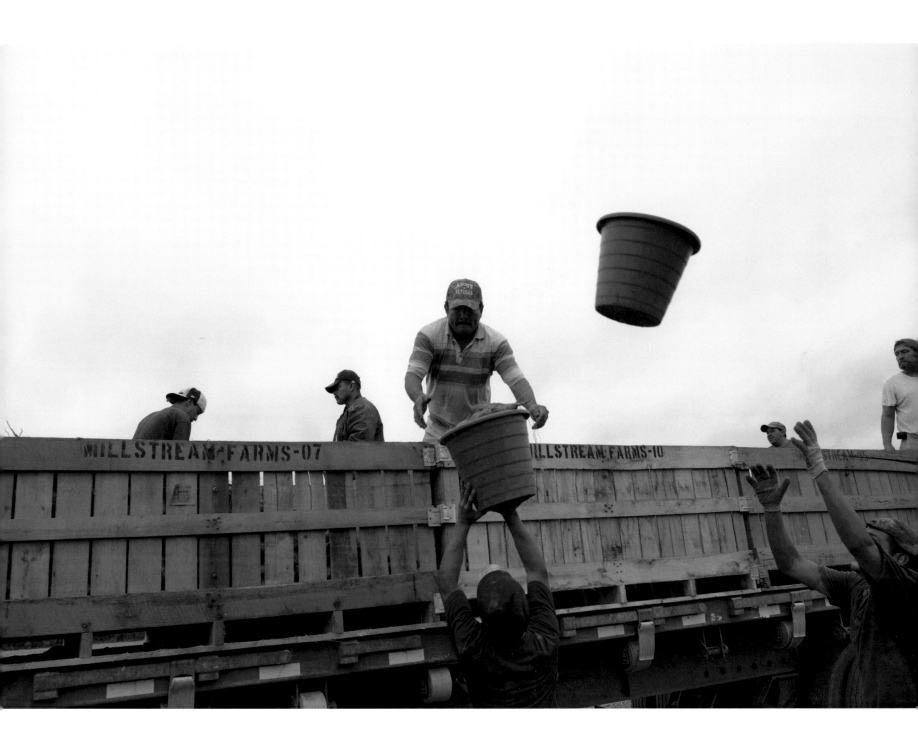

Pickers load trucks with sweet potatoes, Kinston, North Carolina.

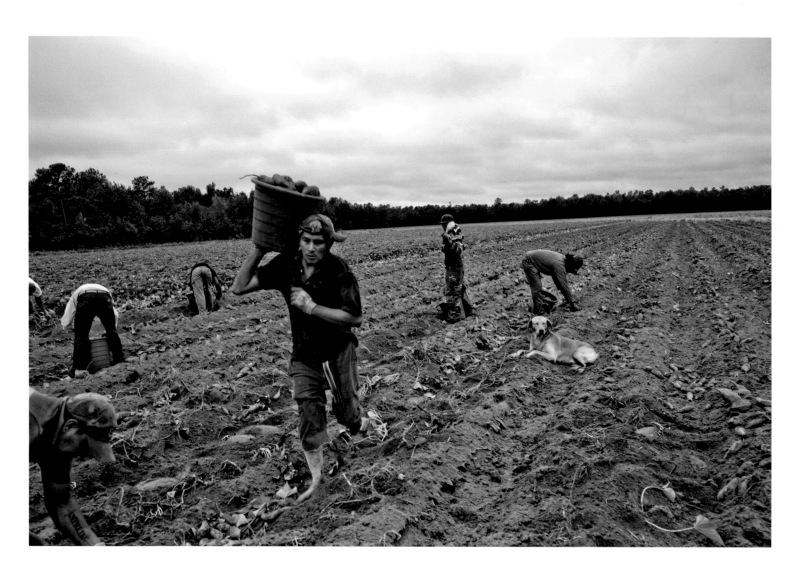

Sweet potato pickers, Kinston, North Carolina.

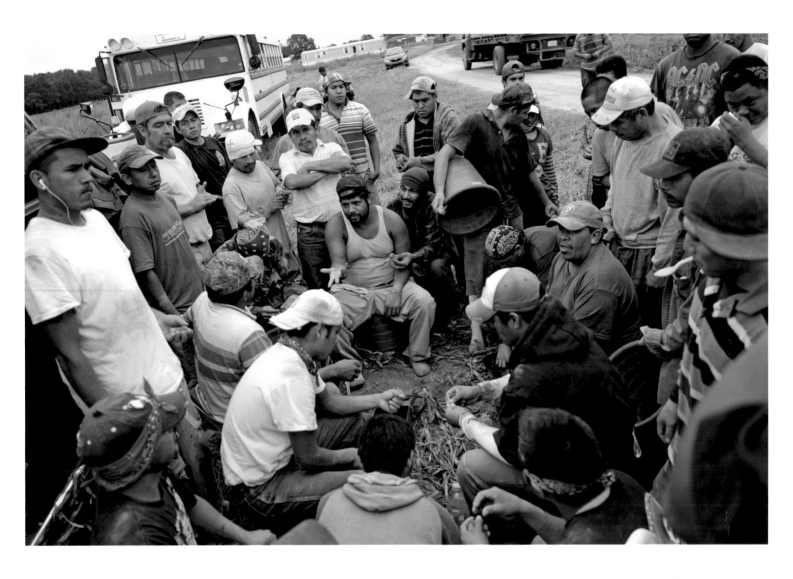

After clearing a field, sweet potato pickers take a break, Kinston, North Carolina.

At this migrant camp in Rantoul, Illinois, most workers are Mexicans who
come to work in Illinois cornfields from homes in Rio Grande, Texas.

Public toilets, migrant camp, Clinton, North Carolina.

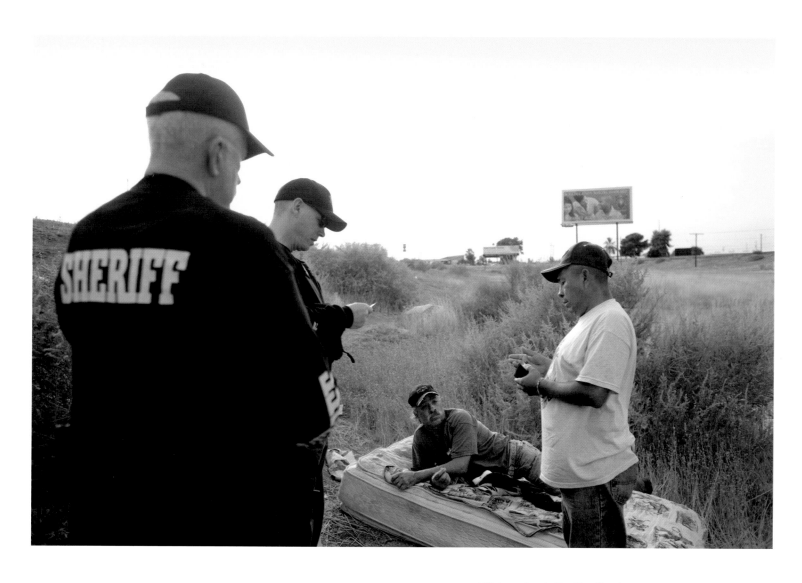

A Maricopa County Sheriff's office deputy stops to check the identification
of two men resting on the side of the road, Avondale, Arizona.

For nearly ten years, Ortiz has been looking closely at youth violence in his hometown of Chicago, and he's photographing youth violence in Philadelphia as well. He documents all-too-frequent incidents of gun violence where gang members shoot one another and bystanders are also killed. He visits grief-stricken families in the aftermath of these tragedies. "Sometimes," he says, "I just knock on their door and talk to them, asking if I can document their situation. I know it's the worst day of their lives—they're burying their children." Many of the families are touched by his solicitude and want him there. Later, he gives them photographs. They welcome something to hold on to that might help them cope with their loss.

He has been turned away once or twice, "but gently," he says. "I think those particular families were stressed out because they were probably going to retaliate, and they didn't want people in their business. I never want to push. A lot of this is about listening to people and reading what they are saying to you."

One day Ortiz visited a street memorial in West Humboldt Park for a boy killed on his fifteenth birthday. It was raining, nothing was going on, so Ortiz photographed and left. Twenty minutes later, a twenty-one-year-old man was murdered by a policeman on that exact corner. Ortiz gets himself into precarious situations occasionally. "Nothing to the point where I'm in grave danger," he says. "I just basically take my time and figure out when I have to get out." Ortiz hadn't realized that the boy's memorial was located at what was then considered one of the most dangerous corners in Chicago.

What is the source of such tragedy? Why are young people dying this way? Ortiz believes that problems start early. "Kids go to school tired and almost malnourished, some not eating breakfast. They go to underfunded schools with too many children in a classroom. On the way home they pass memorials for people who have been killed, corner stores that carry only frozen pizzas and junk food, abandoned buildings. Under this kind of stress, any little thing somebody says can trigger a fight.

People get arrested, they have friends who have been killed. Nobody seems to care." These young kids feel they have nothing right now and nothing to look forward to. Tragedy engulfs everyone, shooters and victims alike.

Ortiz collects mementos and cultural flotsam from the neighborhoods he frequents. "I collect candy wrappers, marijuana bags, the reward posters people put up. I get gifts from parents, eulogies, rest-in-peace T-shirts," he says. "I collect materiality, things I could never throw out. I fold them up and put them away. I don't know what to do with it half the time." The items find their way into exhibits and books.

While photographing these grim realities, Ortiz looks for resilience and optimism, for a sense of community in each neighborhood. "Chicago has hundreds of block parties during the summertime," he says. "They get permission from the aldermen and close off the block, and everybody comes out with their grills. They rent trampolines and Bozo dunk tanks. It's not always blight. We have block parties with marching bands to celebrate life in the neighborhood."

Ortiz sees no point in getting involved politically in gun control. "My thing is getting people to empathize," he says. "Saying you need to get rid of guns is just not going to work." He photographs his stories in black and white. He deepens the blacks and a brings out a range of grays, seeking specific technical, aesthetic, and emotional results.

Ortiz likes the timeless feeling of black-and-white photographs. It means something that a picture could have been made in the 1930s or now. Days of talking and analyzing and looking at photographs with Facing Change colleagues have strengthened his desire to think historically. "The issues photographed by Gordon Parks in Harlem, in Chicago, haven't changed," he says. They've been inherited by the Great Depression's grandchildren. "The neighborhoods are still segregated. The faces might have changed a little bit, but the same problems are there."

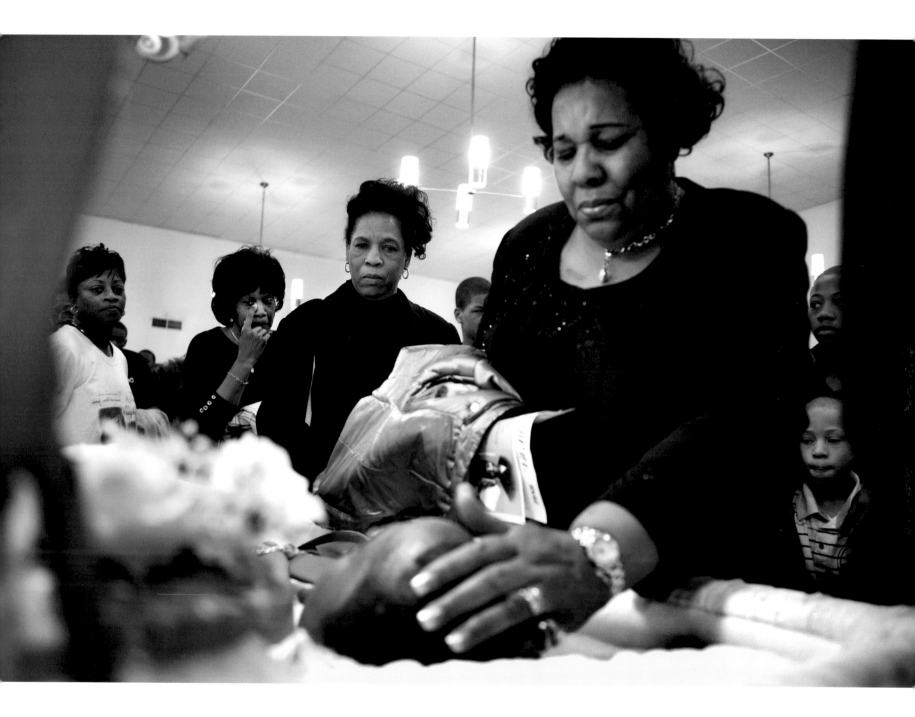

Mourners gather for the funeral of Albert Vaughn, a Chicago public school student beaten to death with a baseball bat.

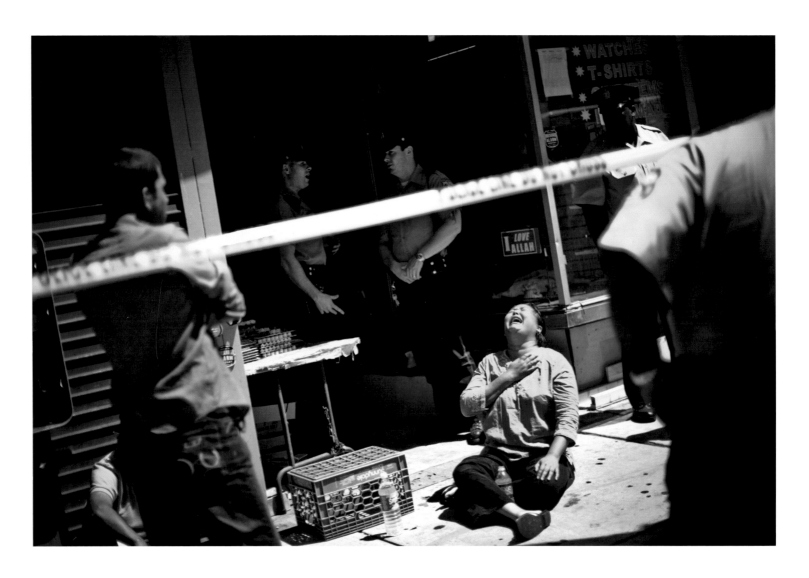

The mother of Fakhur Uddin collapses and weeps as police investigate the murder of her son. Uddin, a twenty-year-old college student, was bound with duct tape and shot in the back of the head inside his family's store in Germantown, Philadelphia.

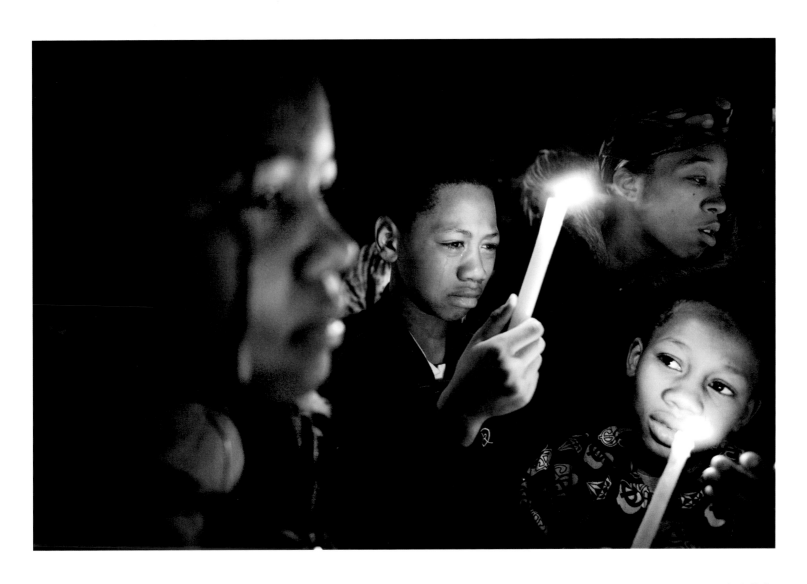

About fifty people gather in remembrance on the Chicago block where Albert Vaughn was killed. Vaughn was known as Little Al, the neighborhood guardian. He was the older teenager who would play ball with the younger kids and try to keep them safe from trouble.

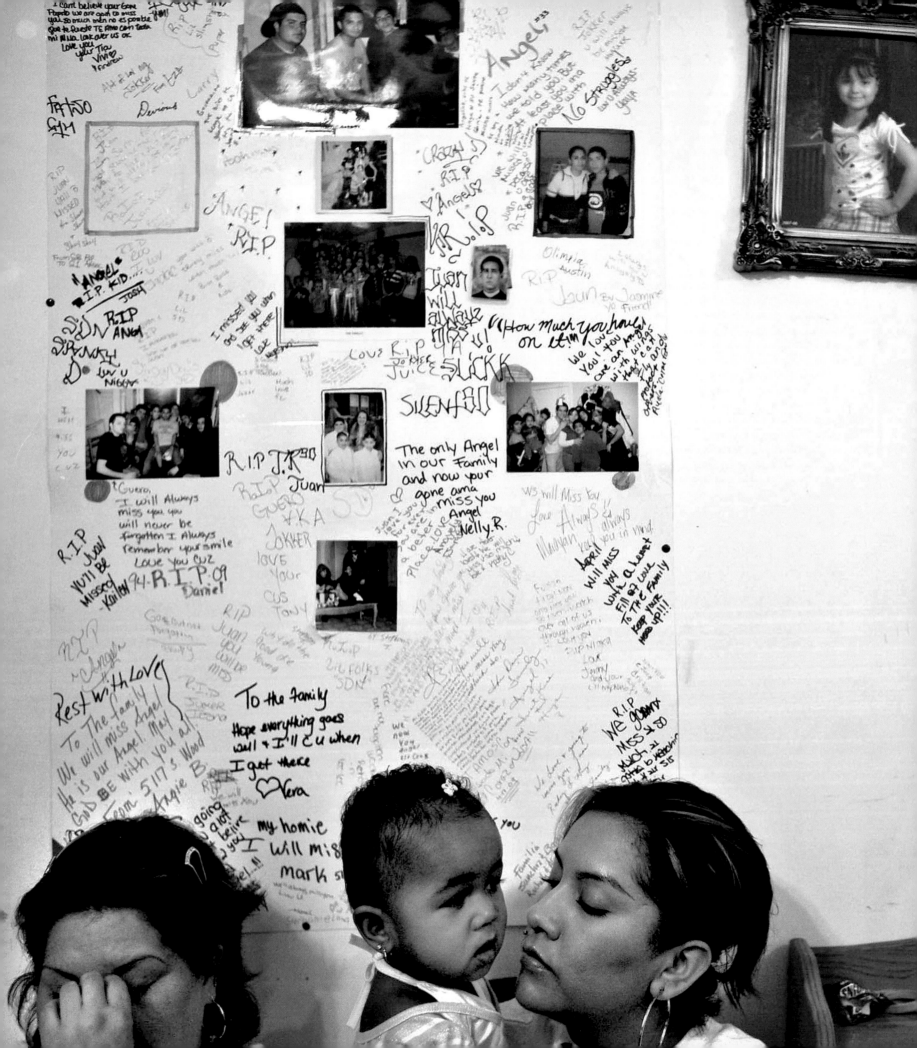

In their Chicago home, the Cazares family mourn the death of their fourteen-year-old nephew, Juan, who often played basketball at Cornell Square Park in the Back of the Yards neighborhood. Family members believe the eighth grader was killed because he was hanging out with the wrong people.

123

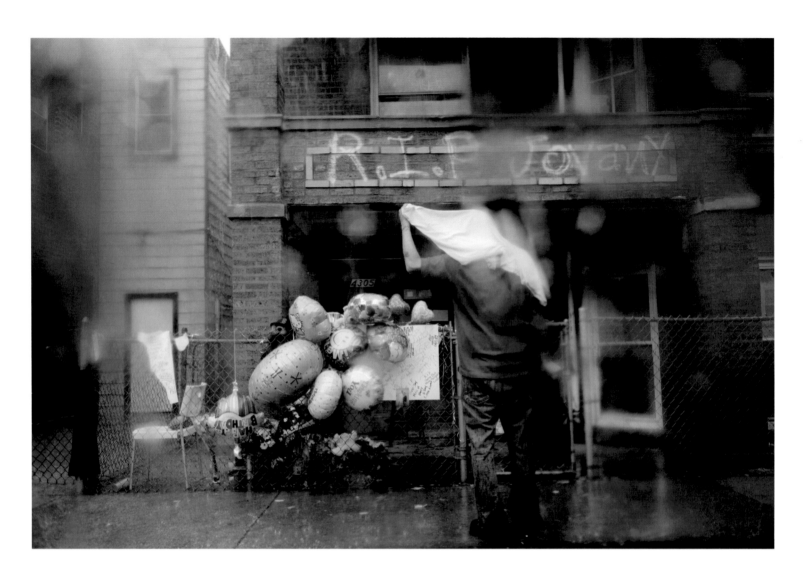

This memorial is for Jovany Diaz, who was celebrating his fifteenth birthday when he was shot and killed in his West Humboldt Park neighborhood, Chicago.

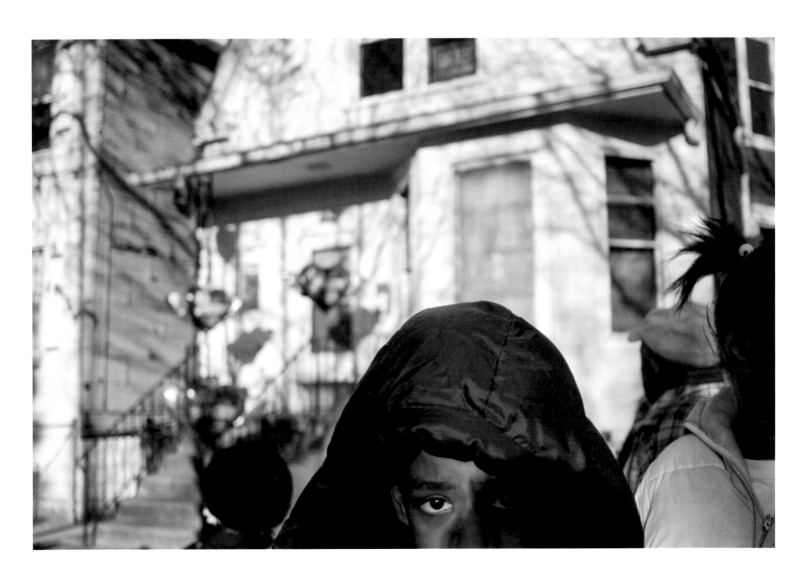

A boy stands in front of the Reed residence, where fourteen-year-old honor student Starkesia Reed was shot and killed. In Chicago, children in the Englewood neighborhood are more likely than children in other neighborhoods to suffer injuries due to violence.

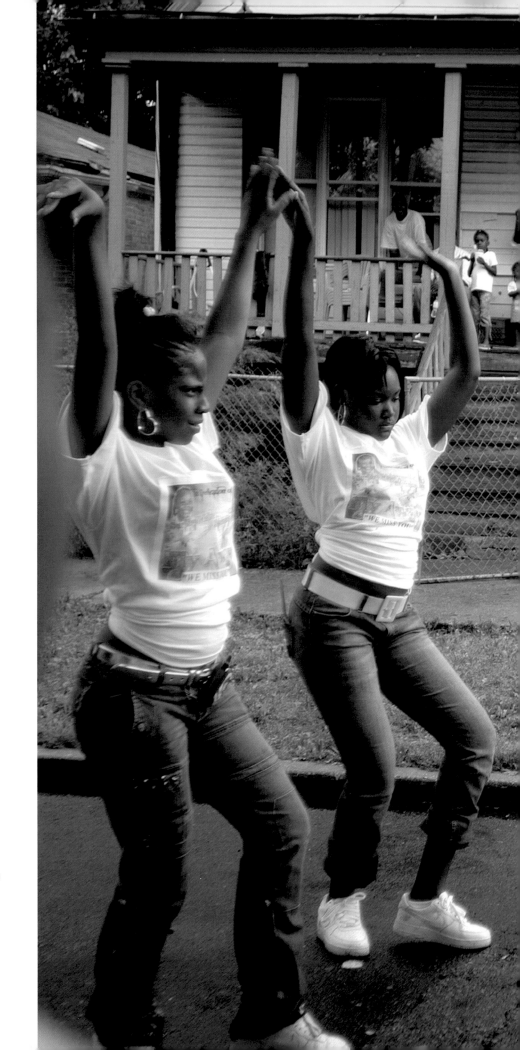

Girls in the Englewood neighborhood on Chicago's South Side memorialize the deaths of Starkesia Reed, fourteen, and Siretha White, twelve. The two young girls were killed days apart in March 2006. Their mothers grew up on Honoré Street where the block party to celebrate their lives took place.

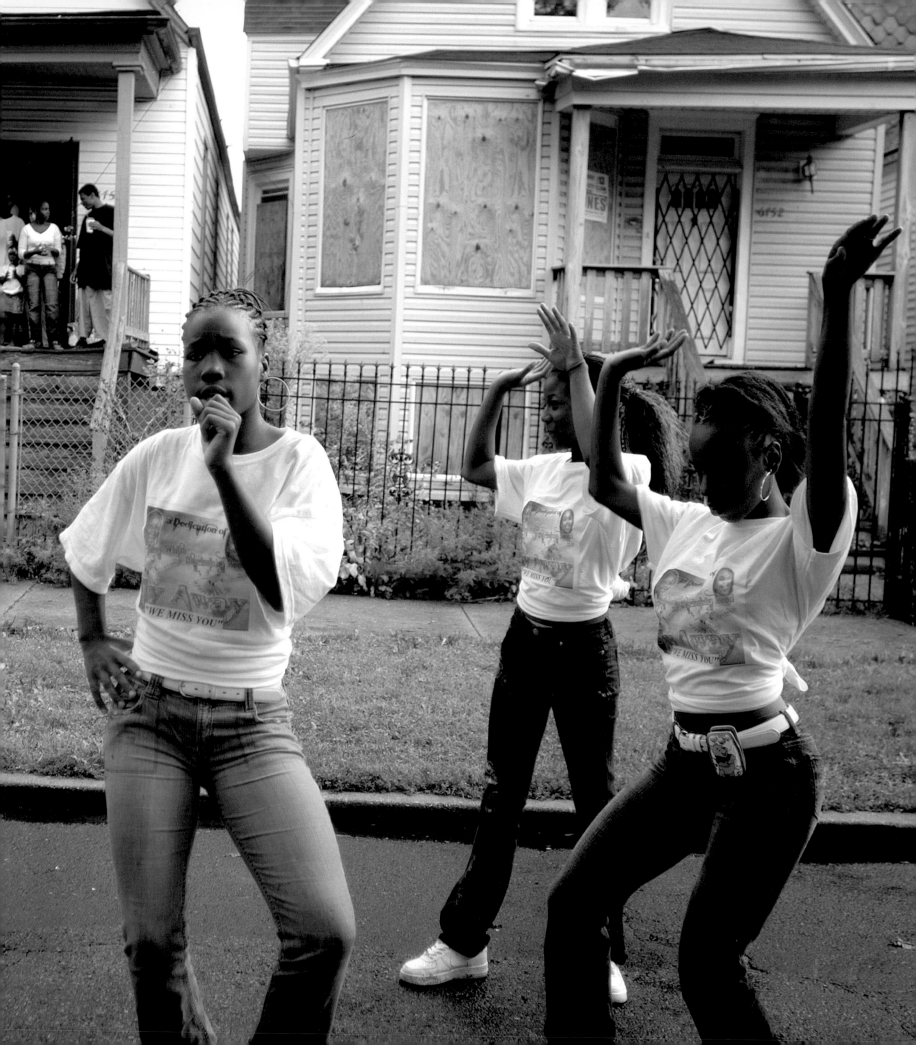

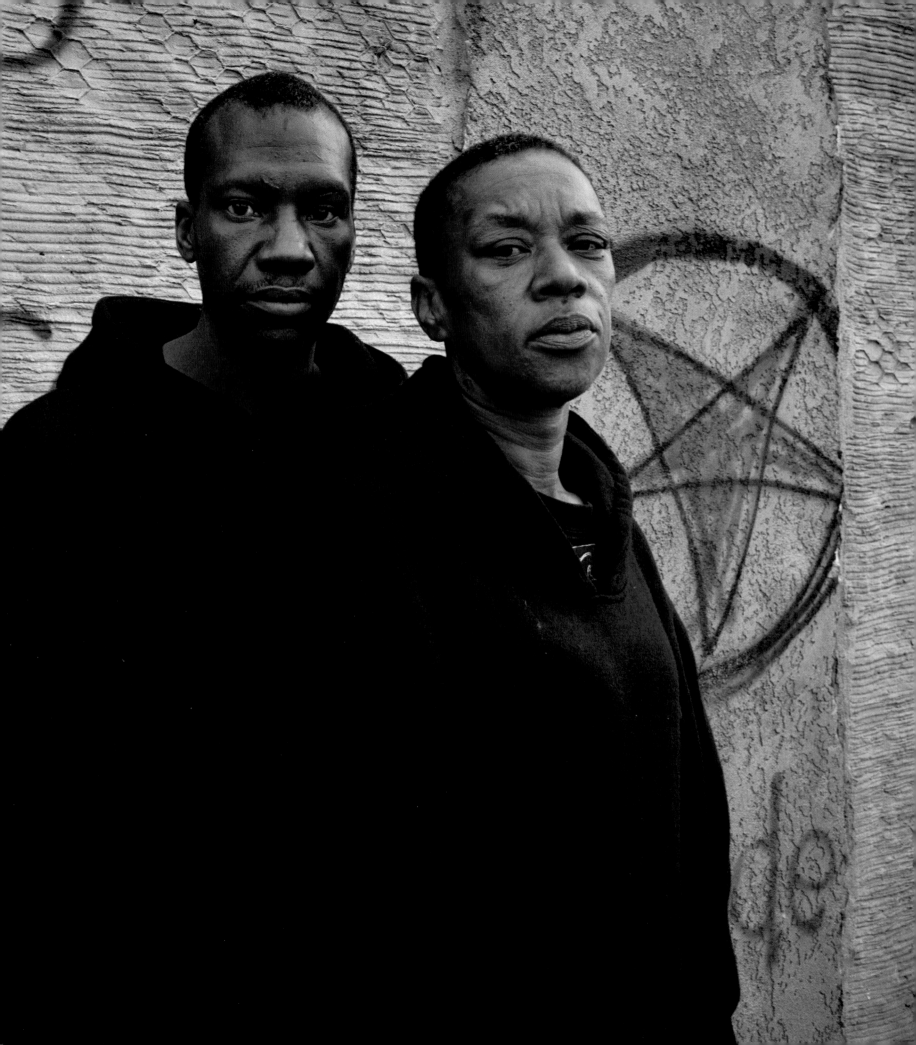

FLATLINES: CRIME ON OAKLAND STREETS

Photographed by Stanley Greene

A flatliner is a person who is dead or may as well be dead. The word refers to the straight line on a heart or brain monitor indicating that the organ in question has stopped functioning. Stanley Greene's Flat Liners documents people on the uncompromising streets of East Oakland. The potent label suggests a desolate life-and-death world where survival isn't guaranteed. Greene knows that world. He cares about people who have gotten a raw deal, and he has little patience for people who don't care.

Gangsters and activists lived on Oakland's International Boulevard in the 1970s. Greene was there then, a member of the Black Panthers and Vietnam War protester. He recently went back to the neighborhood to take pictures. "On International Boulevard shoot-outs and death happen at the drop of a hat," he says. "One kid told me, 'I don't go out the front door unless I've got some kind of metal on me, like a gun—anything.'"

When Greene, camera in hand, visits the neighborhood today, he relies heavily on past experience. "These guys are not stupid. They knew right away I understood what was going on. It's all about body language. It's all about how you approach them. If you walk up there and say, Hey, can I take some pictures? How you feel about it—you okay with this? They'll go, I don't know how I feel about it, but you going to make some money on my ass? And they're curious about maybe becoming immortal."

Every person has a story and Greene is interested. "People talk," he says. "People don't want to pass into the next life without somebody acknowledging they were here. They

Opposite:

Terrance is thirty-nine. He was shot four times, the victim of an attempted robbery at a place where he worked called Price Retail. He had no medical insurance. After a long hospital stay and then rehab for twenty-one months, he finally emerged with no job, no money, and addicted to painkillers. Talking with Greene, Terrance said that he survived as a mule for drug dealers, was busted, and went to prison. By the time he got out in 2010, Terrance was addicted to heroin and forced to live scavenging on the street. That's where he met Rayette.

Rayette, age forty-three, had a nervous breakdown after the death of her mother and father. She started doing drugs, was picked up for possession of a nickel bag of pot, and spent three years in the county jail. When her time was up, she found employment as a taxi dispatcher and took night classes at a community college. This led to a new job as a hotel receptionist. But she suffered from depression, and she finally lost the hotel job. Rayette then got work as a housekeeper but was soon rearrested for dealing street drugs. For that, she spent four years in state prison. When she got out she had another breakdown. Her condition grew worse during hospitalization. When she was released, she was stranded and lost, again living on the street. Rayette became addicted to crack.

want to share something, make a mark: I'm not just this guy with a bunch of tattoos or I'm not just a killer. I've got principles, man. I don't believe in shooting bystanders or beating up on women—you know, principles."

Greene's local contact explained an old-timer's philosophy for minimizing casualties: "If you've got a problem with somebody, if a guy is tagged or marked, he must have done something. You walk up to him with a gun and shoot straight in the head. It's done. Walk away. No one else gets killed. I really can't understand these little gangbangers who go out with machine guns and shoot little babies. We didn't hurt innocents." Sometimes Greene leaves a scene thinking, "Jesus Christ, these people are crazy," but he respects his subjects and pays homage to their honesty.

Two fundamental ideals drive Greene's work—a passion for social justice and a sensibility to the arts. His zeal for both are expressed in his work in this Oakland neighborhood where people have so little chance in life. He's captivated by the way Walker Evans looked at language. "I love the idea of signs. I love symbolism," he says. "One of the great things about the Farm Security Administration and the photographers of that period—they were responding to graffiti and signage, which was then modern." Greene is intrigued by the way modern seeing becomes history.

"So when I saw this guy with his baseball hat and his Hitman shirt, I just said, Wow, that's pretty cool." The man wearing the Hitman T-shirt opened up to Greene, and Greene saw a person who was hurting. "It's important not to let the camera get in the way," he says. "One of the problems with digital is you take a picture and you look. You break your contact with the subject. If you turn your screen off, you are able to keep your eye on the subject. You are having a dialogue."

Powerful content in a photograph isn't enough for Greene. He doesn't like extraneous clutter that interferes with the aesthetic strength of an image. He wants his pictures clean. Structure matters. One of his photographs shows a woman selling drugs. She's being confronted by a man known as "the mayor."

He controls this block and is trying to collect "rent." It's an intense confrontation. The man leans in and makes his point: "You want to sell drugs here, you got to give me a piece. Give it in drugs or give it to me in money. You've got to give up something."

There's an orange bag in the frame. It's distracting, but Greene takes the picture anyway. "You don't know what will happen. These people may go off in a second. You try to get as much into the picture as possible to give a sense of place, but at the same time your eye is moving. You can get away with some imperfection but there's a limit." Greene is ambivalent about this image. Do you keep it or let it go? It's a powerful moment but it's flawed. He made another photograph that includes more elements and works better structurally, an image that is, in his words, "busy with reality."

Greene says even a person familiar with Oakland street life needs a "tour guide." He once had connections back in the day with "the mayor," and Greene approached him. "I was shocked that he was so open with me, taking me to meet people," says Greene. The mayor's reaction was, "What are they going to do? They can't touch me. I've already done the time."

Greene is haunted by the physical threats facing his Oakland subjects and by the financial traps they fall into. He describes "loan sharks" who offer easy money to people not eligible for bank credit. The money allows poor people to buy furniture and appliances, and they pay it back in installments. Yet purchasers often don't realize how overpriced the items they buy are, and if they don't read the fine print on contracts, they may not realize how high interest payments will shoot up if they miss a payment. One ill-advised purchase and they can be wiped out.

These financial schemes, so enraging to Greene, are not particular to Oakland or to today. They have been common in poor communities nationwide for many decades. An October 16, 2014, *Washington Post* story by Chico Harlan, "Rental America: Why the Poor Pay $4,150 for a $1,500 Sofa," describes the practice whereby even retail stores become the "loan sharks," and "a used

Greene sees meaning in calligraphy, and he appreciates its appearance in photography.

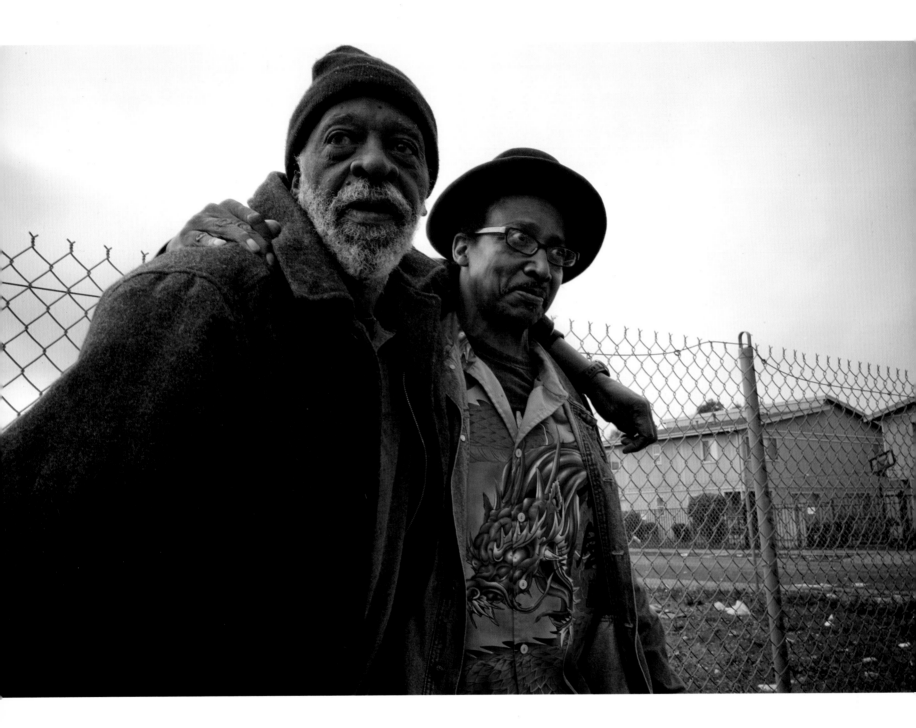

Ronnie (left) is sixty-four years old. When he was twenty-three, he bought a night club. The place was called Name of the Game. "Back in the sixties it was the in spot," Ronnie says. "All the major players hung out there." Today it's a car wash on International Boulevard, where Ronnie is known as "the mayor." He helped Greene get access.

Diamond, Ronnie's companion in the photograph, is fifty-nine. "We practiced diplomacy," Diamond says. "We had skills. We knew when to draw our weapons, and we kept them clean. No drama; it was strictly business. I was never in jail long." Since age eighteen, Diamond has worked the Boulevard. "I always give them what they want—sex, drugs. The customer is always right."

32-gigabyte, early-model iPad costs $1,439.28, paid over 72 weeks. . . . A Maytag washer and dryer: $1,999 over 100 weeks."

Greene photographs in black and white and in color. He says digital is great for color, but he doesn't like it for black and white because it doesn't give the deep, rich blacks he wants "without taking it to such an extreme that it becomes a cartoon of its former self."

As a student years ago, Greene went out at night with his Leica. "I photographed the music scene, all my friends, the punk scene. Pictures were blurred, subjects were cropped. In art school where we used large-format cameras, those pictures wouldn't have been acceptable. With digital they would have been deleted." Though he uses digital technology nowadays when it serves his purposes, he's wary of it. "I can't touch digital the way I can touch a negative," he says. "When you have to back something up with fifteen hard drives, doesn't that say something?" Despite the plethora of digital pictures being produced, he speculates, "We'll end up with more pictures from the twentieth century than the twenty-first because so much is getting deleted."

Greene searched hard before he found his photographic calling. In a conversation with Michael Kamber for the *New York Times* Lens blog, he said, "I wanted to be a musician. I wanted to be Jimi Hendrix, but when I heard Jimi Hendrix I realized I could never touch him. I wanted to be a painter, but Matisse and all those guys were ahead of me. And I wanted to be a writer but, you know, Richard Wright and all those guys. . . . I looked around and there was Gordon Parks and Roy DeCarava. . . . I knew I could bring something." When Greene met photographer W. Eugene Smith, he took up photography seriously.

Greene has photographed in war-torn Chechnya, Iraq, Afghanistan, Somalia, Croatia, Kashmir, Lebanon, and lately, eastern Ukraine. He has photographed life in America from New Orleans to Detroit, Route 66, and California. His 2010 book, *Black Passport,* brings together the inseparable parts of Stanley Greene—his work and his life, his art and his drive to uncover injustice. He says, "I am out there to go as far as I can go."

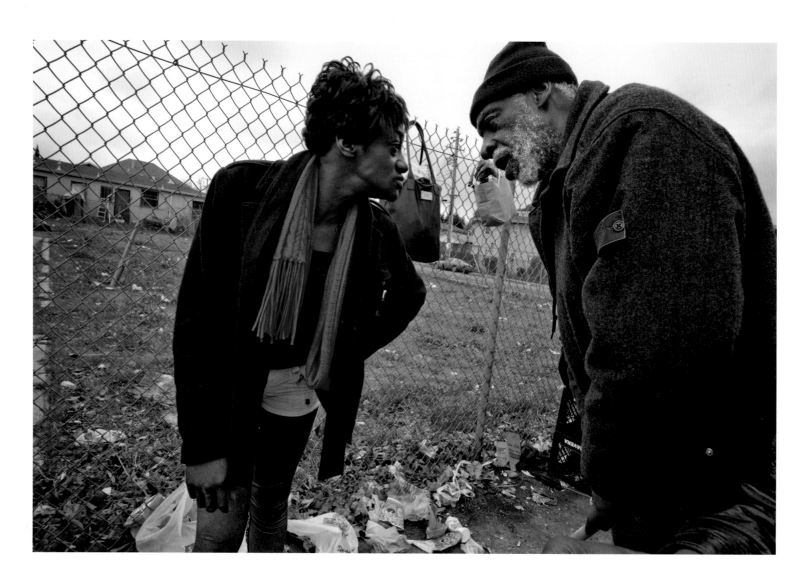

Greene steps in to document an intense confrontation. However, he feels the hanging orange bag clutters the image, and he remains unsatisfied with the photograph.

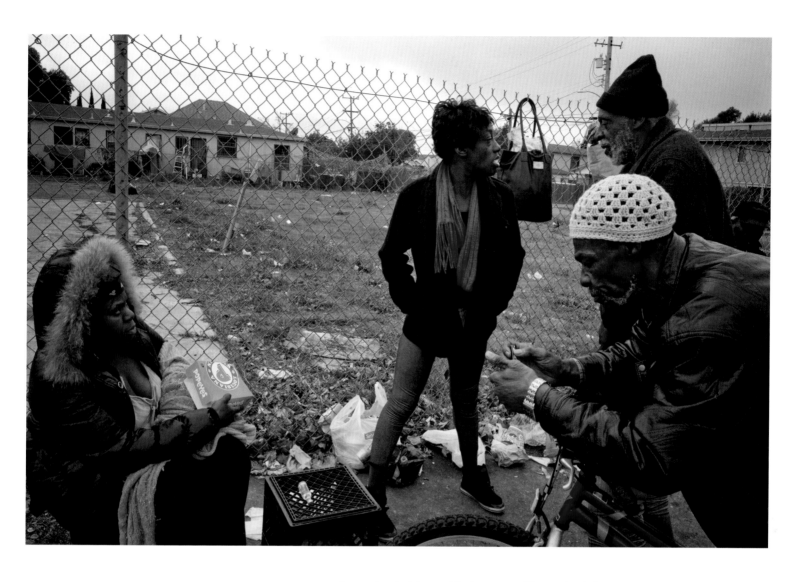

Greene steps back to record the larger scene. Photographically, he prefers the more complex arrangement.

This mattress, outside a children's play yard, is used by prostitutes for everything but sleeping.

An East Oakland man says, "What you need, I got it. Just show me the green."

Tyeshia Anderson, twenty-nine, used to live in stolen cars and under bridges. After living like this for years, she was eventually arrested for prostitution, but she managed to change her life. Now Anderson is a self-employed hair stylist. She spends her time talking girls out of the life. She is trying to get her boyfriend, an addict, off drugs. Her main joys in life are her two kids, Shalimar, three, and Orlando, five.

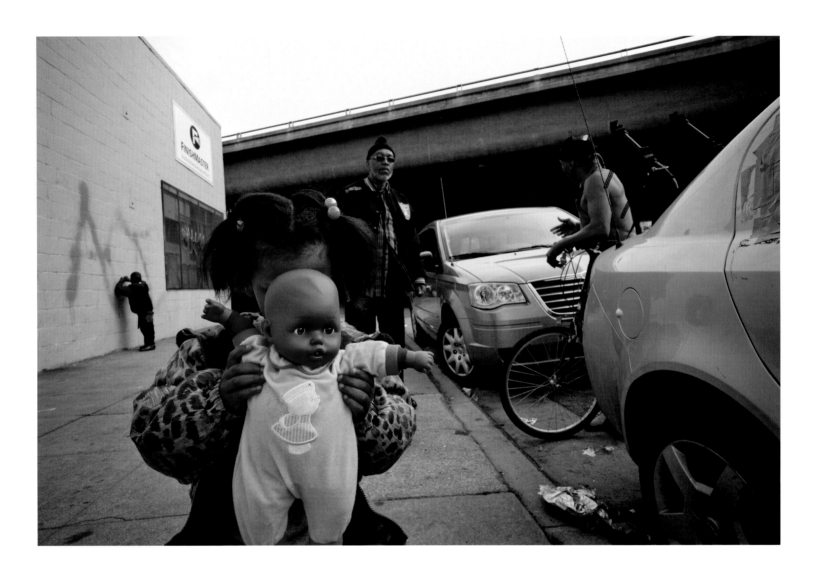

Tyeshia Anderson's daughter.

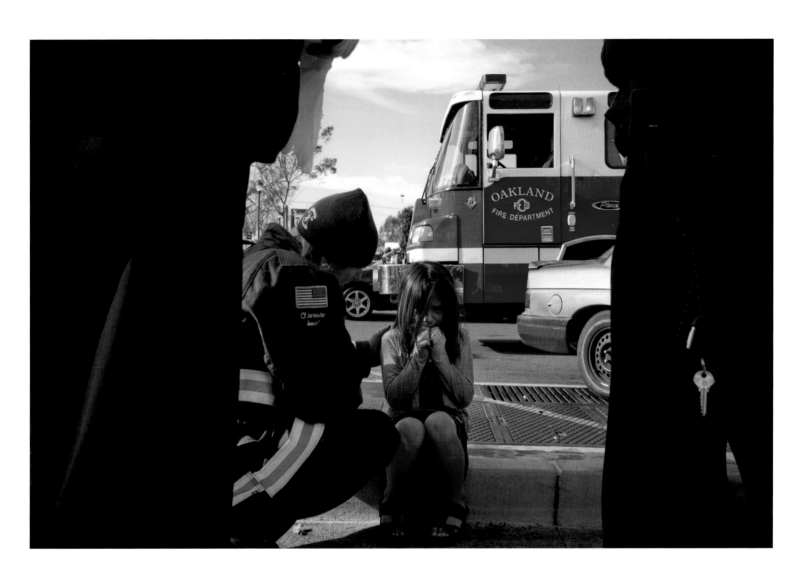

Fire and emergency services help a frightened little girl who, crossing an Oakland street, became the victim of a "clip and run."

"Little James" (right), alias "Spooky," explains in a group meeting, "They do not show you how to deal with feelings in foster homes, so you turn to the gangs."

Twenty-four years old, Donald did time in prison for robbery and for crack and cocaine possession. Donald was recently paroled to a seven-step recovery program and has become a born-again Christian. His childhood was painful: his mother, an alcoholic, was abused; his father, a drug addict, beat him. "Life is as hard as you make it," he now says. "The only thing in life I am afraid of is God, 'cause he made me and he's the only one who can take me out."

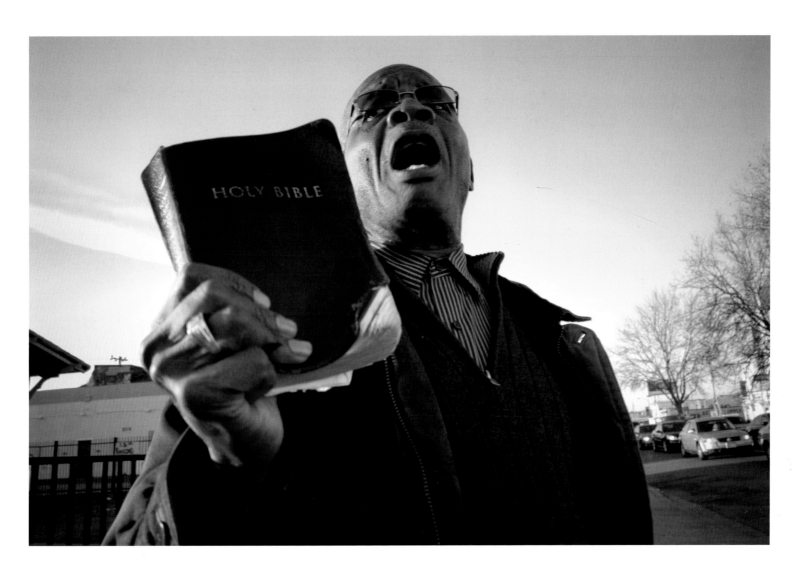

A street preacher on International Boulevard says, "There is a thin line between heaven and the street." It may seem to the casual observer that, as Greene says, "he is speaking to the not-listening masses," but some do turn to religion for help.

The Deacon, age fifty-nine, and TCinque Sampson, age fifty-seven, are former street enforcers for drug dealers in Oakland. The Deacon was never busted. While an enforcer, he became a part-time barber, and now he barbers full-time. TCinque Sampson did twenty-two years in prison and now is a filmmaker.

MIDWESTERN AMERICA

Photographed by Danny Wilcox Frazier

Danny Wilcox Frazier comes from a small Iowa town on the Mississippi River not very far from John Deere's world headquarters. In the mid-1980s, when Frazier was a teenager, a farm crisis devastated the midwestern economy. A complicated cascade of unexpected events and unwise choices had led to catastrophe. Farmers had taken too much risk and incurred too much debt. They had overproduced as US trade policy changed. Land values fell, banks failed, foreclosures rose, and thousands were forced into bankruptcy. "We lost thirty thousand manufacturing jobs, and most of the people who lived in my hometown of LeClaire were suddenly out of work," Frazier recalls. "All I thought about was escape. I didn't want to be trapped in that town."

An opportunity to study in Nairobi offered the escape Frazier was looking for. The time he spent in Africa enlarged his worldview, but it also opened his eyes to the realization that he would always be connected to the culture of the Midwest. He decided to focus on marginalized communities at home, on individuals and families who struggle to maintain their way of life.

At first, Frazier photographed in both color and black and white, but he was dissatisfied with the color. "Everything was lemonade and sweet corn, an idealistic green, a blue sky expanse beyond this flat land. But that isn't what it is to me. It's hard work, it's grueling, it's bone-breaking work, and economically there's ups and downs. It's a really challenging place, always has been." It would take time before Frazier could tame color for purposes he deemed appropriate.

He began a black-and-white project he called *Driftless*. The ancient Driftless Area in the Upper Mississippi River Basin was bypassed by the last continental glacier. The land is rugged and geologically diverse, home to hundreds of threatened and endangered species. For Frazier the word *driftless* also refers to a state of mind. "To me *Driftless* is a lot about standing and watching the Mississippi flow by knowing there is so much more out beyond and you're stuck."

By this time Frazier himself had a purpose: "I want people to connect to the emotional landscape that is the Great Plains, the area of the country that is depopulating at a faster rate than anywhere else," he says. The reasons for depopulation are complex. Mechanization means that not nearly as many people are required to farm the land, which in turn means the need for services—education, health, entertainment, retail, and commerce—are a lot less than before. The emotional landscapes Frazier refers to are expressed in the characters he photographs and in the disconnections that sometimes occur visually within an image, creating emotional tension.

The fragmented feeling is strong in his picture of Jumping Rock, a popular party spot along the Iowa River. "A lot of drownings happen here," he says. "People go, drink and use drugs, jump

Opposite:
Gabriel Stutzman, the youngest of nine children, collects eggs on his Amish family's farm near Kalona, Iowa.

and do flips off the rocks into the Coralville Reservoir." Frazier works close, loves the intimacy, and having grown up on the Mississippi, knows this kind of pastime well. "A lot of drownings happened where I grew up," he says. "We drank beer in high school and would go off the rope swing." The scene at Jumping Rock is for Frazier what a rural summer day is all about.

Frazier's photographs shed light on how traditional Midwest occupations have fared in recent decades, which is to say, not well. Small-town slaughterhouses are a case in point. "In the 1950s they used to be everywhere," Frazier says. "The country butcher took it from live animal to the two halves that constituted the final butchered product. You don't have that anymore in the corporate slaughterhouses. Everyone has a specific cut. Someone kills, someone skins . . ." Frazier mourns the loss of a way of life this small enterprise represents and points out that large corporate slaughterhouses are much worse on the environment.

In 2003 Frazier photographed an Amish farm near Kalona, Iowa. In families like the Stutzmans', children have an active role in farm life. "They wake up at the crack of dawn, and they work before they go to school," Frazier says. "Gabriel, the youngest of nine children, collects eggs every single day, and there's much more he and all those kids do. Many farm children choose not to farm when they grow up because it's hard, hard work." Frazier looks for what he calls "the haphazard details" that reveal the plight of his subjects. "The tear in the towel hanging on the line. This family is poor. They struggle."

Frazier found the scene at the Bakken Oil Field in the badlands of North Dakota extremely disturbing: "If this is the solution to the problem of the Midwest, then in my opinion let's keep the solution out. Manual labor is where I come from. These men work hard, they destroy their bodies, and they are grossly underpaid when you look at the profits the oil companies make."

Frazier was lost. Near Cactus Flat, South Dakota, he drove down a dirt road, past the Minuteman Missile National Historic Site, and saw a ranch with dilapidated buildings. He pulled in, and the couple who lived there welcomed him. "You know, I still stay with them when I'm out there," Frazier says. "John Neumann was always working on tractors and pickups. What I loved about this photo is just his hand."

The Neumanns take in people who are having trouble, Frazier says. They let them crash and offer them work on the ranch. Here, a guest worker sleeps in one early morning.

Rusty Caudle is a bull rider and a farmhand in North Liberty, Iowa. Frazier says, "People who do physical labor are going to be physically strong. It's not just about men. It's about the strength of people who do manual labor—men and women."

In this Old Order Amish settlement near Kalona, Iowa, an Amish family walks to church on Easter Sunday.

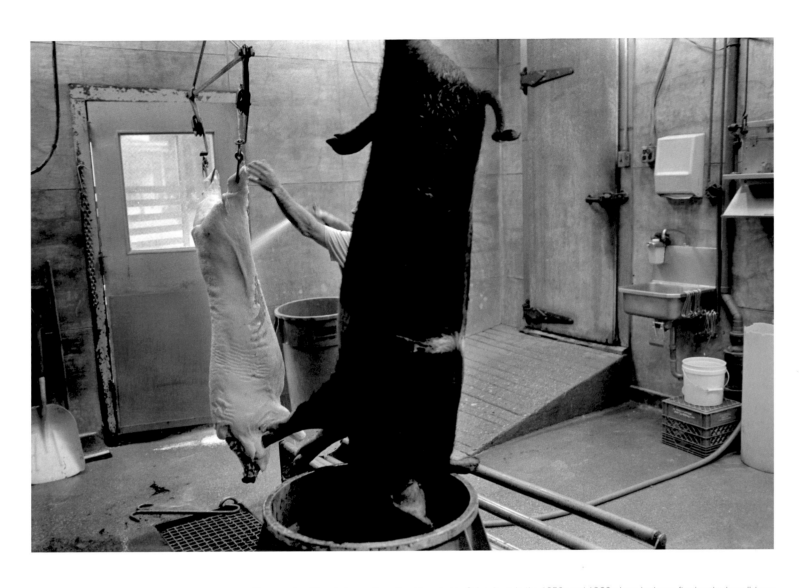

Pigs are slaughtered at a small meatpacking plant in Solon, Iowa. In the 1950s and 1960s, Iowa had over five hundred small-town butchers. Today there are just a third that number. "The country butchers process my deer for me," says Frazier.

The Sale Barn Café in Kalona, Iowa, attracts Midwesterners from across
the region, including horse traders like the Neumanns traveling from the
badlands to a horse auction. In the center, an Amish boy enjoys an ice-
cream cone. "It's just a classic café," says Frazier. "I grew up in these kinds
of cafés with my dad."

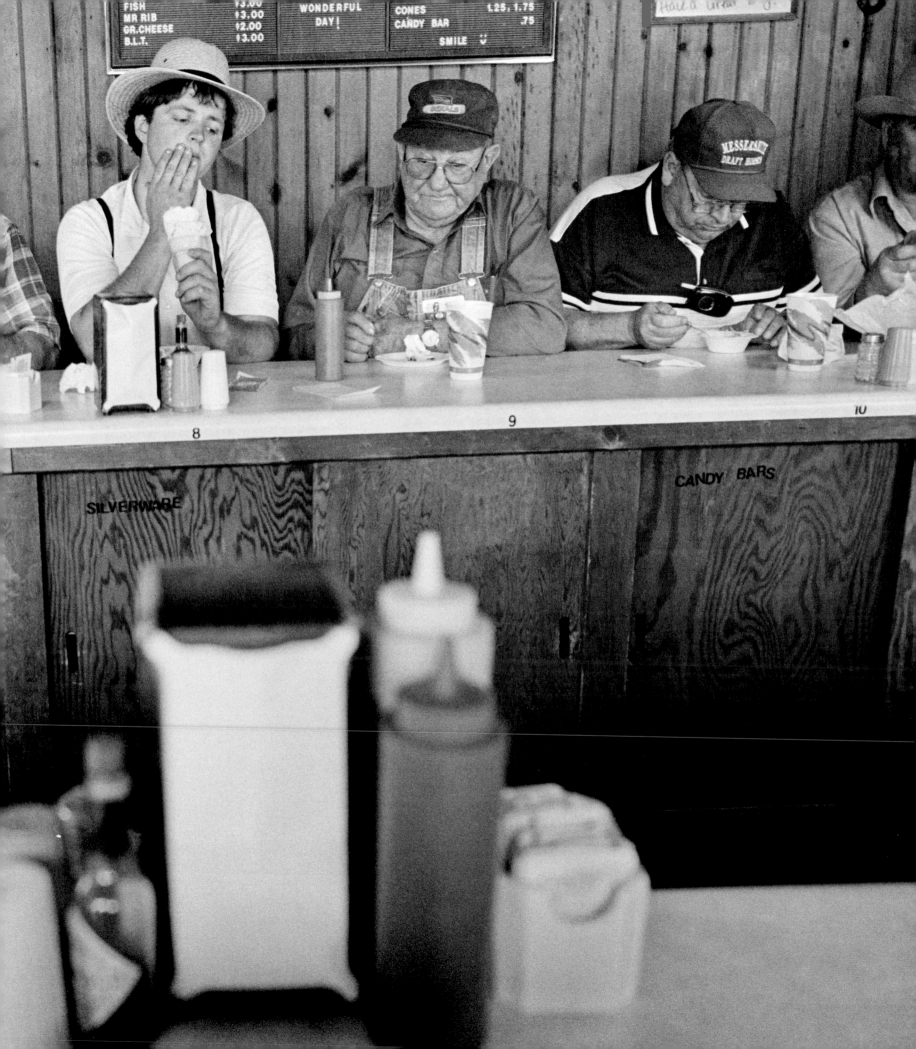

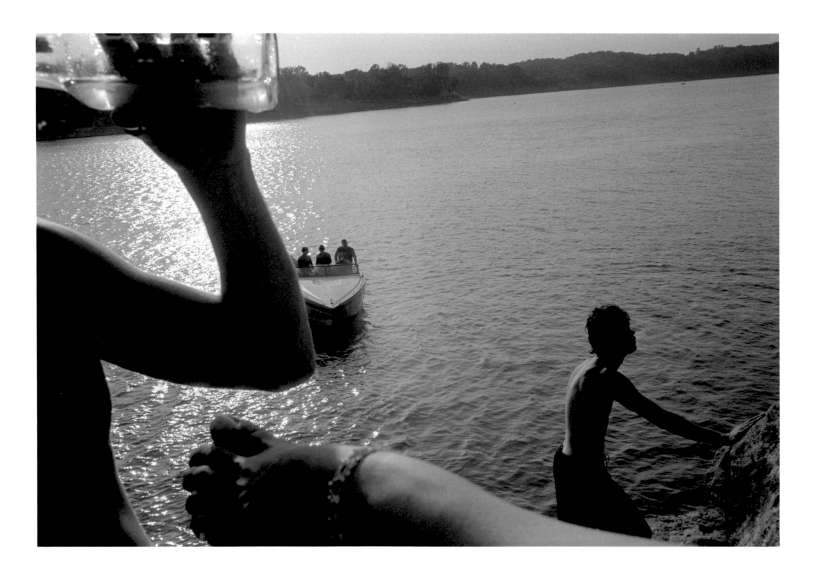

Teenagers drink and swim at Jumping Rock, a notorious party spot along the Iowa River. "A kid tried to swim across. He was coming back and he was drunk and he drowned," says Frazier. "I had to go cover that when I was a newspaper photographer right out of undergrad. That's how I found out about this place."

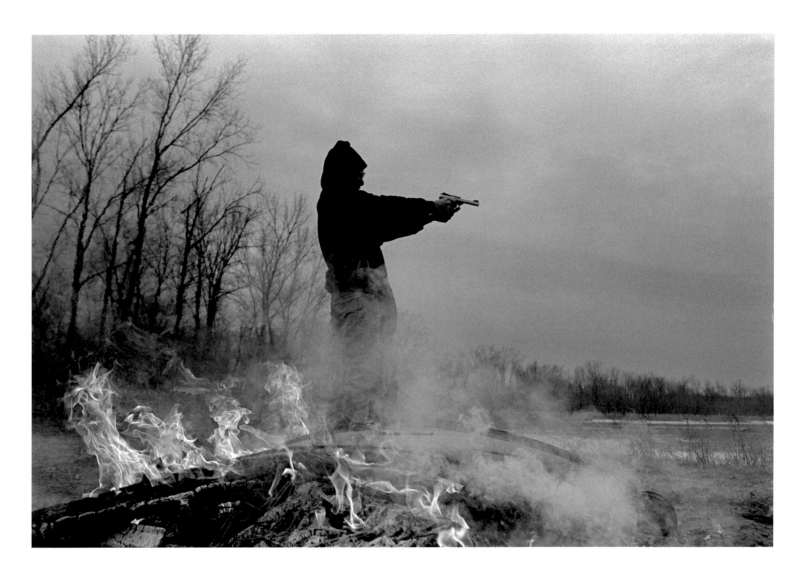

While shooting landscapes in the Hawkeye Wildlife Management Area, Frazier says, "I came across these guys along the Iowa River drinking beer, throwing cans out and target shooting. One guy started talking to me really intensely with a loaded gun and his finger on the trigger. I said, Hey, guys, thanks for the photo. He wasn't mad at me—he was just excited and thought it was cool that I photographed them."

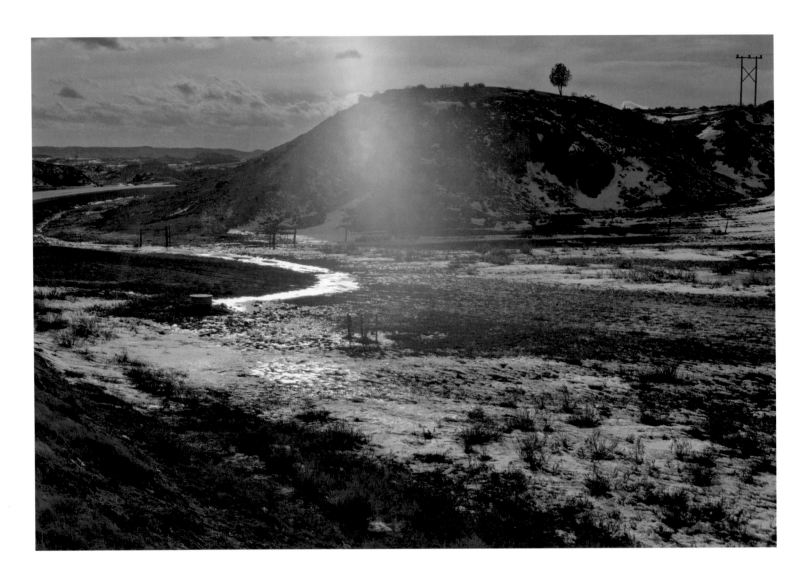

The Bakken shale formation is under the badlands of North Dakota, near Medora, where President Theodore Roosevelt, champion of America's national parks, purchased a ranch. "I'm looking southwest in this photo," says Frazier. "This is the very southern part of the Bakken Oil Field. There are oil wells to my east." Hundreds of thousands of barrels are extracted each day from the Bakken Oil Field by hydraulic fracturing, a controversial technique developed by the oil industry.

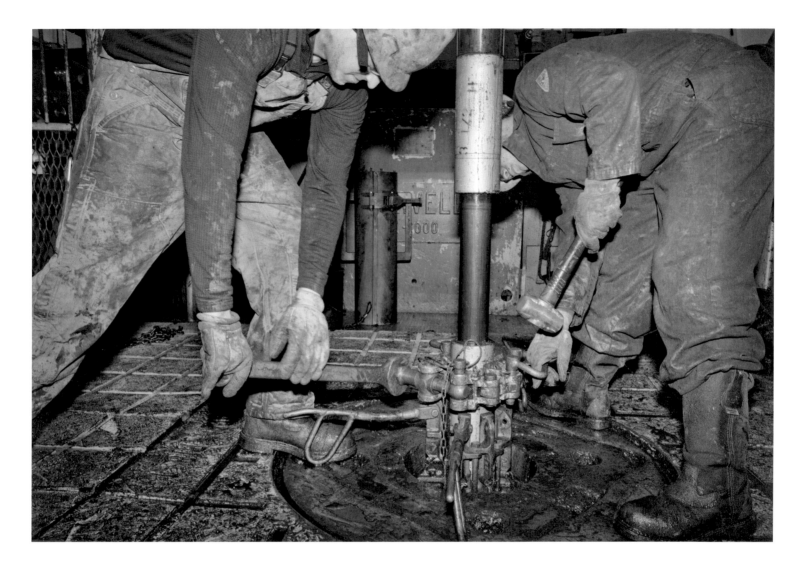

These workers, on the Raven Rig #1 near Watford City, North Dakota, make more money on oil rigs than they could make otherwise, so job seekers flood to this remote region. The oil boom in the Bakken shale formation shows no sign of letting up. "But the roughnecks are grossly underpaid in my opinion," says Frazier, "if you look at the profits the oil company makes. They are far away from their homes and families, and it's the only option they have. They are part of an environmental problem, but they aren't the guilty ones in this operation."

In October 2010 Frazier decided to go to Allen, South Dakota, a small town on the Pine Ridge Indian Reservation. He wanted to go, he says, because Allen is considered the poorest town in America. "As I drove in, being a white man, I was just as nervous as I've ever been—but not for my safety. I was nervous that people wouldn't accept me, wouldn't give me enough time to let them know why I was there, why I wanted to photograph. I respected the fact that they could just push me away as a white man." On the way to Allen, Frazier got lost and encountered John Waters, "a very proud Oglala Lakota." Waters invited him home, and Frazier accepted a cup of coffee and photographed Waters's little boy. "That, literally, is the very first frame I made on the reservation," he says.

He photographed the Lakota in both color and black and white. "I carry a ridiculous amount of equipment," he says. "Sometimes I have six cameras on me, some in bags. Sometimes I'll have about four on me. I look like that character from *Apocalypse Now*." In the moment, he picks up the camera that suits his vision, but he has begun to think this approach may be taking a toll on his lower back. "On *Driftless* I carried one camera, one lens," he says.

One day in fall 2011, Frazier said good-bye to his brother, who was departing with his unit for Afghanistan. Afterward he jumped into his truck and drove to Pine Ridge. "I planned it that way because I didn't want to go back to my regular world right then," he recalls. "The night I got there, John Waters's family—they've been great to me—asked me to do a sweat. That's a great honor—being an outsider and asked to be part of the sweat ceremony. And that day it was very special to me."

Frazier's empathy and respect for his subjects regularly turns encounters into enduring friendships. When he met Lakota activist Eileen Genise, she had been working with a suicide prevention program called Sweet Grass. "She is everything that is great about Lakota and everything that is great about human beings," Frazier says. He spent days traveling with her, learning about being a Traditionalist, "what it was like to be raised in a boarding school, not speaking Lakota, the loss of identity." The boarding school system enforced cultural genocide, Genise told him.

Nowadays the average age of farmers in Iowa is over seventy. "I need to document that," says Frazier. He is photographing towns with viable businesses and downtowns that have embraced immigration. "There are seasonal agricultural workers coming from Mexico and Central America on temporary work visas, and there are Hispanics staying permanently. There are a lot of West Africans. We have towns in Iowa where there is still meat processing. East Europeans and Russians. It's a very cool thing. This is where my work will be going."

The sun sets in the badlands of South Dakota, the home of the Oglala Lakota. The Lakota have long resisted the US government and continue their legal battle over the sacred Paha Sapa (Black Hills). Today, most Lakota in the Pine Ridge Reservation live in abject poverty in what is the poorest region of the United States.

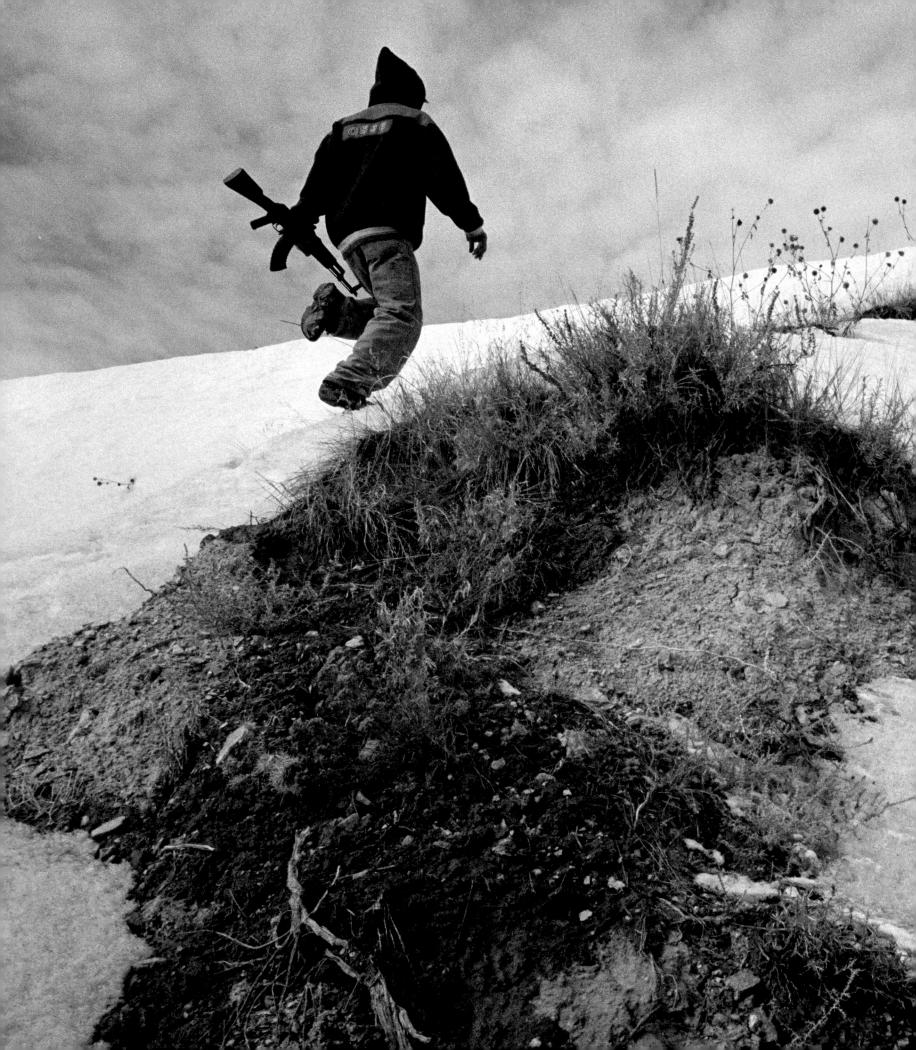

Hunting deer is an important part of life on the Pine Ridge Reservation. Some in remote areas depend on game for their regular diet. But for most, hunting is more for the sake of tradition than for survival.

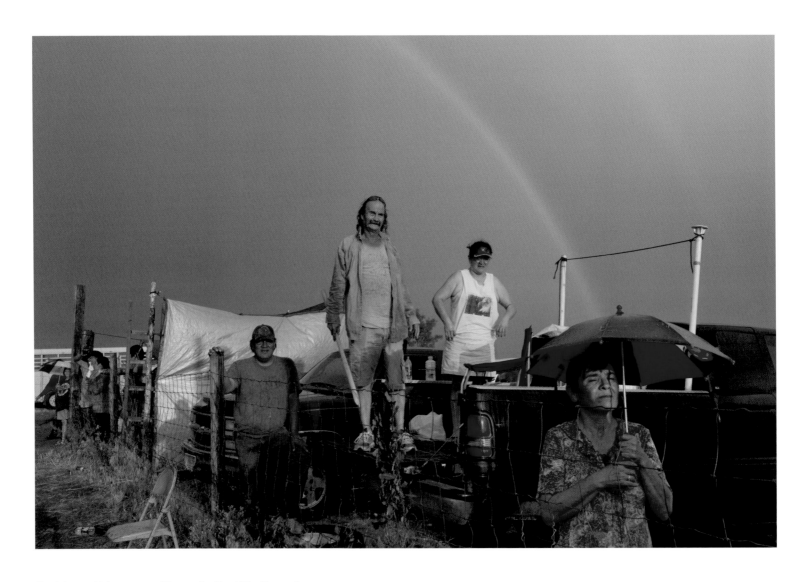

Spectators watch horse competitions on the Pine Ridge Reservation.

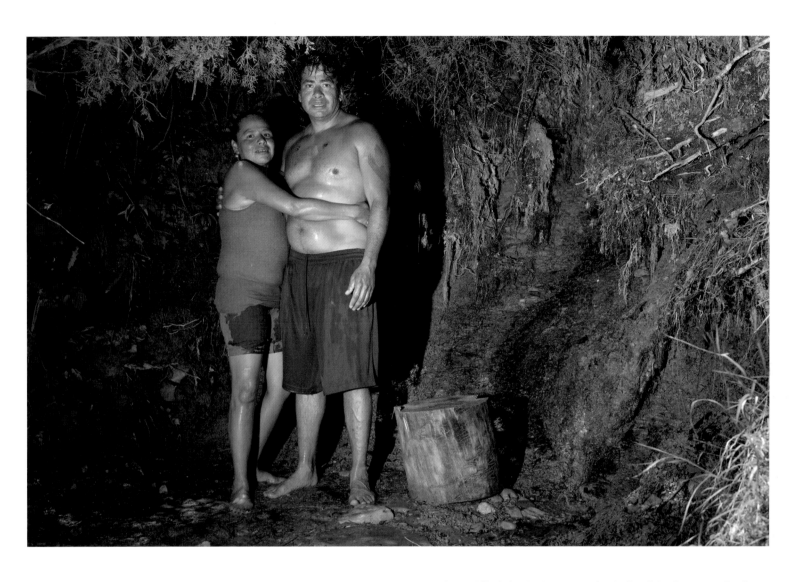

Lyle and Sheila Jacobs the morning after the Pine Ridge Reservation Sun Dance.

John Waters poses near his family's land on the Pine Ridge Reservation outside Allen, South Dakota. "I had been looking for the most troubled places economically in rural America, and my research told me Allen is considered the poorest small town," says Frazier. On his way there, he encountered John Waters on his horse. "John agreed to be photographed and invited me into the house for a cup of coffee. I began photographing John in 2008," says Frazier. "I made this portrait in fall 2011. It took a long time to capture something I really felt was who he is." Frazier injected structure in his complex portrait with an upright post carefully situated in the background.

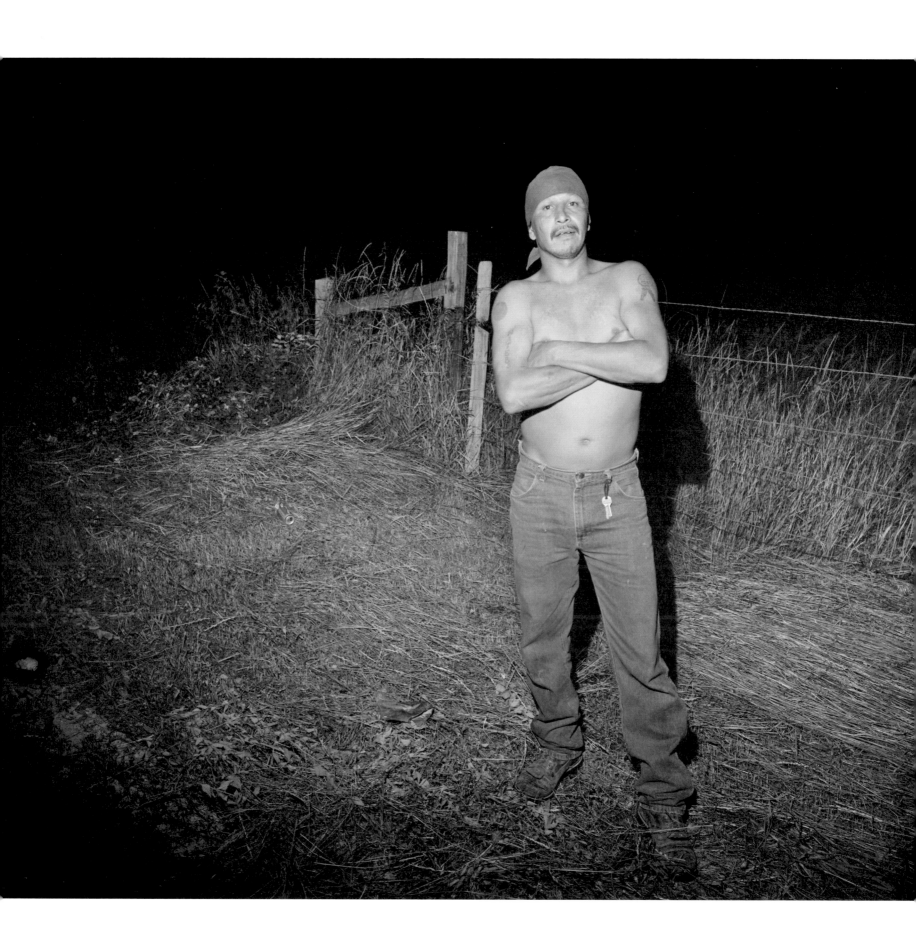

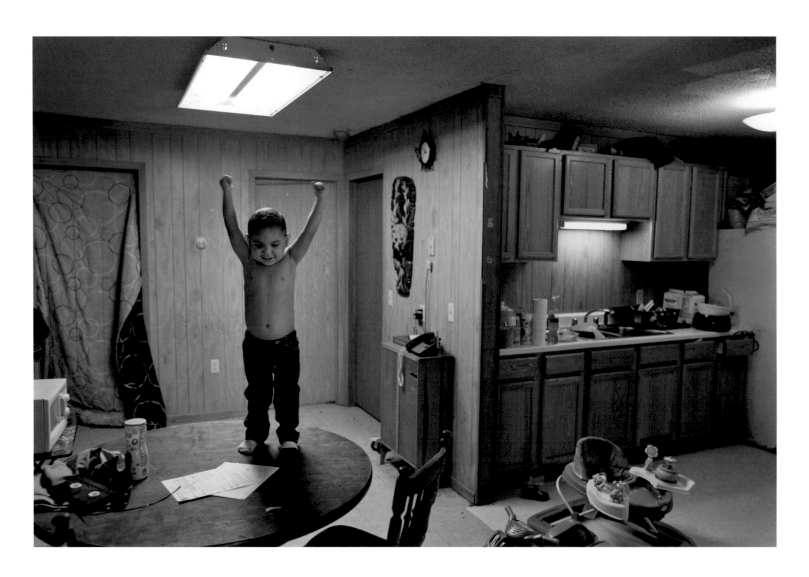

A little boy is cared for by his uncle while his mother works. With unemployment on the Pine Ridge Reservation at over eighty percent, extended families live together and look after one another.

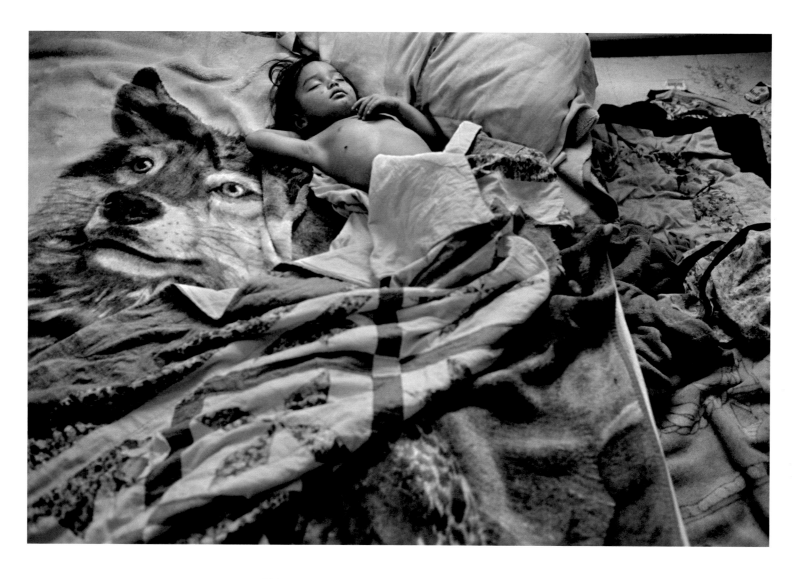

While they were talking on that first visit to Waters's home, Frazier says, "I followed John into the bedroom to get his cigarettes. I had my Leica around my neck, and Wikuchela Waters, his youngest, was sleeping on the bed. John was reaching for cigarettes, and I looked at John and he just smiled, and I made three frames."

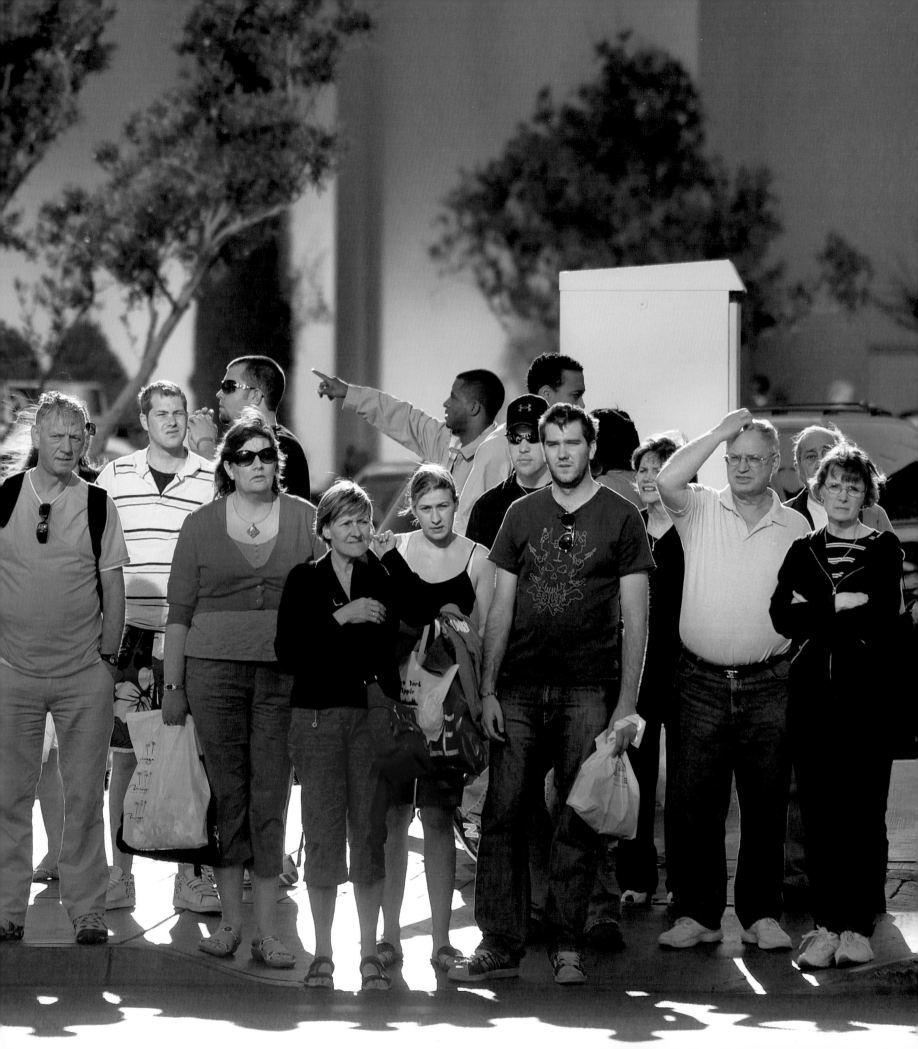

STORIES THROUGH MULTIPLE CAMERAS

Photographed by David Burnett

Before David Burnett arrived in Las Vegas in 2008, money flowed easily. "People could put their kids through college with a hotel job," he says. "By the time I got there, real estate values in Vegas were starting to slip away. Everything was turning." Still, not everything had changed. Vegas remained the one-of-a-kind American phenomenon where people come to play and gamble.

When you meet David Burnett for the first time, you encounter a good-humored, affable man, a witty storyteller. You'd never know how serious and accomplished a photographer he is. He talks about his field experiences lightly. He says he began photographing his Las Vegas story just off the plane when he stopped in the men's room. "I saw a guy with a mop and Elvis, and there's just something about Elvis being ever present," he says. "And I thought, Okay, I can leave now, I got a picture."

With popular concepts of Las Vegas in mind, he went out into the city looking for images that captured Vegas' reputation as a place for second chances and instant transformation. "I saw this guy who had just gotten off the bus from Wisconsin, and he's got his pillow and his two bags. He could be someone desperately searching for a little piece of the American dream."

He pursued visual evidence of Vegas' well-known dreams and fantasies—the gambling spots and shopping destinations, the world-renowned Bellagio hotel. He photographed a smiling tree, which he referred to as "this tree-looking thing. It's a good place for people watching." At night there were light shows. People seemed to spend half their time looking straight up and the other half photographing fellow travelers looking straight up.

Opposite:
David Burnett says one of his favorite photographs from his time in Las Vegas is of this pedestrian crosswalk.

173

"Back down in the old part of town everybody is allowed to do and say what they want," Burnett observes. "A few guys had 'sexual sin leads to hell' posters. Right in the middle of all the honky-tonk and all the gambling and casinos and the flashing lights, you've got people reminding you you'd better repent." In residential neighborhoods he saw opulent homes, swimming pools, skateboarders, bikers, a dog park.

Before the housing crisis, Las Vegas had been the fastest growing city in America for over two decades. Every month thousands of people had moved to the city. Real estate speculators were taking full advantage, selling houses to all comers whether they could afford it or not. At the height of the subsequent crisis, thousands of homes were going into foreclosure monthly. There seemed to be no way out. Burnett boarded a minibus called the "Foreclosure Express," operated by a real estate company to take people around to see distressed houses for sale. Photographing a house, a motel, that had fallen into disrepair "was like being an archaeologist and running across something that used to be," he says.

In prosperous neighborhoods where possibilities for growth had seemed limitless, unfinished construction now looked like the frozen moments when plans had dissolved, building stopped. "There was an otherworldly quality to a lot of it," Burnett recalls.

As a city, Las Vegas recovered when Wall Street did. "But if you were working at McDonald's, if you were on that end of the economy, the Wall Street recovery didn't benefit you. Things are still bad," Burnett reports. His Las Vegas work has grown to mean more to him recently. He wonders what has happened since he was there and thinks about going back.

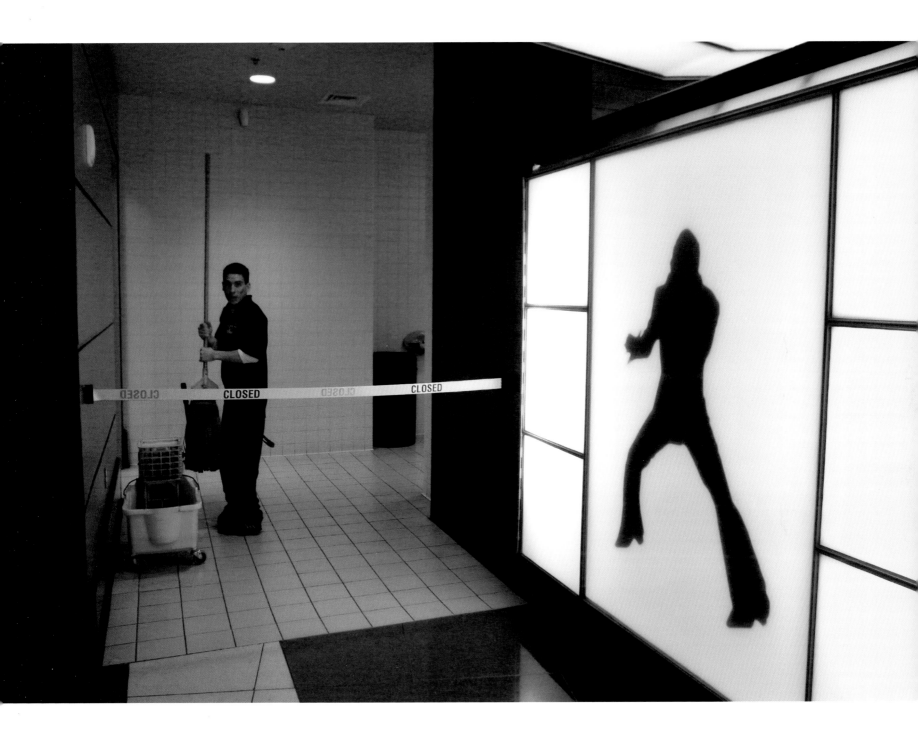

Elvis in the restroom at Las Vegas' McCarran International Airport.

On one visit to this Boulevard South shopping plaza, Burnett says, "There was a big poster that was put up, and I like the blue the young woman was wearing. It just kind of worked with the blue in the balloons."

Conservatory and Botanical Gardens at the Bellagio Hotel on Las Vegas Boulevard.

Burnett photographed this shopping plaza on Boulevard South several times. "I went there because of its funny mix of palm trees and faux Southwest architecture," Burnett says, "and it was right next to the airport, which is Vegas' lifeline to the world."

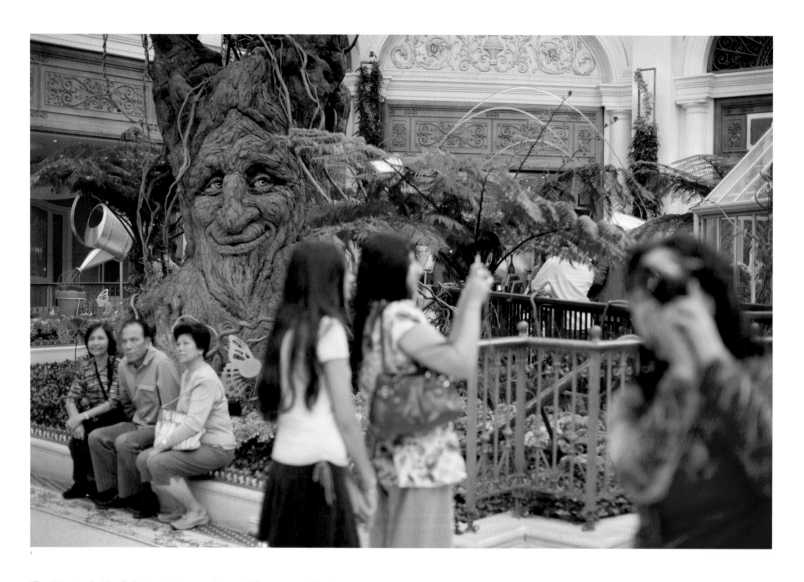

"The 'living tree' at the Bellagio acted as a real magnet," Burnett says. "People would come streaming around and have their pictures taken next to it, behind it, in front of it. The Bellagio has got a certain panache to it."

Burnett says, "There is a big, covered shopping and gambling area in the old part of town. They've created light shows on overhead lights. Everybody is a photographer."

A cycling park, a track for skateboarders and bikers, is next
to a dog park at the Silverado Ranch athletic facility.

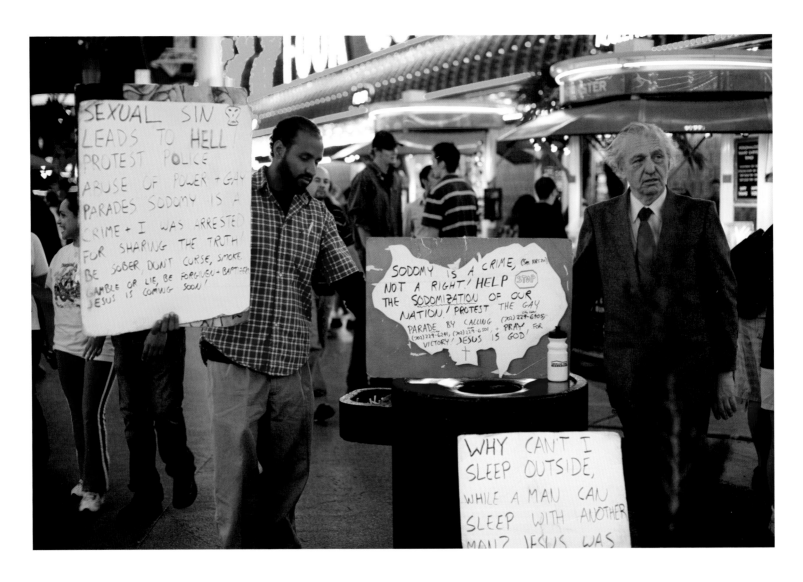

In the older part of town, Burnett says, "right in the middle of all the honky-tonk and all the gambling and casinos and the flashing lights, you've got people reminding you you'd better repent."

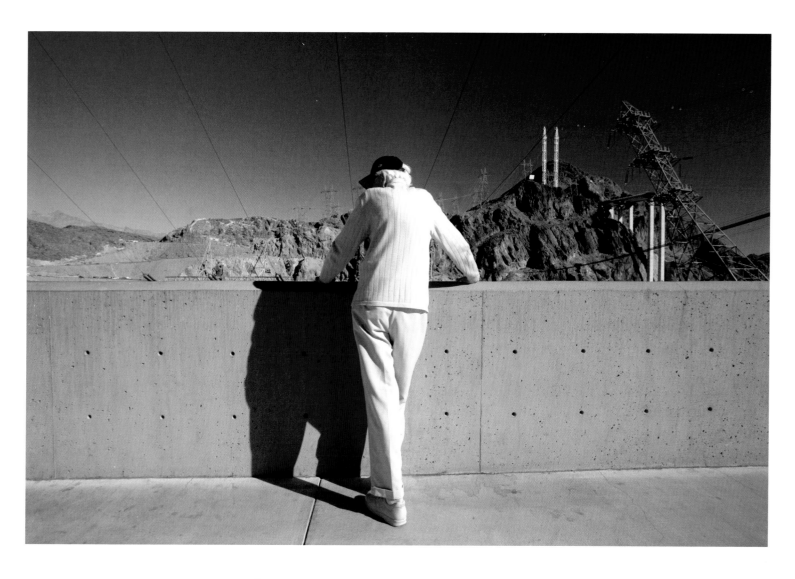

People go to the end of Lake Mead to see Hoover Dam. "It's more than a power station. It's a big tourist attraction," Burnett says.

Burnett has spent more than four decades photographing stories in more than eighty countries. He has covered politics, wars, sports, music, historic anniversaries, and what he refers to as "everyday events nobody remembers." Once, in an interview, he referred respectfully to "the ability of some photographers to distill something special out of what might not seem to be very special situations." Admirers of his work would find this to be an apt description of Burnett himself.

Burnett uses a variety of digital and predigital cameras. "He sets the standard for all of us," photographer Alan Chin says. "He brings a 1940s Speed Graphic press camera when he's on the presidential plane and also uses his iPhone." Burnett decided, remarkably, to photograph the 2012 Summer Olympics in London with a 1940s Speed Graphic and four-by-five-inch black-and-white sheet film. The beautiful results of this challenging undertaking appealed to him and to a huge viewership.

He used a four-by-five camera, with color film this time, to shoot Hurricane Katrina. For this project he used his digital camera as a note-taking device leading up to the four-by-five. He would make a digital shot, study it for framing and generally for how it appeared two-dimensionally, then make a picture with the big camera that would look a little different.

"You don't have to really be a craftsperson to make good pictures anymore," he admits. "You can use a little camera. You can use your phone. There's no question that a lot of good pictures get made that could not possibly have been made ten or twenty years ago. But as amazing as digital can be—certainly it's unrivaled in terms of the speed of delivery—there are times when you're left with an incomplete feeling."

In the September 22, 2014, issue of *New Yorker* magazine, writer Nick Paumgarten considered the latest digital point-of-view camera, the GoPro. "In some respects," he wrote, "the GoPro is like the Brownie and the Polaroid, devices that democratized photography and revolutionized the way we think about the past and even the way we fashion the present, with an eye to how it will look later, when we linger over photographs of it."

But Burnett wonders how long people will linger. "The millions of photographs coming at us day after day tends to make it harder for a really great picture to have the kind of time and reverence we should give it," he says. "There won't ever be a still picture that can breathe and have a life. That was a great picture but that was yesterday. Nobody will care anymore."

Burnett looks back a little nostalgically to the days when photographers didn't know what they were getting until that box of slides or the contact sheets came back from the lab. "There was always a kind of dread we all felt in the pit of our stomachs, wondering if we got a picture," he says, recalling his time shooting in Vietnam especially. "It would be a week before anybody had really seen what they did. You put the film in an envelope, it was flown back to New York, a motorcycle picked it up, took it to the lab, got it processed overnight, contact sheets were made. . . . Photography was different then. It was really about faith. You tried to have your technique down, but you had to make a real leap of faith just to imagine you were getting a picture at all."

Burnett enjoys the quirky paradoxical things that happen in real life. "You never really know everything that's going on," he says, "and I like those kinds of pictures that don't tell you everything."

"The Foreclosure Express was a program started by a real estate company to take prospective buyers out to look at distressed properties and see if they couldn't sell a few that way," Burnett says. "I don't know if any of these folks ever bought into it or not."

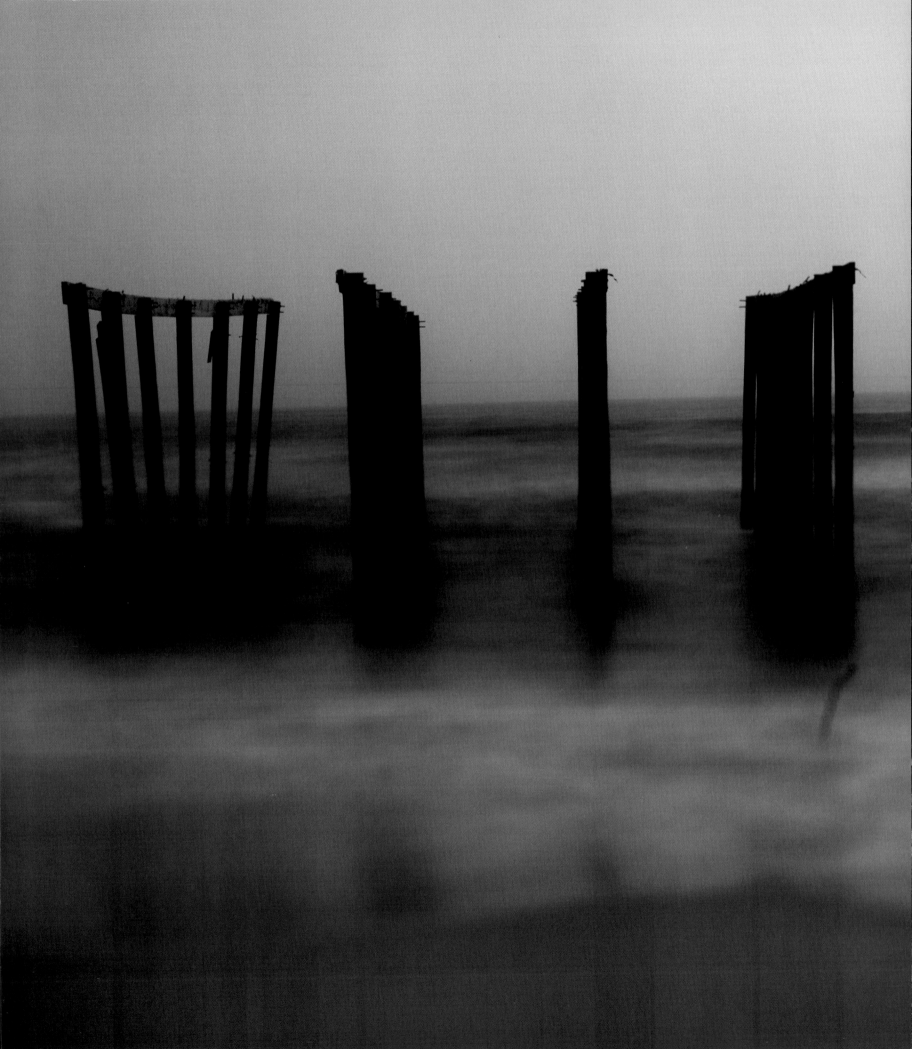

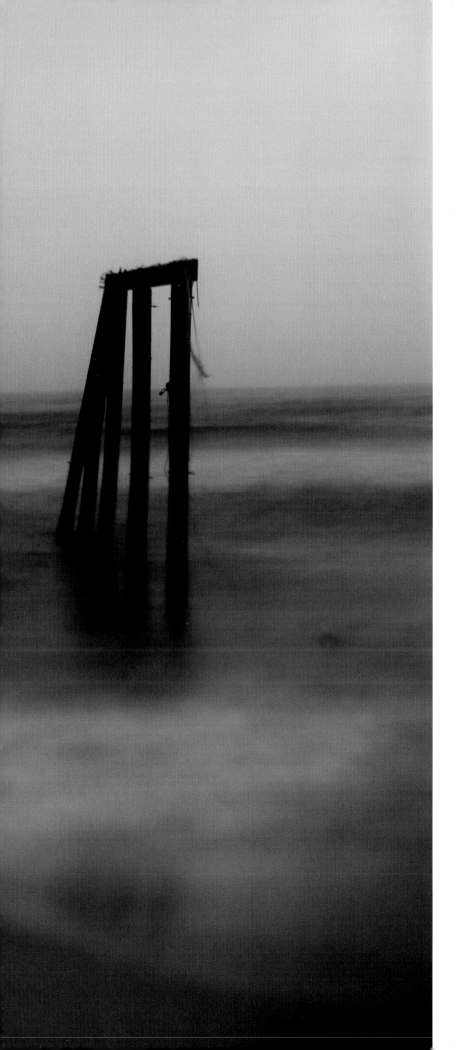

Pilings in the water are all that remain of a house on Dauphin Island, Alabama, that was struck by Hurricane Katrina.

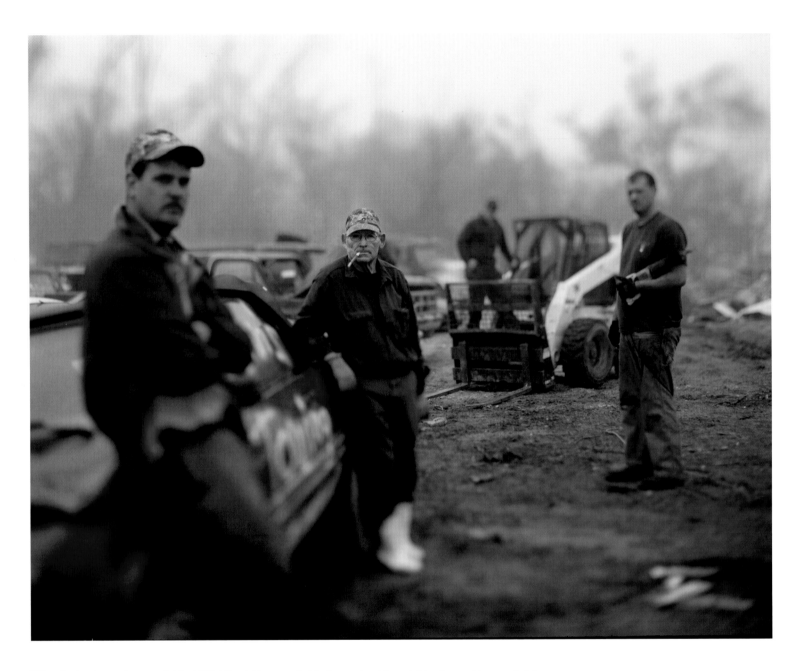

This saltwater-damaged car was finished. "What they told me was that for the most part the only thing they could save out of these swamped cars was the catalytic converter," Burnett says. "Everything else was just a total loss."

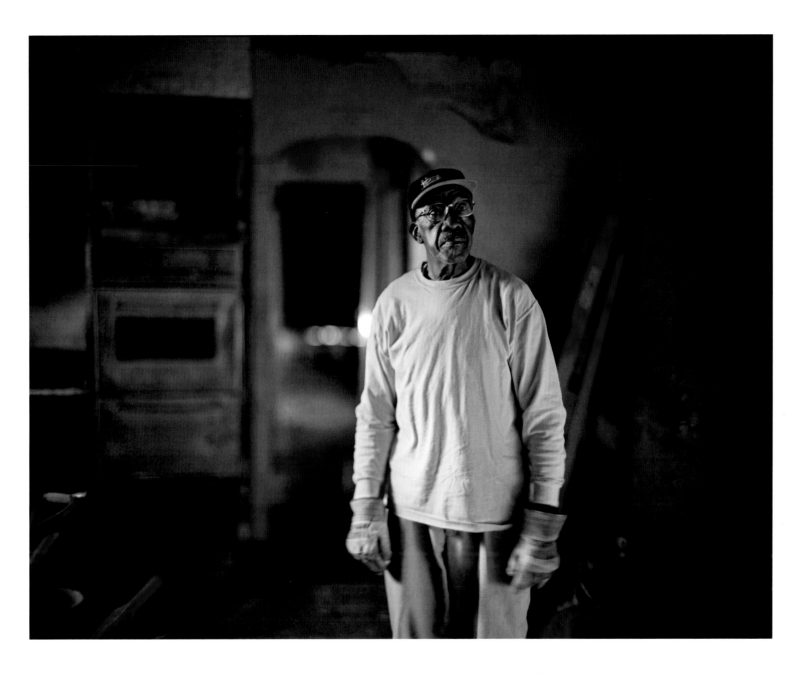

Herbert Gettridge built this house in 1953. After Hurricane Katrina, he was determined to repair it.
The enormity of the damage would have defeated most people.

Hurricane Katrina struck the upscale Lakeview neighborhood and did damage, but not
nearly as much damage as in less-prosperous parts of the city.

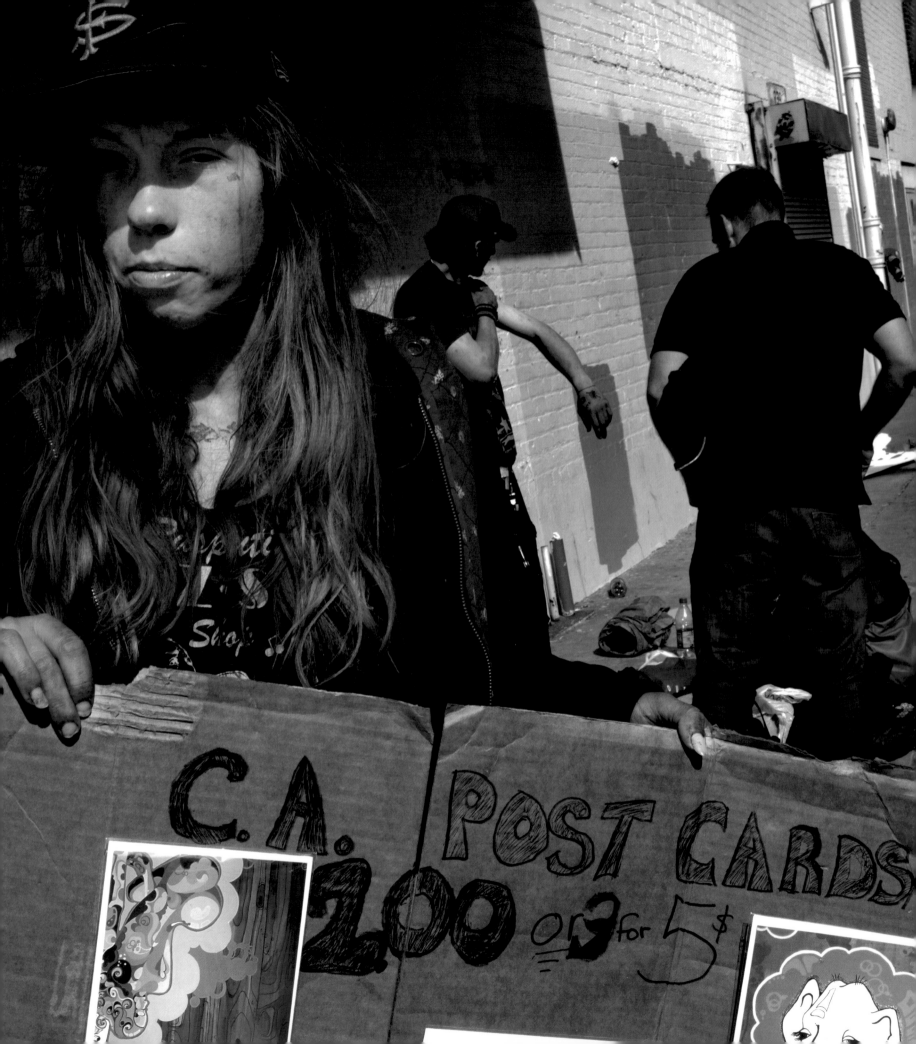

SAN FRANCISCO'S MID-MARKET CORRIDOR

Photographed by Darcy Padilla

Darcy Padilla has most recently been photographing San Francisco's Mid-Market corridor, where indigent San Franciscans live in turn-of-the-twentieth-century hotels. This living arrangement was made possible about thirty-five years ago when San Francisco passed an ordinance securing the hotels for a population in need. "The city can't get rid of them," says Padilla, "and historically cities get rid of people."

This isn't the first time Padilla has photographed in the Mid-Market district. At the height of the AIDS epidemic in the early 1990s, she documented a team of doctors working in one of the hotels and spent three years photographing hotel residents. "I was interested in what the individuals had been through in their lives that put them in this place," she says.

In February 1993, in the lobby of the run-down Ambassador Hotel, she met eighteen-year-old Julie Baird carrying her week-old baby. Julie permitted Padilla to photograph her and gradually allowed Padilla into her life. Their relationship evolved slowly, growing deeper and more trusting over a period of eighteen years. Padilla photographed Julie through abusive relationships, drugs, imprisonment, poverty, and the birth of five more children. To document Julie's tumultuous life, Padilla followed her as she moved from place to place. In Alaska, in 2011, Julie died from AIDS. Padilla was with her.

Recently, Padilla returned to Market Street in San Francisco's Tenderloin district, where she had first met Julie. "What I found were these Internet companies moving in," she says. "Now there are two worlds that are parallel but not touching. Twitter employees commute in and out of the neighborhood in luxury

Opposite:
Padilla met Summer in Stevenson Alley off of Sixth Street. She was camping out in the alley with a group of friends. They sold handmade postcards for much-needed money.

buses while residents live in single rooms without bathrooms." There is a growing housing shortage in the city, generally. Wealthy newcomers are buying properties where they can, displacing lower income families and pushing rents up.

Padilla decided to photograph the local residents on the streets. She explains she's documenting the neighborhood to show how it's changing with the influx of new businesses. "I want to have a dialogue with each person to ask what their story is," she says. "It can't happen without the person really being aware of what I'm doing and wanting to be in the photo." Many in this population feel like outsiders in a world that's passing them by. They welcome Padilla's interest. "They understand their story is more important than we know," she says.

One day, walking by a coffee shop, Padilla was struck by a woman gazing out at the street. "Her expression was just empty," Padilla recalls. "I asked what her name was and she said, 'I am worthless.' She told me she was living nowhere right now. She had lost her place. Her self-esteem was so incredibly low. It was just really sad."

On another day Padilla photographed two men on their way to the Civic Center area, where the Sisters of Notre Dame were serving dinner on Tuesdays and Thursdays. "There was a lady in line who was kind of limping," Padilla recalls. "The men told her go sit down; they would bring her food. They came to me and said, You've got to go talk to her and take her picture."

The woman was Eva Pilarski, ninety-one years old. "Eva broke my heart," says Padilla. "She had been living in a convalescent home in Sacramento. She didn't like it there, so she had come to San Francisco and was now living in a senior's home, coming to the Civic Center to eat because she doesn't have a lot of money and has nobody in her life." After telling this to Padilla, "she slowly walked away."

Residents of the Mid-Market corridor often seem to lead solitary lives, but Padilla points out there are those who find companions. In any case, people need money. A woman named Summer sleeps in an alley with a group of friends. They sell handmade postcards for cash. A man called Opera with a beautiful voice sings for money. Padilla's openness and unfeigned concern engages people, but not everybody wants to talk. Some are shy or simply don't have much to say.

Occasionally conversation is simply out of the question. "I saw a homeless guy with a big blanket around him get off a bus," Padilla recalls. "I said, Can I take your picture? It felt like I was in a movie set, it was so beautiful. He looked at me with these great eyes and kind of smiled, and he stopped and posed, and then he just walked away. I thought, Wow, he delivered. But you could tell he just wasn't there."

The lives Padilla photographs, already fragile, are made more tenuous by the housing shortage. The city's rent-control housing, overall, has decreased by more than a thousand units in the past two fiscal years. *New Yorker* writer Nathan Heller, in his July 7, 2014, story "California Screaming," reported, "Some speculators looking to capitalize on growing demand have started circumventing rent control using buyouts: lumps of cash given if long-term tenants leave." And Heller describes a 1986 California law, the Ellis Act, which permits evictions in cases "when landlords want to go out of business permanently."

Threats of homelessness are part of the Mid-Market district story. "Twitter employees aren't really in the neighborhood except while working," says Padilla. "The population that actually lives in the neighborhood doesn't work in the neighborhood." But current residents often have nowhere to go when wealthy newcomers want to move in. Twitter was given tax incentives to come to San Francisco. The assumption was that they'd create jobs, but so far this hasn't panned out as envisioned.

The Twitter bus started operating in June 2012 and makes three stops. Padilla asked the driver if the bus is ever full. He said no. Statistics are incomplete and don't tell the whole story in any case.

There are cultural as well as financial clashes between forces for gentrification and San Francisco's tradition as a home for marginalized communities. The city hires people to clear the

Twitter employees are shuttled around the Bay Area in unmarked, private luxury coaches with tinted windows, climate control, and WiFi.

streets, "to help keep the streets safe," Padilla says. "But safe for who? The neighborhood is changing, so how about a good community center where people can have coffee and sit. How about public bathrooms. . . . Cops from Central Station put unconscious people on stretchers, pick them up off the streets so they can be detoxed and get proper care, but the main concept right now is to keep the street as clean-looking as possible for the new people who are renting the office buildings."

Padilla's frustration borders on incredulity when she sees people just walk by without trying to understand the desperation and complexities that lead a person here. She tries to bring identity to poverty by portraying her subjects in the brief time she has with each. "Gary was totally cool with having his picture taken. He was just sitting on the tip of a trash can with his marijuana and his Olde English getting high, having his own party. He was really a nice man. Every time he finished drinking or smoking, maybe about twenty times, he would offer me some. I kept saying no. I haven't been able to track him down again. I was lucky to be on that corner with him on that day."

Padilla says, "Whether it be drug addiction, depression, emotional abuse, sexual abuse, displacement, lack of medical care, lack of family and friends—all these things play into creating this permanent poor society in America. It's important to discuss what we need to do to help people out of this permanent state of poverty."

The Muni 83X Mid-Market Express is informally known as the "Twitter Bus." The line began operating in June 2012. Padilla says, "I asked the bus driver if it is ever full, and he said, 'No, not really.'"

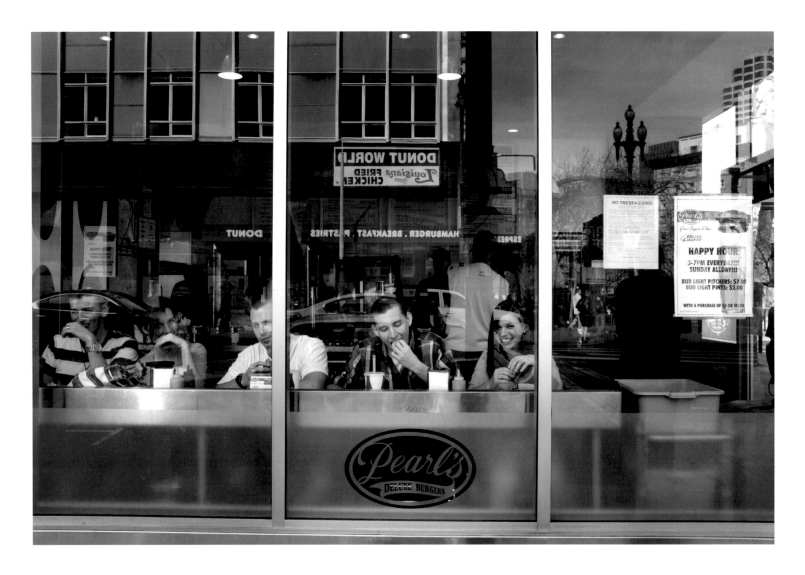

Patrons pay six dollars for a burger at Pearl's. The restaurant opened in October 2011 in the heart of the Tenderloin
and catered mostly to nearby tech workers. It closed in January 2014—the location was not profitable.

Padilla approached the woman with the blank stare gingerly. When asked her name, the woman answered,
"I am worthless." Padilla talked with her until she explained she had lost her home and revealed that her name is Marlana.

Padilla photographed this man walking slowly through Mint Plaza in San Francisco. She had photographed him earlier on Fifth Street, where he held on to the wall to support himself.

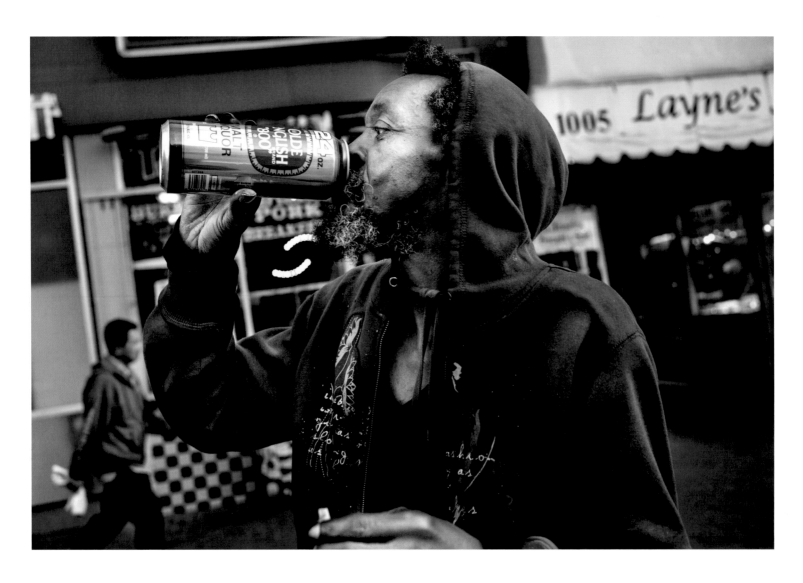

Gary smokes a joint and drinks his twenty-four-ounce Olde English 800 on a Friday night on Market Street. "He politely motions the joint my way," says Padilla. "I say, no thanks."

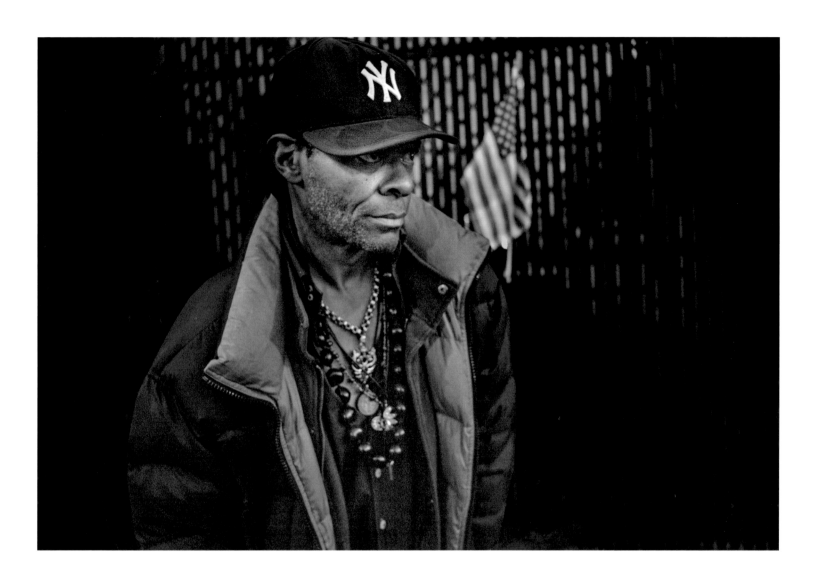

"It was a lively night," says Padilla. "I started talking to this man because I loved his hat. He studied at Juilliard, was a professional opera singer, and has an amazing voice. He goes by the name of Opera. His life just went in the wrong direction with drugs. Now he's homeless and dealing with addiction. He sings for money in the Metro underground. He was a really lovely man."

"The Ambassadors [a community safety program] told Sasha, if you walk yourself to the detox place five or six blocks, they'll probably let you keep your shopping cart," Padilla says. "So he said he would take himself, and they gave him a bottle of water and left. Even though he's really out of it, he elects to walk himself so he can keep his belongings. For some people that is an issue—a big issue."

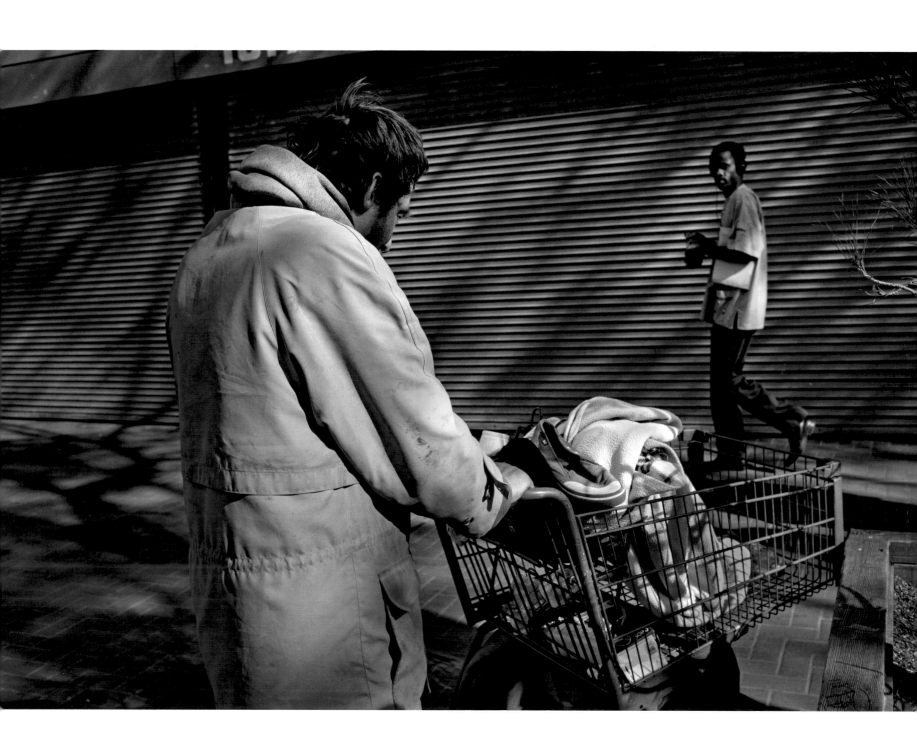

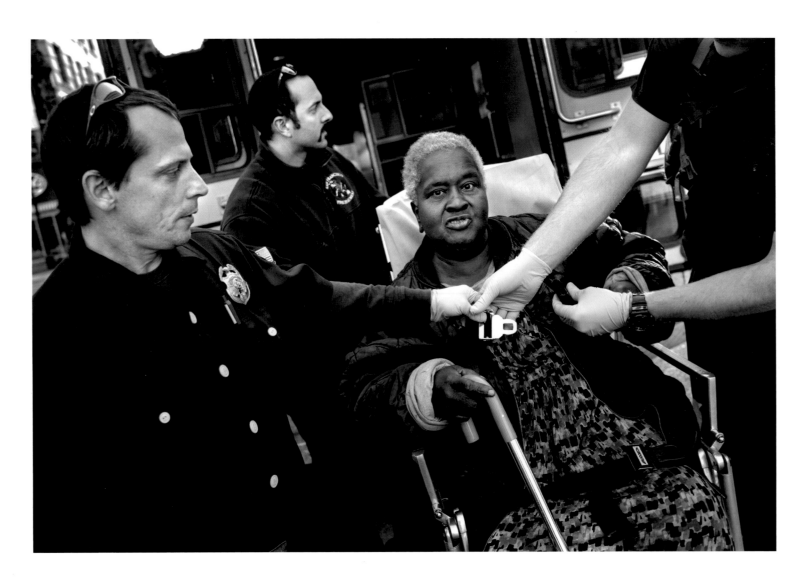

"I met Anne leaning up against a fire hydrant on Market Street. The light reflected in her eyes, and she looked absolutely beautiful. I asked if I could take her photo and she said yes. She said she lived in a shelter and didn't think it was safe. I noticed an ambulance coming in the wrong direction and Anne said, 'Oh they are coming for me. I'm not feeling well.' Matt, the ambulance driver, was very familiar with Anne. He said she injects urine into her veins so she can be picked up and have a place to stay at the hospital for a week or two."

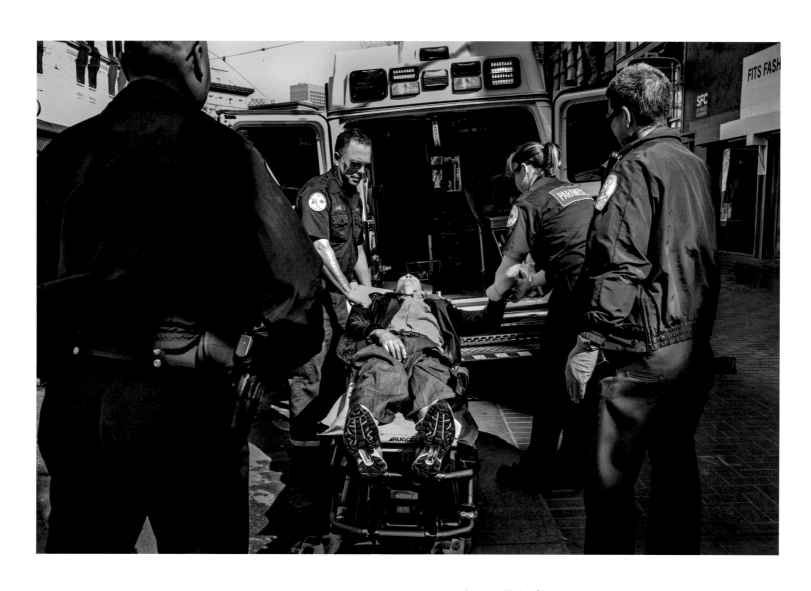

A man on Market Street is picked up because he is unconscious from drinking.
The police from Southern Station will take him to a detox center.

"It's important to me to do more than photograph. I want to have a dialogue with each person to ask what their story is," says Padilla. But there are times when that's not possible. This man got off the bus, and "he looked at me with these great eyes and kind of smiled, and he stopped and posed, and then he just walked away."

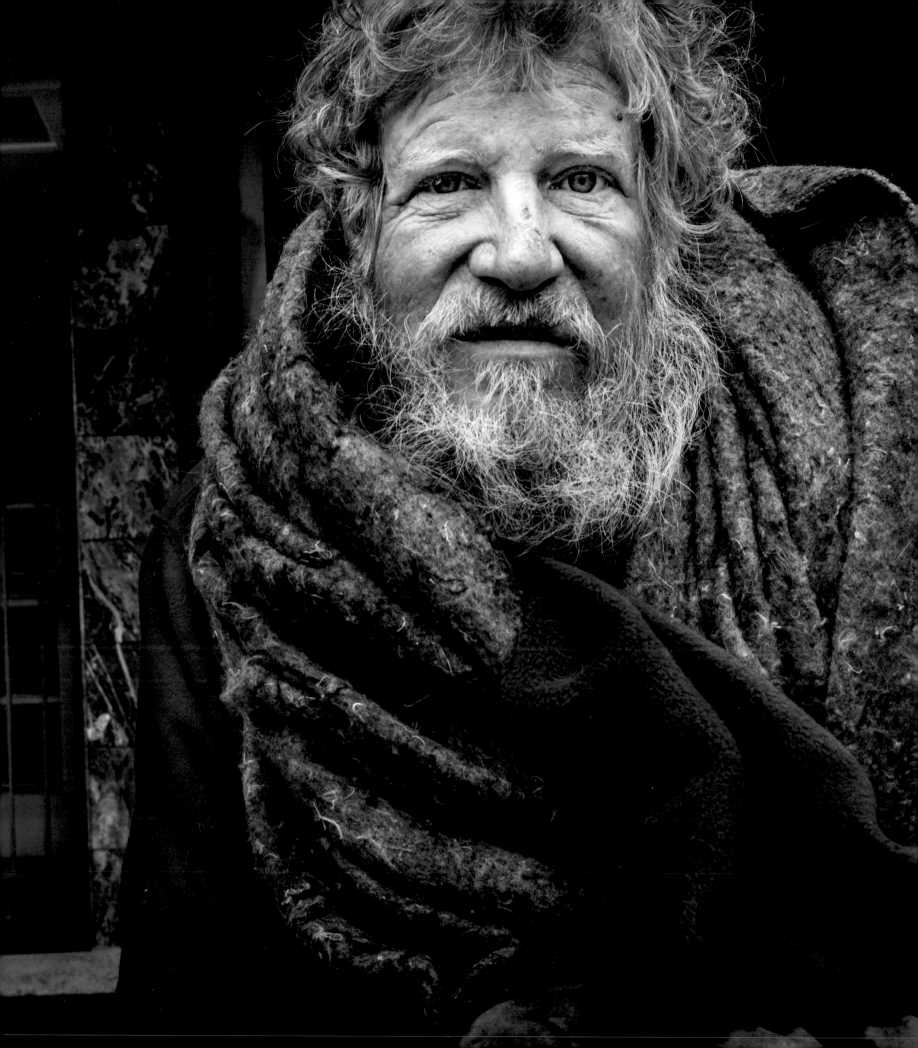

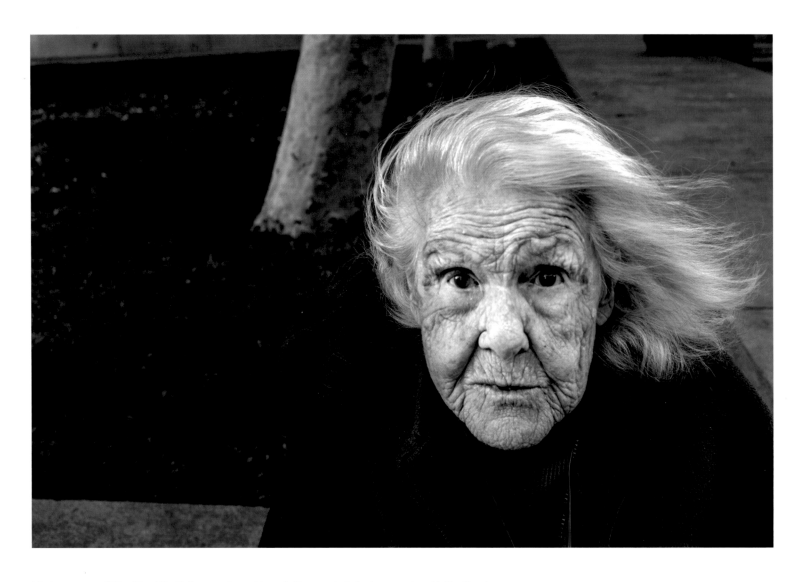

Ninety-one-year-old Eva Pilarski had left a convalescent home in Sacramento to live in an apartment in San Francisco.
She waits for handouts from the Sisters of Notre Dame, who give food to the poor.

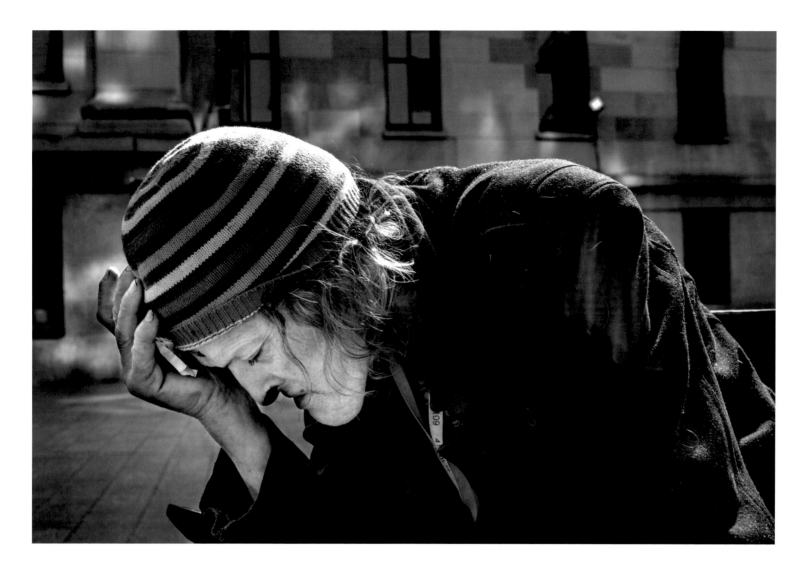

Stephanie found out she had diabetes from the methadone clinic when her blood sugar was low. One of her legs had been amputated and the other was infected and in danger when Padilla took this picture. "Stephanie has been a transgender for the last thirty years and told me about what it was like to be transgender in San Francisco in the eighties—in the nineties," Padilla says.

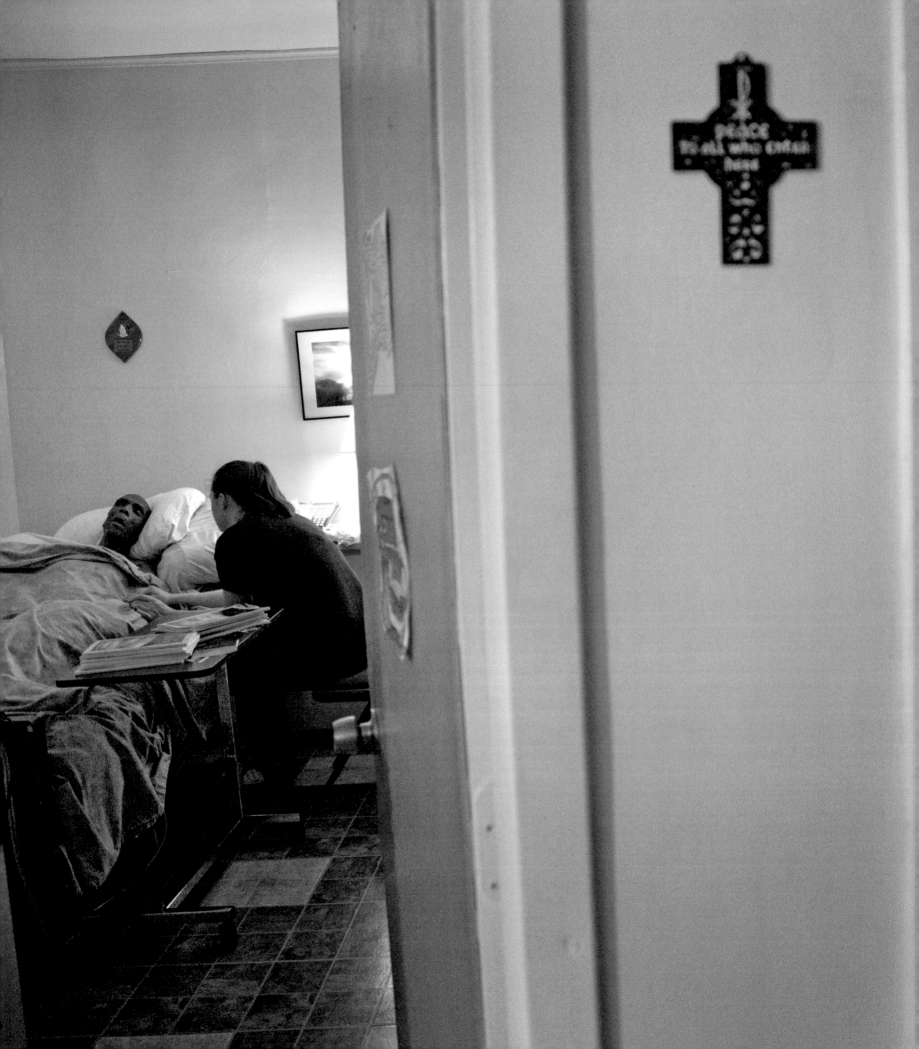

LOOKING FOR SOLUTIONS

Photographed by Lucian Perkins

At the end of the 1980s, Lucian Perkins photographed Dr. David Hilfiker for a *Washington Post Magazine* story. Hilfiker operated a much-needed clinic for the poor in the Washington, DC, neighborhood of Adams Morgan, where Perkins lives. "I was really impressed with him at the time and his name stayed with me," says Perkins.

A few years later he came across Hilfiker's name again and decided to pay him a visit. He was surprised to find that since they had last met Hilfiker had turned his home into a hospice serving homeless people dying of HIV/AIDS. "He created Joseph's House when his children left for college," Perkins says. "It was an amazing thing to do because this was a residential neighborhood where people were freaked out about AIDS." Over the years Hilfiker has managed to successfully integrate Joseph's House into the community. It was and remains a bold and compassionate venture.

Hospitals serving terminal patients with no means of support turn to Joseph's House for help when the end of life draws near. Eligible applicants are interviewed and asked directly whether they are interested in coming to the hospice. Registered nurses, licensed practical nurses, personal care aides, administrative staff, and volunteers are on call around the clock for the people who are admitted.

In most cases volunteers are young people spending a year before continuing to nursing or medical school. They come from Americorps and other community-service and faith-based organizations. They're provided with room and board somewhere in DC, and they are paid a hundred dollars a month.

"My idea was to follow some of these volunteers and see how experience at a place like this would change them," says Perkins. "I met Cameron Cochran and three other volunteers the first day they came. Cameron was totally lost. She was in her first year of college and didn't know what she was doing with her life, and she dropped out of school, which was a difficult decision for her." She found Joseph's House and stayed for three years. Perkins witnessed her growth from a woman who had never seen anybody die to a confident, self-aware person. "I never considered myself strong or competent," Cochran told Perkins. "At Joseph's House I was pushed to do things I never thought I could do. For me, opening up to the idea of death, accompanying death, has taught me how to live for the first time in my life."

Perkins also got to know the residents at Joseph's House. One resident, Elijah, arrived on his birthday. The staff prepared a small birthday cake, recalls Perkins. "He said, I'm really glad I'm alive today." He had been diagnosed with two months to live, and he lived nine months. "What happens is that people come in actively dying, and all of a sudden they are surrounded by people who care about them and are taking care of them and they get better."

Perkins was deeply moved by the residents he encountered. One was Lonnie Blue, who had spent a lot of time in prison. "He was very hard, very skeptical," says Perkins. "Then, over the course

Opposite:
Cameron Cochran, a twenty-two-year-old former volunteer and current staff member of Joseph's House, watches over Lonnie as he is dying.

of a few weeks at Joseph's House, he really started to soften, to laugh. He was incredibly intelligent. He had such a grasp of history, especially of Washington, DC. He lived for about two months."

One man arrived unresponsive and spent his first week unconscious. "Then one day he just woke up and started talking and was an amazing guy," recalls Perkins. "He ended up living probably for three or four months, and then he finally died. But it was a bizarre case. I actually came the day when he woke up and it was like—wow!"

People who come to Joseph's House may be there for months or may live only for a day or two. When a person reaches the final hours, staff and volunteers take turns keeping vigil, providing physical care and simply being an attentive, caring presence. After a person dies, when the body is taken out, family, staff, and volunteers form a procession and follow.

Perkins was at Joseph's House on and off for three years. "It was almost like I was part of the family," he says. "They were upset if I wasn't there. In the early days one of the nurses said, you can't film this, you can't film that. I think once they realized they could trust me, and we developed this relationship and bond, I was part of the family, and I still consider myself part of the family." He filmed during his visits and also made still photographs: he embraces the diversity of photographic gear now available and considers the pros and cons of combining technologies on any given project.

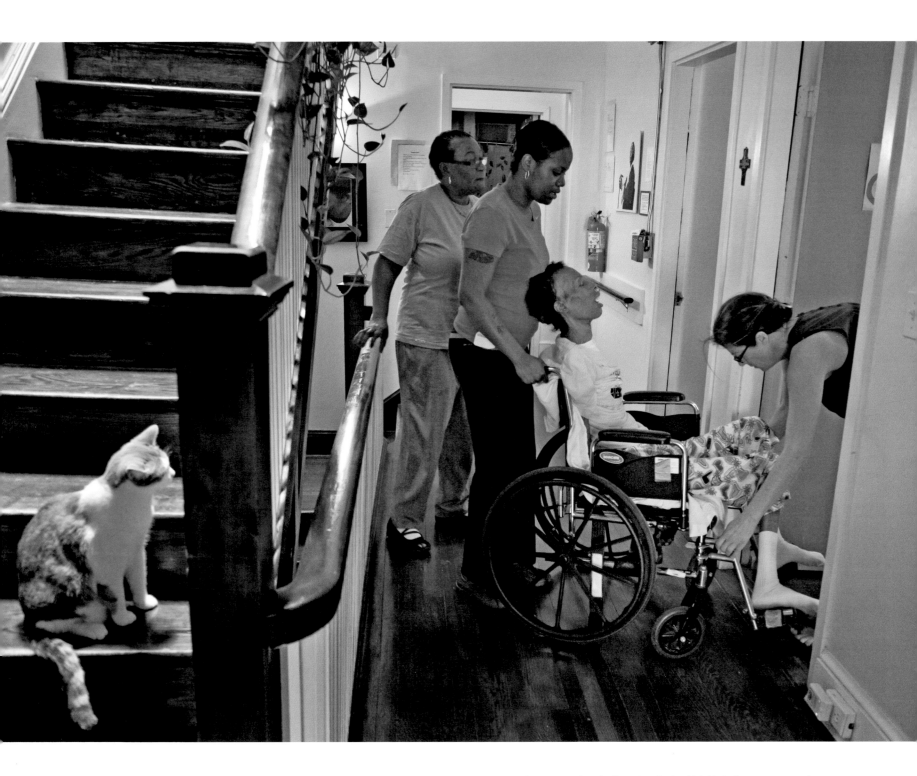

Nurses Gabriel Ademiloye (left) and Ann Dodge (right) help Cortez, a new resident, into her room at Joseph's House. Cortez died two weeks later.

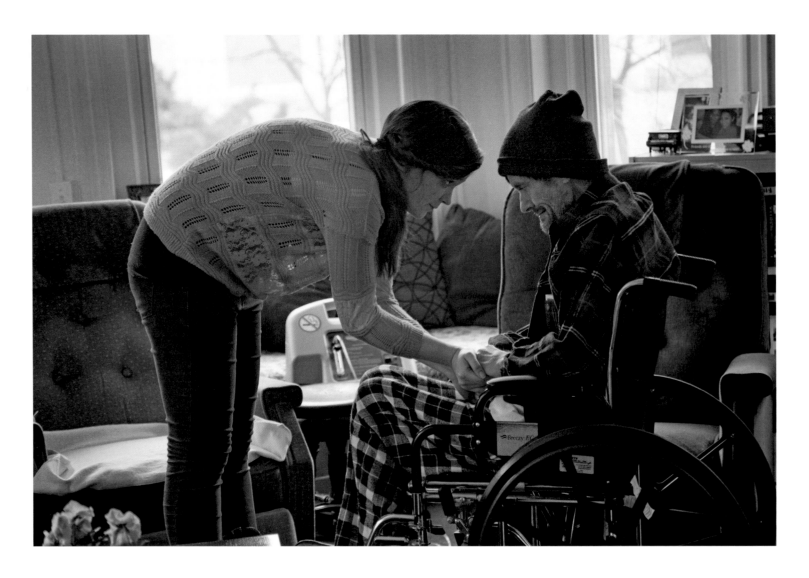

Cameron Cochran, who came to Joseph's House as a twenty-year-old volunteer, helps Brad, a resident, move to a chair in the hospice's living room.

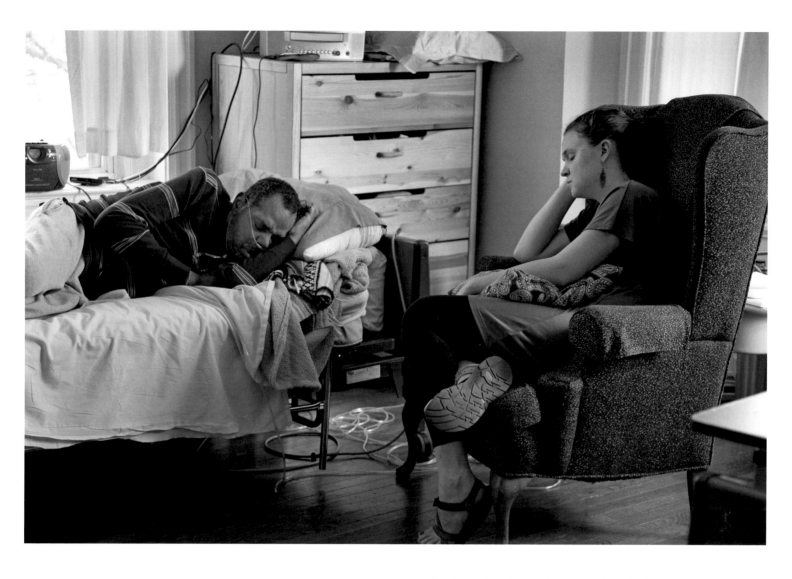

Cameron Cochran, now twenty-two, closes her eyes to rest as she keeps Michael, a new resident, company.

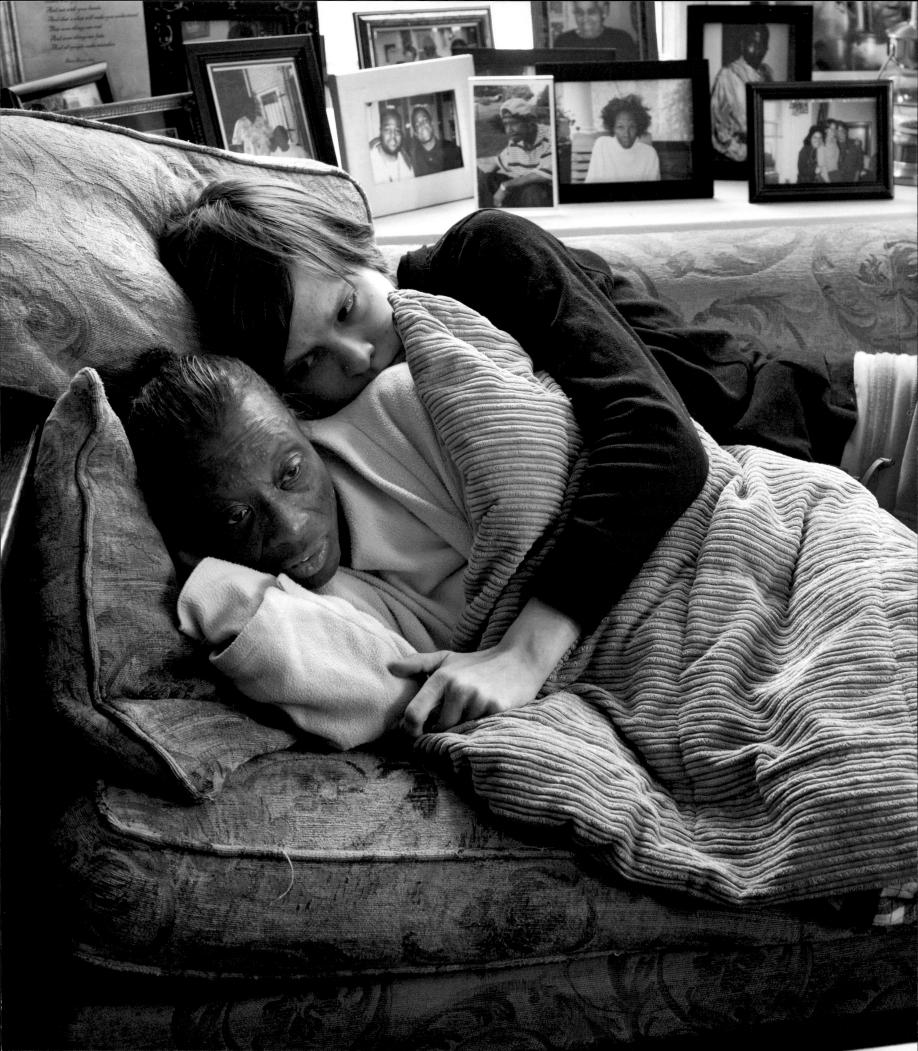

Twenty-three-year-old volunteer Kate Lichti puts her arms around Francis, a resident at Joseph's House, as she tells her that Elijah has just died.

Andrew, a year-long volunteer at Joseph's House, watches as Wilbur slowly passes away.
It was Andrew's first time witnessing someone's death.

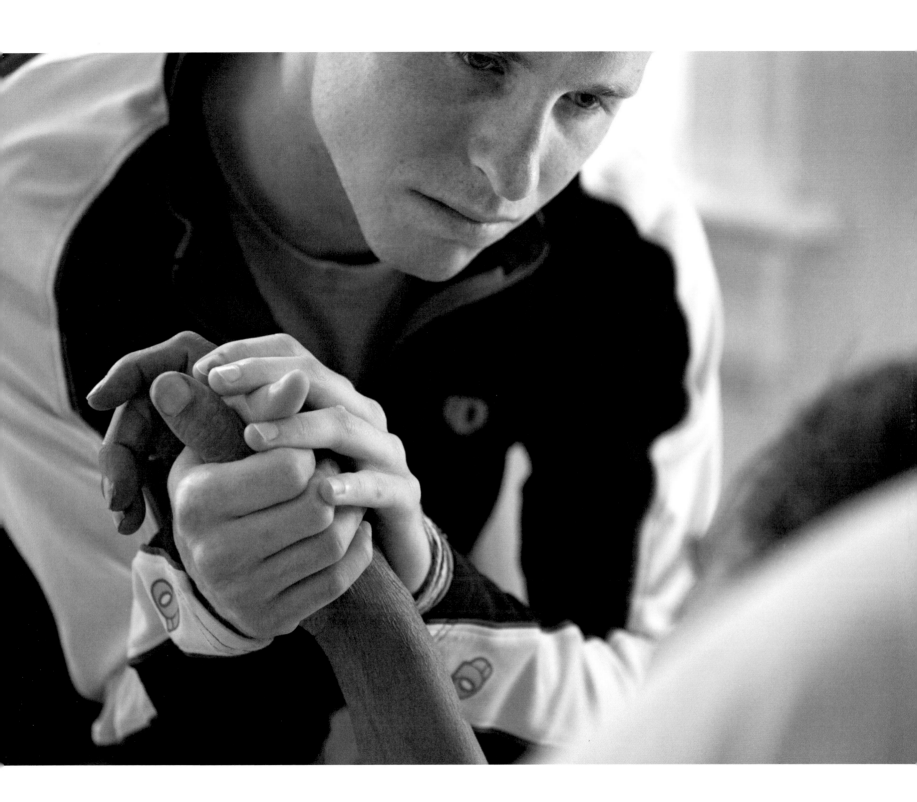

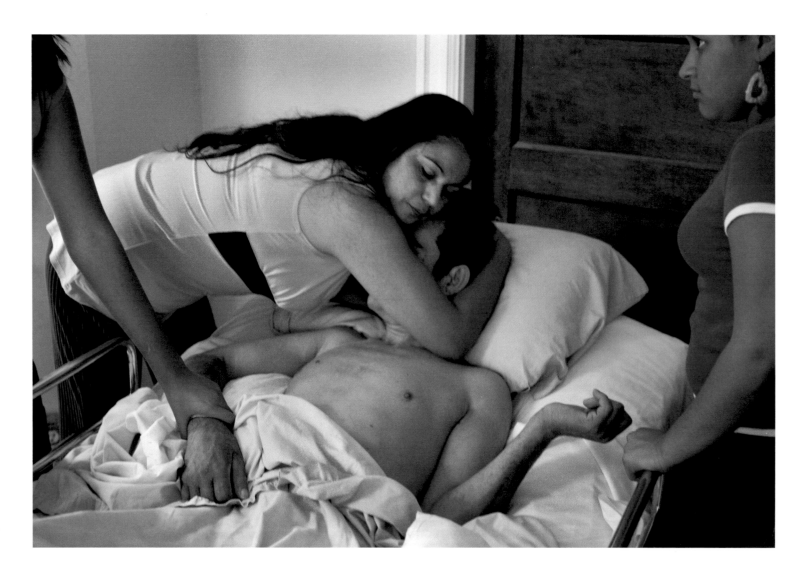

Mauricio is comforted by his wife, Ayeta, and their family as he begins to die.

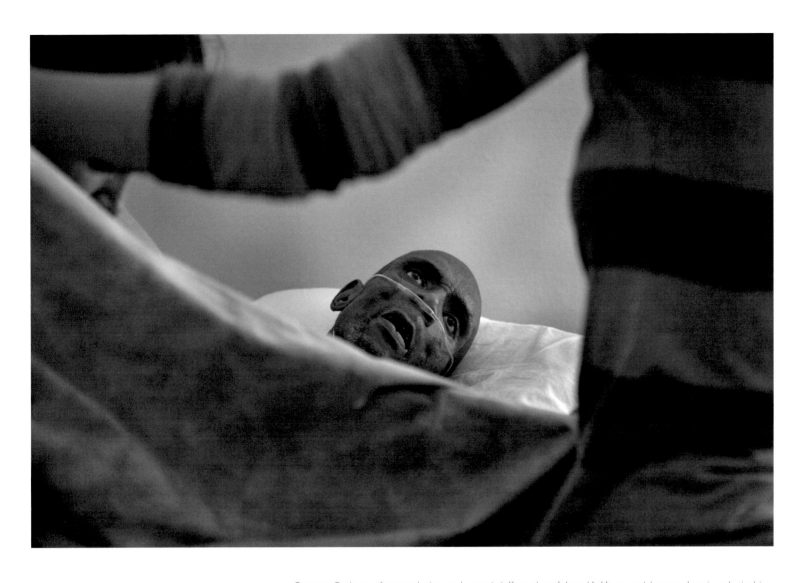

Cameron Cochran, a former volunteer and current staff member of Joseph's House, watches over Lonnie as he is dying.

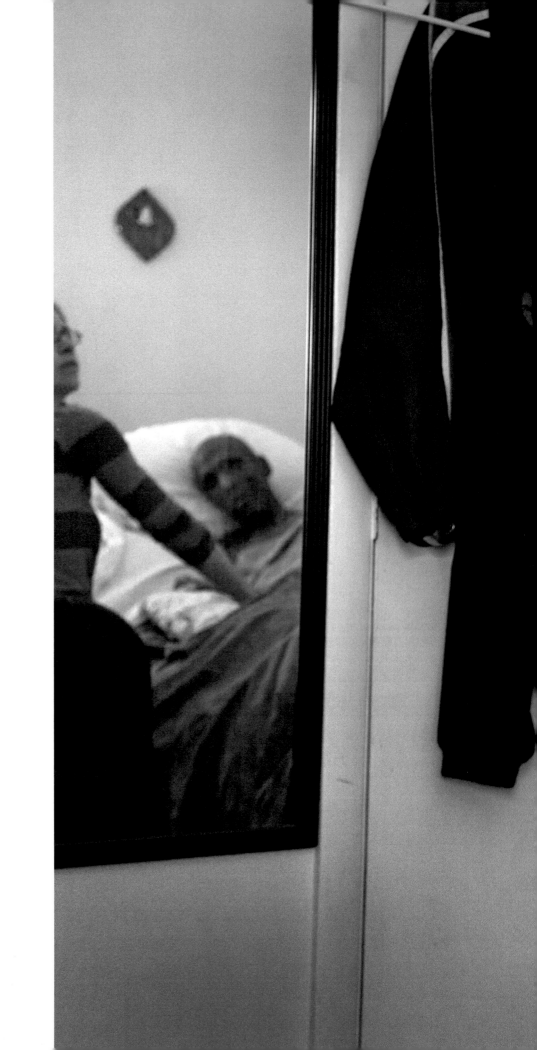

Volunteers try to comfort Lonnie as he dies. Though he was only at the house for a couple of months, he became very close with many of the volunteers.

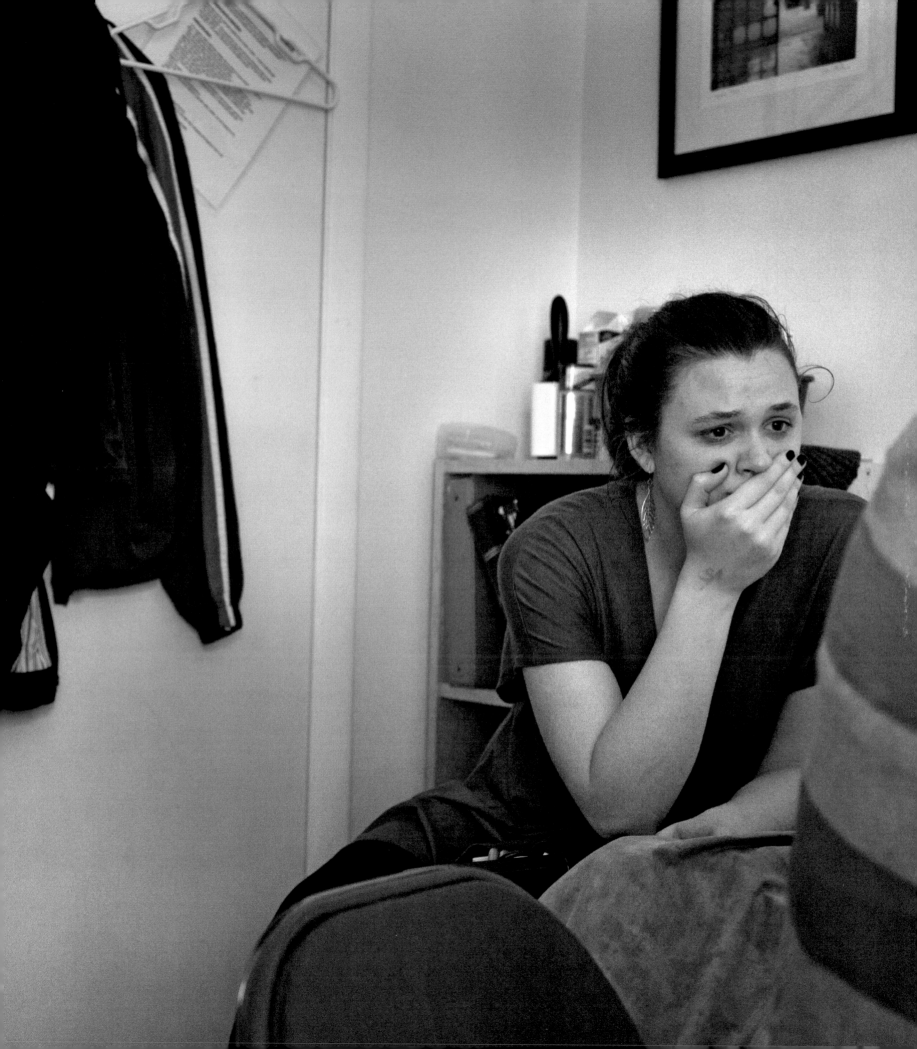

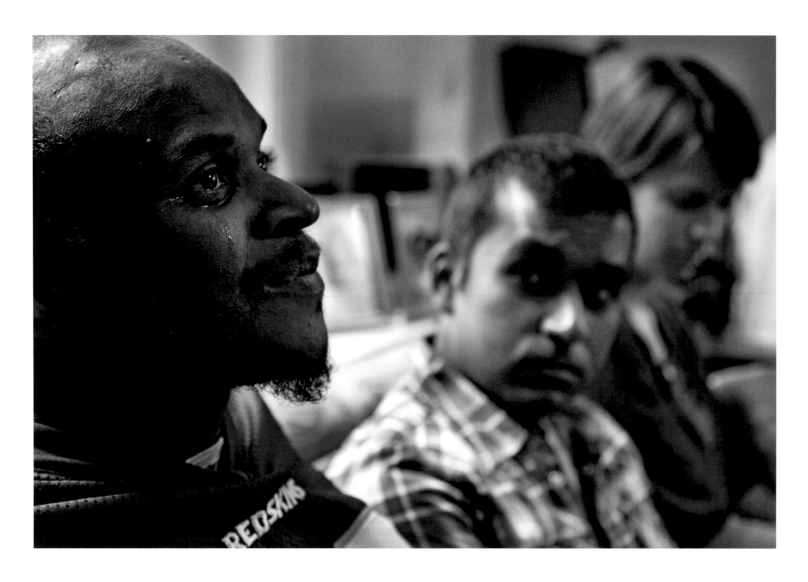

Butch, a resident of Joseph's House, cries as he reflects on the death of his friend
LaVada during her memorial service. Listening to him is volunteer Istiaq Mian.

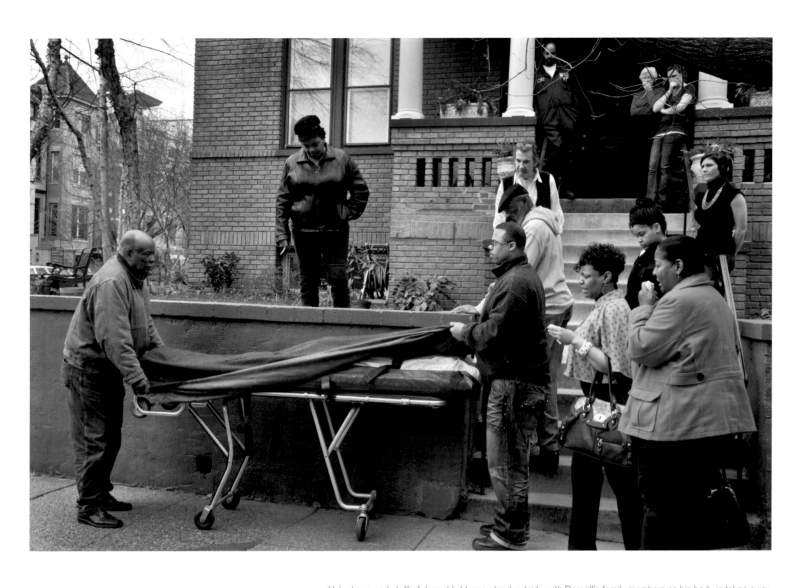

Volunteers and staff of Joseph's House stand outside with Darnell's family members as his body is taken away.
It is a Joseph's House ritual to always go outside in silence as a resident's body is removed.

Perkins's concern and curiosity about world events has drawn him in many directions. He is stimulated by the diversity of subjects he can cover as a newspaper photographer. These days documenting and publicizing the state of health care in America is a calling for him and has become a mission for Facing Change. It is a tough topic to photograph—illness, pain, and suffering are difficult to look at, often hard to even see.

He has photographed health care from multiple vantage points. He covered the obesity epidemic, focusing on victims, causes, and solutions. "The food situation in America is horrible, the more you study it," he says. He has photographed the Affordable Care Act—Obamacare—including legislators and protestors, pro and con. He encounters punishing indifference and inspired activism.

Inspired activism is a good way to describe the organization Remote Area Medical (RAM), originally founded in 1985 by pilot Stan Brock to bring free medical care to inaccessible regions of the Amazon rain forest. When Brock realized medical care in the United States was failing to address an enormous need, he moved his focus to America's rural communities. RAM depends on private donors and professional volunteers, and it forms partnerships with local communities. Health care is delivered by mobile medical centers, each sophisticated and complex, fully equipped and in place for only a few days a year.

In July 2014 Perkins photographed a RAM event in Wise, Virginia, a small town on the Kentucky border. RAM comes to the Wise County Fairgrounds every year for a weekend. "People in dire need come prepared to wait in long lines," says Perkins. "When I was there, I think there were three thousand people who stayed there all weekend to get free medical service." When Perkins arrived with his camera at 5:30 a.m. on Saturday, hundreds of people were already in line to get into the clinic during a rainstorm. Hundreds had been sleeping on the fairgrounds overnight in anticipation. "Over fifteen hundred people received tickets to get in that day," says Perkins. "The rest were turned back, to come tomorrow." Those who benefited emerged grateful, some tearfully so, their lives changed by the quality medical, dental, and vision care they received.

Perkins says that nowadays he tries more and more to photograph stories from the standpoint of solutions, "finding people, finding organizations, that are trying to change the system." He tells stories through the eyes of activists who, even when they can't fully solve medical or other challenges, may inspire others.

Perkins is conscious of and attentive to the work of his colleagues. He brought forward the work of talented Russian photographers by creating and organizing the InterFoto festival that took place in Moscow annually between 1994 and 2004. As a founder of Facing Change, Perkins works to bring together American documentary photographers and publicize their work.

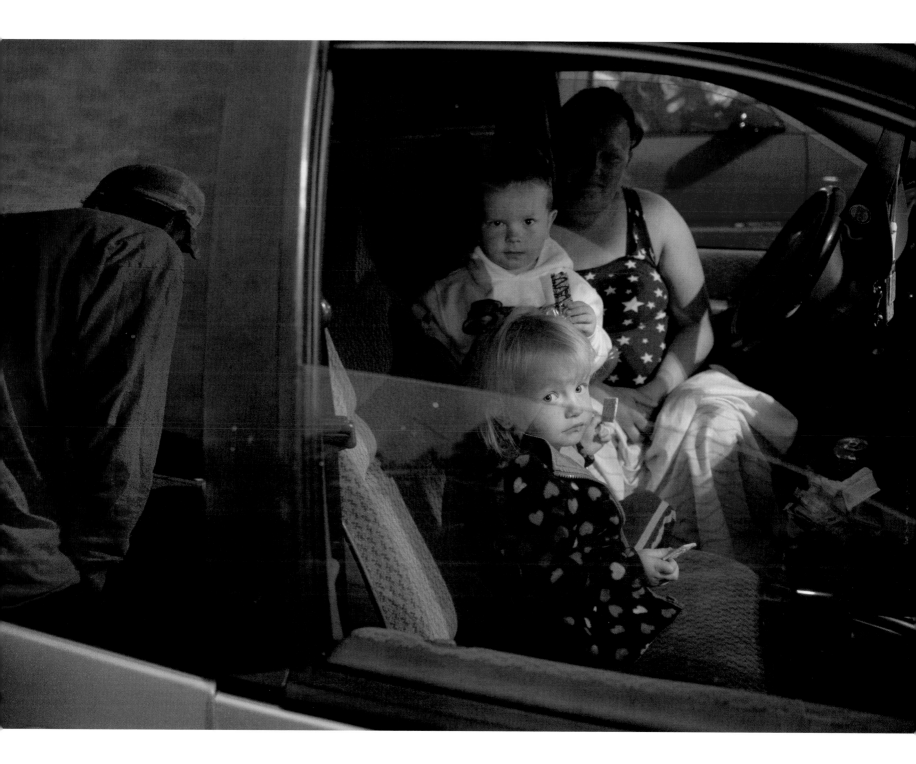

Tim Bass of Coeburn, Virginia, stands outside as his wife and children sit in the car where they slept overnight. Bass needed dental and eyework done. "I'm disabled, and it is really hard for people these days," he told Perkins.

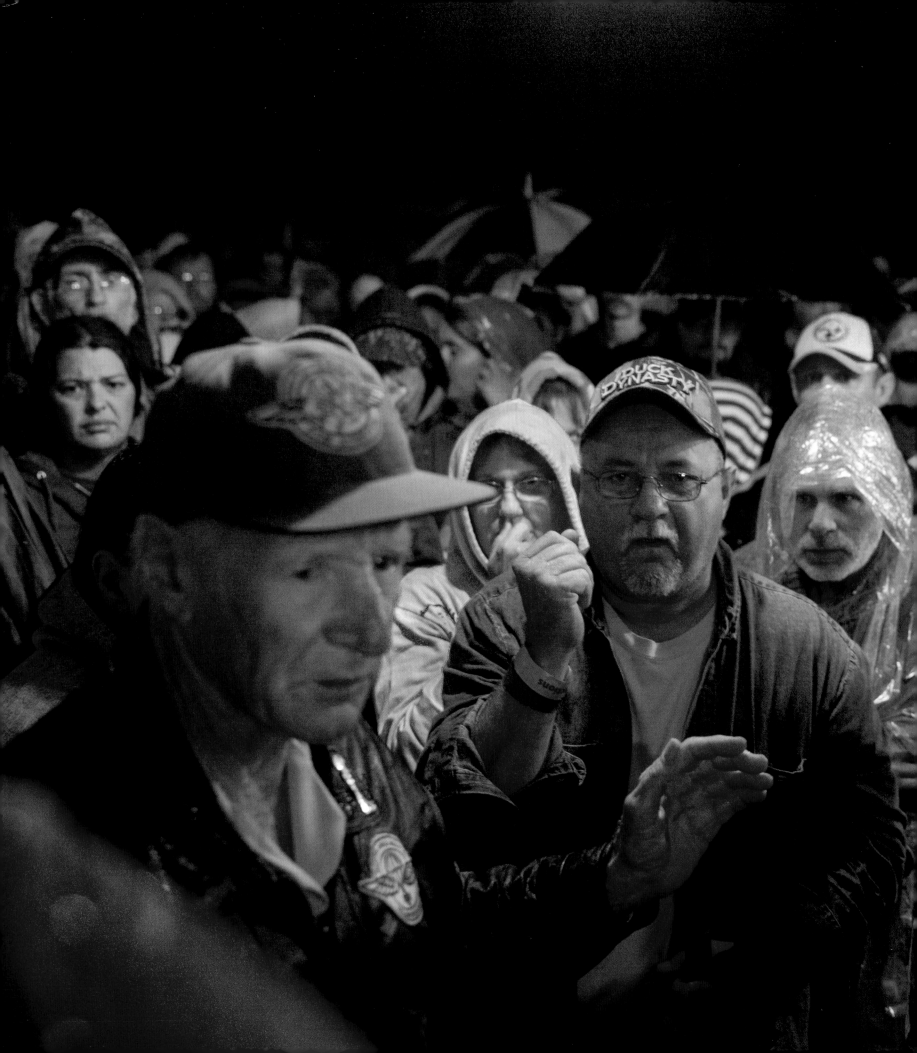

Three thousand people lined up before dawn on a stormy Saturday hoping to get into the Remote Area Medical (RAM) clinic set up at the Wise County Fairgrounds. Many, with children in tow, spent the entire night waiting outside or in their cars to get treatment. Here, RAM founder Stan Brock (far left) allows people into the clinic's makeshift tents.

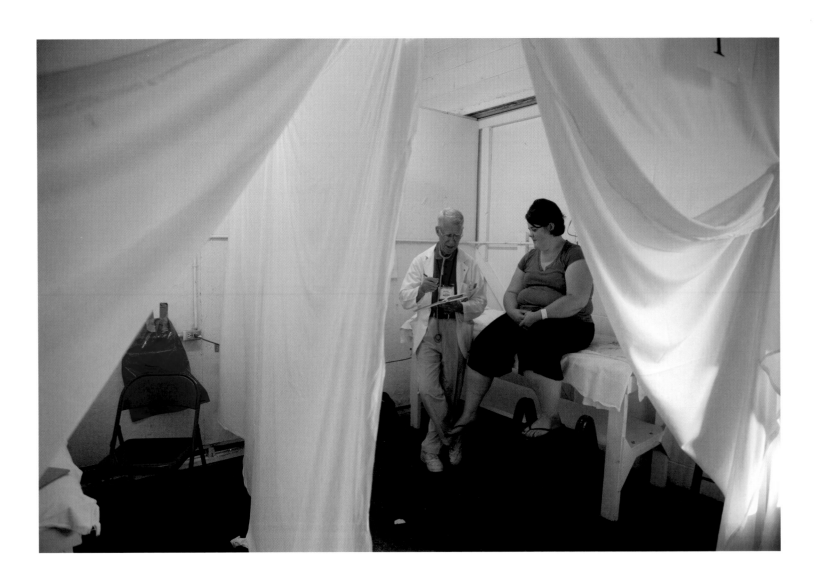

Dr. Jerome Skaggs of Hopewell, Virginia, prepares to examine Amber Moore-Rivera of Glade Spring, Virginia.

Two women wait for their numbers to be called.

A patient waits to have his teeth extracted after getting a mouth X-ray at the Remote Area Medical clinic in Wise, Virginia.

THE FLAG

The photographers in this book weren't looking for the American flag. They photographed chance encounters.

Danny Frazier was photographing in Walkerville, Montana, near Butte, "when a guy came out of his house and began putting up a flag," he recalls. "The wind blew, I rushed over, and—bang."

Alan Chin went down to the World Trade Center site the night President Barack Obama announced that Osama Bin Laden had been killed by US forces in Pakistan. "What struck me about the crowd is that a lot of these people were around ten years old when 9/11 happened," he says. "This horrific thing happened, and you see the flag. I don't claim to know what that means." As a child, Chin says he had been a Boy Scout devoted to the flag, and now he sometimes wonders about the line between loyalty and chauvinism, even xenophobia.

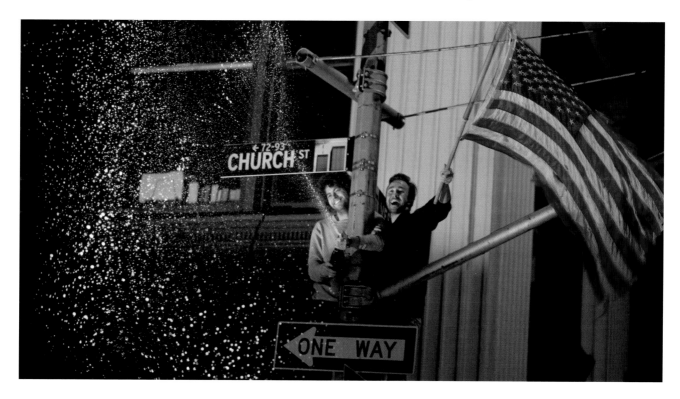

Opposite: Ray Morgan, Walkerville, Montana, Danny Wilcox Frazier, 2013.
Above: Ground Zero, New York, Alan Chin, May 2, 2011.

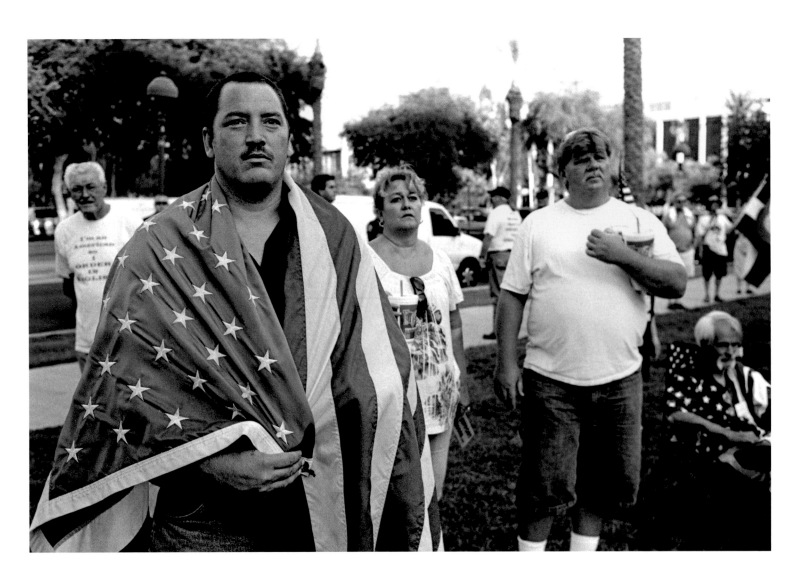

In Phoenix supporters of Arizona Senate Bill 1070 call for deportation
of illegal immigrants, Carlos Javier Ortiz, July 2010.

Milvertha Hendricks, eighty-four years old, waits to be evacuated from the New Orleans convention center after Hurricane Katrina, Alan Chin, September 2005.

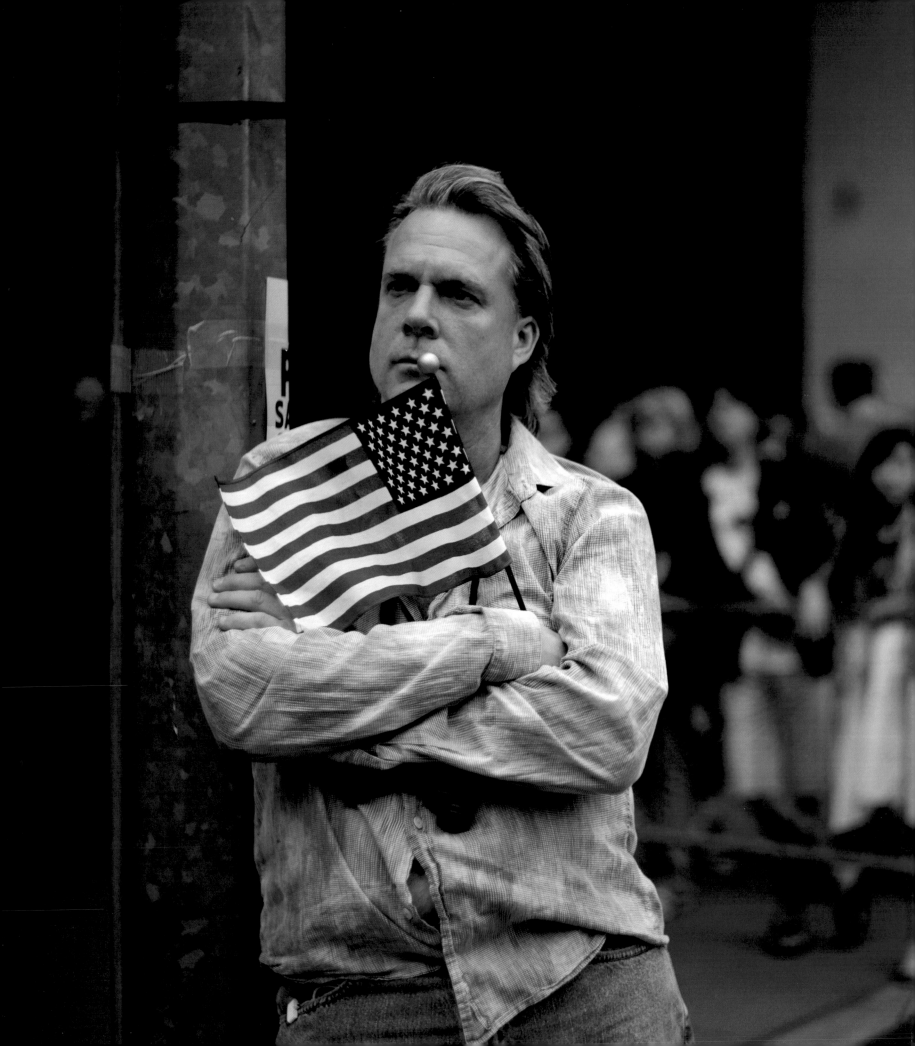

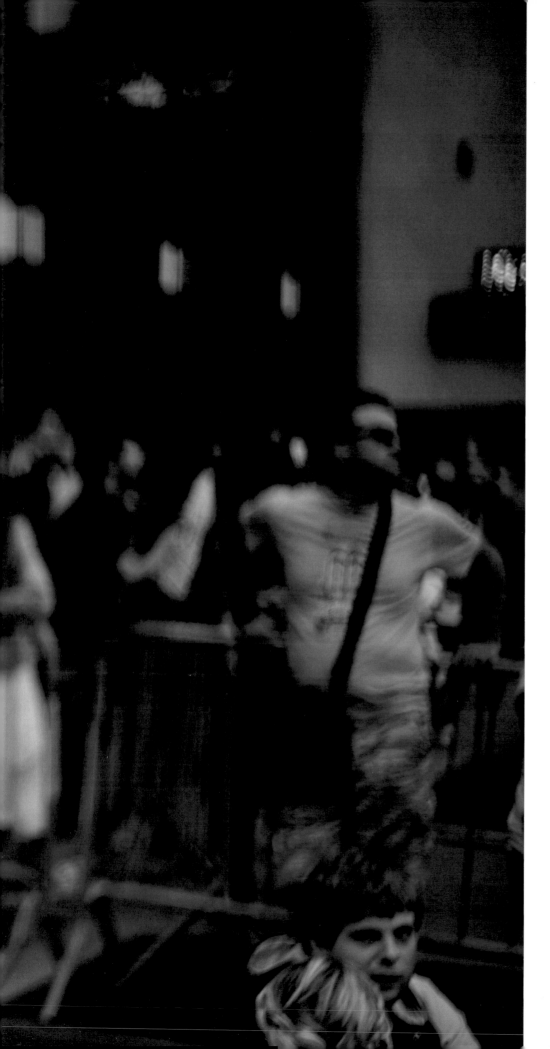

Tenth anniversary ceremonies for 9/11 in New York's
Financial District, David Burnett, September 11, 2011.

243

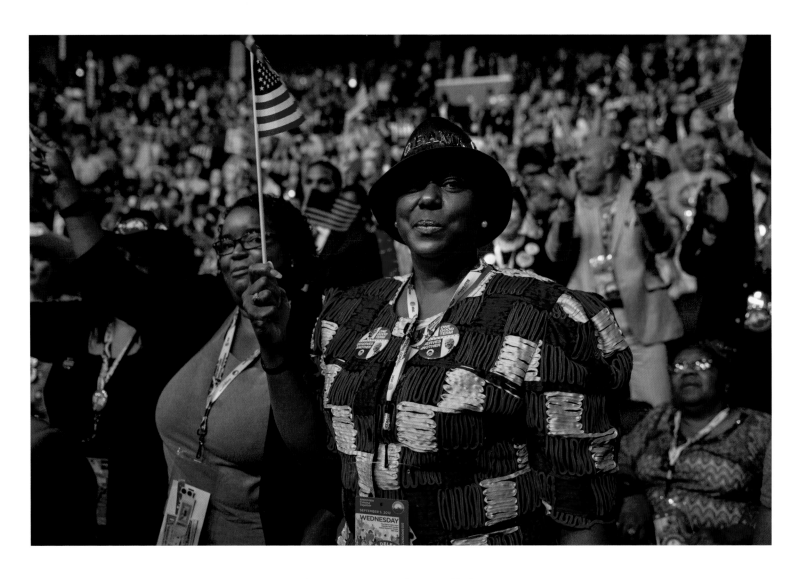

Texas delegate, Democratic National Convention in Charlotte, North Carolina, Lucian Perkins, September 2012.

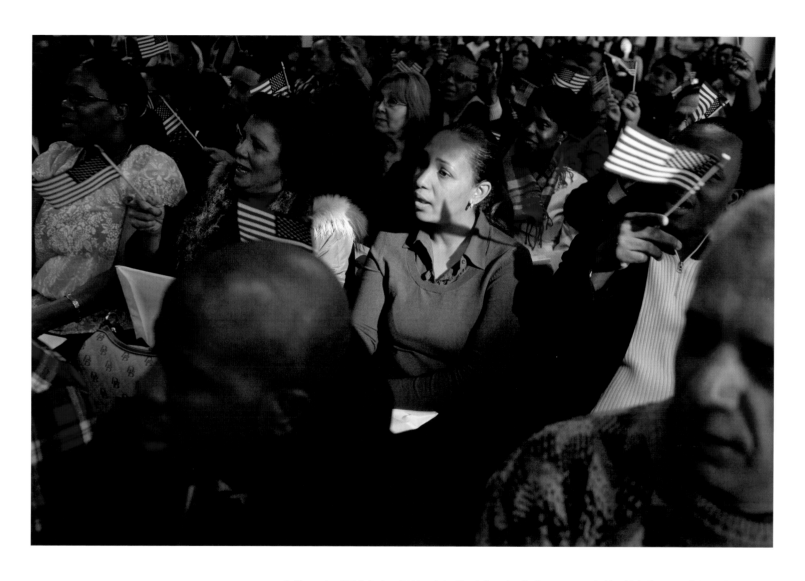

In December 2010, Andrew Lichtenstein attended a naturalization ceremony in New York. "It was really beautiful," he says. "I think every American should go to a naturalization ceremony because we can sit here and talk about all these injustices, the borders, the prisons, racism, and slavery. And it's so easy to forget that this country is made up of people who came and wanted to make a life here. What other country does that? It's so amazing."

THE PHOTOGRAPHERS

DAVID BURNETT has been covering momentous events in the United States and abroad for four decades. He cofounded Contact Press Images in 1976. He has worked for all the major news magazines in the US and Europe and has exhibited and taught widely. Burnett has won the Photographer of the Year award from the National Press Photographers Association, and the Robert Capa Gold Medal from the Overseas Press Club. In 2009 he won prizes in the Best of Photojournalism competition and the Eyes of History contest sponsored by the White House News Photographers Association. Burnett is the author of two books: *Soul Rebel: An Intimate Portrait of Bob Marley* (2008) and *44 Days: Iran and the Remaking of the World* (2009).

ALAN CHIN was born and raised in New York's Chinatown. Since 1996 he has covered conflicts in Iraq, the former Yugoslavia, Afghanistan, Central Asia, China, and the Middle East. He spent several years deeply documenting the aftermath of Hurricane Katrina. Other American coverage includes the 2010 BP oil spill and three presidential election campaigns. He followed the historic trail of the civil rights movement and reported on the rust belt states of Ohio, Michigan, and Pennsylvania. Chin is an editor and photographer at BagNews. His photography is published by *Newsweek* and the *New York Times*. Honors include nominations for Pulitzer Prizes in 1999 and 2000. Chin's work is in the collection of New York's Museum of Modern Art. He exhibits at Sasha Wolf Gallery and the Asian American Arts Centre. He is creating a personal book from his documentary project *Toishan, China: Another Home 8,000 Miles Away*.

DONNA FERRATO is a renowned photojournalist whose seminal work on domestic violence opened up a hidden world that people did not want to confront. Her book *Living with the Enemy* (1991) went through four printings. She formed her "I Am Unbeatable" campaign to lead young women away from the cycle of domestic violence and toward self-sufficiency and independence. The city of New York officially declared October 30, 2008 "Donna Ferrato Appreciation Day" for her work as a women's advocate. She is president and founder of Domestic Abuse Awareness and has been a member of the executive board of directors for the W. Eugene Smith Memorial Fund. She has received many professional honors and awards, including the Robert F. Kennedy Award for Outstanding Coverage of the Plight of the Disadvantaged; the International Women's Media Foundation Courage in Journalism Award; and the Missouri Honor Medal for Distinguished Service in Journalism. Her work has been published in *Time* (two covers), *Life, New York Times Magazine, USA Today, U.S. News & World Report,* and *Los Angeles Times*. Her photographs are included in the permanent collections of the International Center for Photography, New York City; the former Corcoran Gallery of Art, Washington, DC; and in Henry Buhl's private Hands Collection, among others. Additional books by Donna Ferrato include *Amore* (2001) and *Love & Lust* (2004).

DANNY WILCOX FRAZIER has documented marginalized communities across the United States, with close focus on people struggling to survive in devastated rural communities across his home state of Iowa. His book *Driftless: Photographs from Iowa* (2007) was awarded the Center for Documentary Studies/ Honickman First Book Prize in Photography (photographer Robert Frank, author of *The Americans*, selected Frazier's work for the prize). Frazier directed and coproduced a documentary with MediaStorm, winning a Webby Award and an Emmy nomination for New Approaches to News and Documentary Programming (2010). His foreign assignments have taken him to Afghanistan, India, Cuba, Uganda, Kenya, Tanzania, Nigeria, the Ivory Coast, Kosovo, and Mexico. His work has appeared in *Harpers*, *New Yorker*, *National Geographic*, *New York Times*, and other international publications. Frazier is the recipient of numerous fellowships and grants, including an Aftermath Project grant in 2009. His photographs are in public and private collections, including the Houston Museum of Fine Arts, the Philadelphia Museum of Art, the George Eastman House International Museum of Photography and Film, Duke University's special collections library, the Honickman Foundation, and the Smithsonian's National Museum of American History.

STANLEY GREENE's most recent book, *Black Passport* (2009), is a bold and intimate look at his work and life. POY (Pictures of the Year) selected it as a finalist for Best Photography Book of 2010. In 2004, the year after Trolley Books published his book *Open Wound: Chechnya 1994–2003*, Greene was awarded the W. Eugene Smith Award. In 1998 he received an Alicia Patterson Fellowship. Greene has received five World Press Photo Awards, a W. Eugene Smith Humanistic Grant (2004), an Open Society Foundations Grant (2006), and a Getty Images Grant for Editorial Photography (2011). He received an Aftermath Project grant for "The Rise of Islam in the Caucasus" (2013).

Greene photographed the fall of the Berlin Wall and has covered wars in Africa, the former Soviet Union, Central America, Asia, the Middle East, and recently, Ukraine. In 2008, 2009, and 2012, his work was exhibited in Visa pour l'Image, the French photojournalism festival. He is a founding member of the photo agency NOOR.

ANDREW LICHTENSTEIN is a photographer, journalist, and educator. His book on American soldiers killed in the Iraq War, *Never Coming Home*, was published in 2007. He is currently teaching at the International Center of Photography and finishing a long-term story on American history. He lives in Brooklyn, New York.

CARLOS JAVIER ORTIZ was born in San Juan, Puerto Rico, and raised in Chicago. He devotes his photography and film work to long-term documentaries focusing on marginalized communities, gun violence, race, and poverty. He has received grants from the Open Society Foundations, the Richard H. Driehaus Foundation, the Pulitzer Center on Crisis Reporting, the California Endowment National Health Journalism Fellowship, and the Illinois Arts Council Artist Fellowship. Ortiz's photographs have been exhibited in galleries and museums around the world, and they are displayed in the permanent collections of the Worcester Art Museum in Massachusetts; the International Museum of Photography and Film in Rochester, New York; the Museum of Contemporary Photography in Chicago; and the Detroit Institute of Arts. He won the Robert F. Kennedy Center for Justice and Human Rights Photography Award for his series *Too Young to Die*, a multiyear, comprehensive examination of youth violence in the United States and Central America. In 2014, his book *We All We Got* was published, along with the release of his film by the same name. Ortiz's work has appeared in *Time, American Photo, The Week,* and *Slate*.

DARCY PADILLA is a photojournalist and documentary photographer living in San Francisco. Her work is published and exhibited internationally. Her many honors include a John Simon Guggenheim Memorial Foundation Fellowship; W. Eugene Smith Grant in Humanistic Photography; Open Society Foundations, Individual Fellowship; Alexia Foundation for World Peace Grant; Getty Images Grant for Editorial Photography; Alicia Patterson Foundation Fellowship; and World Press Photo, First Prize for Long-Term Projects (first recipient). Padilla is an adjunct lecturer at the San Francisco Art Institute and a member photographer at Agence VU, Paris. For more than eighteen years she followed and photographed the life of a young woman with AIDS, resulting in her landmark project "Julie 1993–2010." Her monograph *Family Love*, based on that work, was published in 2014.

LUCIAN PERKINS was a staff photographer for the *Washington Post* for twenty-seven years. He has won many awards, including the Pulitzer Prize for Explanatory Journalism, with staff writer, Leon Dash, 1995; World Press Photo of the Year, 1995; and Pulitzer Prize for Feature Photography, with Carol Guzy and Michael Williamson, 2000. Perkins is the author of two books: *Runway Madness* (1998) and *Hard Art, DC 1979* (2013). *Runway Madness* was exhibited at the Newseum in Washington, DC, and New York City, 1998. *Hard Art, DC 1979* was exhibited at the Center for Documentary Studies, Duke University, in 2014. Perkins has also curated the work of colleagues. His exhibits include the traveling "Russia: Chronicles of Change," Southeast Museum of Photography, Daytona Beach, Florida, 1996–1997; World Press Photo exhibition, Amsterdam, Netherlands, 1996; and three exhibitions for Fotoweek DC in 2009: "Iraqi Voices," "Inside/Outside," and "My Cuba." Perkins cofounded InterFoto, an annual international photography conference in Moscow, Russia, from 1995 to 2005, and he was cofounder of Facing Change: Documenting America in 2009. Currently, Perkins is an independent photographer living in Washington, DC.

MAGGIE STEBER has worked as a documentary photographer in sixty-five countries. Her longtime work in Haiti received a prestigious Alicia Patterson Foundation Grant and an Ernst Haas Grant. A selection of her Haiti photographs was published in *Dancing on Fire: Photographs from Haiti*. Steber worked in Cuba from 1982 to 1985 and photographed a day in the life of Fidel Castro for *Newsweek*. From 1999 to 2003, she served as assistant managing editor for photography and features at the *Miami Herald*. Steber's photographs have been widely exhibited throughout the United States and the world. Her clients include *National Geographic*, *New York Times*, *New Yorker*, *Smithsonian*, *Politico, Stern,* and many others. She has served on numerous judging panels and currently serves on the advisory board and as a teacher of FotoKonbit, a Haitian nonprofit that teaches photo workshops for Haitians from fifteen to forty years old. Her awards include the Leica Medal of Excellence; Overseas Press Club Olivier Rebbot Award for Best Photographic Coverage from Abroad; the Missouri Honor Medal for Distinguished Service to Journalism, University of Missouri; First Prize for Spot News, World Press Photo Foundation; and First Prize for Magazine Documentary in Pictures of the Year. Steber has created two multimedia productions: *Rite of Passage* (produced by Brian Storm, MediaStorm) and *Madje Has Dementia* (AARP).

TEXT AND ILLUSTRATION REFERENCES

PAGE 8: Betty Miller, ed., *Elizabeth Barrett to Miss Mitford: The Unpublished Letters of Elizabeth Barrett Browning to Mary Russell Mitford* (London and New Haven: John Murry, 1954), quoted in Mike Weaver, ed., *The Art of Photography 1839-1989* (New Haven and London: Yale University Press, 1989), 7.

PAGE 8: Philip Gefter, "The Next Big Picture: With Cameras Optional, New Directions in Photography," *New York Times*, January 23, 2014, http://www.nytimes.com/2014/01/26/arts/design/with-cameras-optional-new-directions-in-photography.html.

PAGE 9: Fred Ritchin, interview by Jeremy Lybarger, "Can Photojournalism Survive in the Instagram Era?" *Mother Jones*, July 18, 2013, http://www.motherjones.com/media/2013/07/bending-the-frame-fred-ritchin-photojournalism-instagram.

PAGE 130: Chico Harlan, "Rental America: Why the Poor Pay $4,150 for a $1,500 Sofa," *Washington Post*, October 16, 2014, http://www.washingtonpost.com/news/storyline/wp/2014/10/16/she-bought-a-sofa-on-installment-payments-now-its-straining-her-life/.

PAGE 133: Stanley Greene, interview by Michael Kamber, "Stanley Greene's Redemption and Revenge," *New York Times Lens Blog*, July 22, 2010, http://lens.blogs.nytimes.com/2010/07/22/shoptalk-7/.

PAGE 186: Nick Paumgarten, "We Are a Camera: Experience and Memory in the Age of GoPro," *New Yorker*, September 22, 2014, http://www.newyorker.com/magazine/2014/09/22/camera.

PAGE 196: Nathan Heller, "California Screaming: The tech industry made the Bay Area rich. Why do so many residents hate it?" *New Yorker*, July 7 & 14, 2014, http://www.newyorker.com/magazine/2014/07/07/california-screaming.

Photographs on pages 10, 13, and 15 appear courtesy of the Library of Congress.

Shooting script and letter on page 12 courtesy Roy Stryker Papers, Photographic Archives, Archives and Special Collections, University of Louisville.

ACKNOWLEDGMENTS

I first heard about Facing Change while enjoying a latte in a Starbucks down the street from *Pravda* in Moscow. It was July 2010, and I was talking about Russian photography with Andrei Polikanov, photography editor for *Russian Reporter* magazine. Andrei mentioned the Facing Change collective and named several photographers I knew—Lucian Perkins, Anthony Suau, David Burnett.

I loved the idea of Facing Change, and the minute I returned to Washington, I contacted Lucian and Anthony. This wasn't the first time I had thought about a book on America. I had prepared a book proposal on America only months before and had shared the proposal with Kevin Mulroy. Together we had taken it to the Library of Congress. Now Anthony and Lucian were eager to collaborate. Kevin and our colleagues at the Library agreed it was a good fit.

Facing Change photographers formed their collective in 2009 to document the crucial issues of our day. Their diverse and clear-eyed work is hugely important to those who care about current public life. My appreciation for their photography and their idealism has only grown as we have worked together.

Most of the photographers met with me in Washington to look at photographs and talk. Margaret Wagner, managing editor of the Library's Publishing Office, gave us space and supported our work. Beverly Brannan, curator of photography in the Library's Prints & Photographs Division, hosted each visiting photographer for an afternoon. The highlight of those afternoons was her vivid commentary on the FSA collection.

Helena Zinkham, chief of Prints & Photographs, was instrumental in the decision to house these photographs in the Library's permanent collection.

Special thanks to Kris Hanneman, who, in addition to her work as researcher, managed our digital files and has been a daily partner in many ways. Thank you to Jeff Campbell, the best text editor I've ever worked with, and to David Chickey, whose work I've admired for years. The design team for this project includes David Skolkin and Timothy Edeker. We are fortunate to have these talented people as partners on this book.

Thank you to Nina Alvarez and Sheryl Mendez, members of the Facing Change board of directors, and to Lucian Perkins, acting member, for their generous and thoughtful encouragement. The Facing Change board in turn acknowledges the vital role Open Society, WilmerHale, and Leica have played in the work of Facing Change.

I am grateful to Sam Abell for looking at covers, to Meredith Wilcox who answered questions about rights issues, and to Dena Andre whose experience, wisdom, and friendship I've been able to turn to in time of need.

Thank you very much to Kevin Mulroy, of Potomac Global Media, to Stephen Hulburt and Holly La Due, of Prestel Publishing, and to Karen A. Levine, for bringing this book to publication.

And thank you to my family: Naftali, Ronnit, Oren, Beth, Dara, and especially to Avrom, who has lived with this book in all its various stages for almost five years.

Published by Prestel, a member of Verlagsgruppe Random House GmbH in association with The Library of Congress

Prestel Verlag
Neumarkter Strasse 28, 81673 Munich
Tel. +49 89 4136 0
Fax +49 89 4136 2335

Prestel Publishing Ltd.
14-17 Wells Street, London W1T 3PD
Tel. +44 20 7323 5004
Fax +44 20 7323 0271

Prestel Publishing
900 Broadway, Suite 603, New York, NY 10003
Tel. +1 212 995 2720
Fax +1 212 995 2733
E-mail sales@prestel-usa.com

www.prestel.com

Produced by Potomac Global Media, LLC

Library of Congress Cataloging-in-Publication Data:

Bendavid-Val, Leah.
 Facing change : documenting America / Leah Bendavid-Val.
 pages cm
 Includes photography from Maggie Steber, Alan Chin, Andrew Lichtenstein, Donna Ferrato, Carlos Javier Ortiz, Stanley Greene, Danny Wilcox Frazier, David Burnett, Darcy Padilla, Lucian Perkins.
 ISBN 978-3-7913-4836-0
 1. United States--Description and travel. 2. Social change--United States. 3. Popular culture--United States--Pictorial works. 4. Documentary photography--United States. I. Title.
 E169.Z83B445 2015
 917.304--dc23
 2015010099

Editorial direction by Holly La Due
Design by David Chickey, David Skolkin, Tim Edeker, Montana Currie
Text Edited by Jeff Campbell
Research by Kristin Hanneman
Proofread by Jane Sunderland
Production by The Production Department
Printed in China

ISBN 978-3-7913-4836-0

Frontispiece: Protest against Dominique Strauss-Kahn, who is confined to a Tribeca apartment during his trial for assaulting a maid in New York's Sofitel Hotel, Donna Ferrato, 2011.

Page 4: Flag maker Scott Peterson measures a flag on June 17, 2009, the day before installation, South Miami, Florida, Maggie Steber.